THE CARING MUSEUM

THE CARING MUSEUM

New Models of Engagement with Ageing

Edited by Hamish L Robertson

MUSEUMSETC | EDINBURGH & BOSTON

CONTENTS

PREFACE

Peter Whitehouse
Professor of Neurology, Case Western Reserve University
Professor of Medicine (Neurology), University of Toronto

FORGIVE ME IF I DO the obvious and begin by "musing" on the contents of *The Caring Museum* with hopes and expectations of amusing and bemusing anyone who has the good fortune to engage the book. Museums as literal but mythical "homes for the Muses"– and the Muses as the nine Greek mythical female spirits of the arts and sciences – seem a good place to start as we contemplate the future of museums and of aging and caring and their intergenerative interface.

Musing itself needs a little reinvigoration in modern life. Its etymology may lie in the general concept of "thinking", but modern cognition seems to focus on speed and efficiency. We live in fast, short-term oriented hypercognitive societies. Musing is different. There is an art and science to musing which is intensely metaphorical. Musing takes time; it involves pondering and even meditation. To muse involves digesting, ruminating, and often in silence, often by oneself. It is less concerned about outcomes, especially short-term ones. How different is this than the usual rapid collective ratiocination, if not rationalization, that we do in frenzied modern life?

Museums are a place to encourage this kind of deeper and more reflective thinking. Perhaps they can be part of our quest for wisdom (as it was when I organized an undergraduate seminar course on Wisdom and visited museums). Surrounded by artifacts from the past, perhaps we as visitors can better contemplate the depths of our humanity in the present and imagine hopeful futures that we can help create. Perusing the galleries, we move slowly and quietly with friends and families. Perhaps we can gain a little humility from the past adventures and misadventures of others. We are challenged to remember what we learned about the subjects of the exhibits in school or on previous visits.

Hence museums and aging have a natural affinity.

Museums and caring seems a bit of a stretch historically. Yes, museums care about visitor comforts but mainly they care in a broader, perhaps public health sense, for something more elusive. It is important to remember from whence we and others came, how we know and support each other in the global community and celebrate through the arts and other inventions. It is critical to celebrate diversity. Museums care about culture – deeply.

Museums are our places to expand one's horizons and to engage the brain and body to learn. But like all learning organizations they are facing enormous challenges to reimagine and reinvent themselves. What kind of museums will communities support financially and through their membership and visiting behaviors? How will museums both lead and follow cultural trends? Modernity and the Western Enlightenment are being challenged by shifts in economic activity and perhaps creativity and even the energy of civilization moving more towards the East, but in various directions. The so-called West is subject to critiques of the dominance of rationality, the zeal for individualism, and the fragmentation of knowledge in the world. Income equity, a huge international problem, creates tensions between the so-called North and South in some individual countries and in the world. How can museums and other learning organizations assist us to consider values in life besides money – and development goals individually and collectively besides economic growth. Public schools, higher education, and libraries are all facing the need for reinvention. How will 21st century learning occur and where? What is the value of a museum to education and its community? What will

the museums of the future (if they survive and thrive) show about our time on the planet?

Yet just as we need to tell new stories about museums and their roles, we need new narratives about aging and caring. How can the collaborative dance among these evolving ideas lead to new stories that help humanity address its challenged future? Social inequity, culture clashes, and global climate change require new collective wisdoms, global moral values, and systems thinking. Narratives based around experiential and service learning are the most powerful forces that may help us create a more sustainable future – full of flourishing rather than degeneration and even extinction. Museums and ageing share the need for invigorating and hopeful narratives.

Hence let me tell a few stories about museums with which I have engaged as advisor, program developer, and visitor.

Over 25 years ago, when my three daughters were in elementary school, I took one of my sabbaticals in my hometown of London. Given the size of our flat in Bloomsbury, we didn't do just home schooling but museum schooling as well. The National Portrait Gallery, the National Gallery, the Natural History Museum and the British Museum became the places in which we learned as my daughters skipped nine months of their elementary school experience in the United States. History came alive through historical and natural objects of all kinds. It was object-based learning, but embedded in my children's relationships to both their parents and a completely new city to them.

Frankly, we didn't use the British Museum quite so much on that trip but it was right around the corner from the flat and has been a prototype of a museum for me over the many

days that I spent in that area of London next to the National Hospital for Neurology and Neurosurgery where I would often study. The 18th century aspirations of the British Museum to be the citizen's museum in which the whole world could be seen in one building was in many ways realized. But starting last year it began a process of thinking about the museum of the future. The British Museum represented the Western Enlightenment focus on rationality and individuality. What will the post-modern British Museum look like? We'll get back to the future museums later.

We also visited the Museum of London occasionally which also allows me to make the point that London itself is a city which in many ways is a living museum. We lived in Bloomsbury near the Charles Dickens House as well as near where the spirits of the Virginia Woolf, William Butler Yeats, and other Bloomsbury artists seem to still dwell.

My current collaborator on museum work, Yoko Hayashi from Tokyo, has taught me the importance of different aesthetics of both art and the places that display art. Our Cleveland Museum of Art has a wonderful Japanese and Asian collection, comparable in quality in many cases to the National Museum in Tokyo. Japanese museums were modelled after Western museums and yet are subtly different in scope and purpose. We are beginning to work with the aesthetics of the depiction of aging in Western and Eastern art as well as the development of specific programs for older people. The Cleveland Museum of Art for example (see Hilton chapter) participates in the program developed at MoMA in New York for people with dementia. Yoko translated Meet Me at Moma into Japanese and replicated the program in her country.

One of stories I like about the MoMA program is told by a colleague who was involved in the evaluation of the program. Because the research assistants could not always tell who had the clinical label of dementia and who was the care partner, the name badges were coded using a pattern of capital and lower case letters to make sure that the observers could differentiate the different groups of people. How interesting is that, since one of the messages of Meet Me at MoMA is that the experience of sharing art is a universal human experience that transcends specific labels like dementia.

Many people are now focusing on developing dementia-friendly communities. How should first responders and shop-keepers respond to people with cognitive challenges when they are having difficulty making change or navigating a city street? Such community transformation includes efforts to acquaint institutions such as museums to be more responsive to the needs of those with memory impairment. Training staff is an important step in this process. Frankly, my own view about dementia-friendly communities is that they should be part of a broader age-friendly communities. My wife and I recently visited several museums in Manchester and were impressed with how they were being integrated into Manchester as the first World Health Organization designated Age-friendly city in the United Kingdom. London became the first capital city designated as Age-friendly. Manchester has been and is an ambitious city that wonderfully exhibits its powerful roots in labor and progressive politics (and sports) in its museums.

Another museum adventure with lessons about assisting seniors occurred in Toronto. The Heritage Museum is located at Baycrest Health Center, one of the 15 affiliated hospitals of

the University of Toronto, where I also have a faculty appointment. This museum develops themes and rotating exhibits around Jewish traditions and their impact on the world at large. An upcoming exhibit exhibition will focus on Jewish physicians and their role in Toronto and the world. Because many of the elders cannot easily travel to the museum, the staff has developed a portable exhibit that travels to residents in the various nursing home and other living facilities associated with Baycrest. Bringing museums to people is an important theme for the future.

And finally a mention of two museums in Cleveland: one quite old, the Dittrick Medical History Center which includes a museum of medical artifacts focusing on items like microscopes, surgical instruments and contraceptive methods, and one very new, the Museum of Contemporary Art located just down the street from each other. I have shared a few projects with Chief Curator Jim Edmonson of the Dittrick over the years in my area of interest, the history of neuroscience and Alzheimer's. In October 2013, when we planned a social event at the new Museum of Contemporary Art for our scientific conference, From Neurodegeneration to Brain Health: An Integrated Approach, I wanted to use art as a way of building bridges between different ways of imagining the brain and its health. So with the cooperation of both staffs we displayed an exhibit of medical devices used to study the brain from the early 1900s: for example, surgical instruments involved in frontal lobotomies and phrenological "brain" models. During the dinner we displayed images of the brain photographed through the microscope, which was the revolutionary advance used to image the brain at the time of Alzheimer, juxtaposed

with images from modern neuroimaging such as PET and MRI scanning. One intended message was that science is often driven by the development of new methodologies which themselves have specific cultural dimensions. One of the exhibits at the museum at the time we had our event was entitled *Only Words Eaten by Experience* by artist Simon Evans, focusing on mental illness. This title was especially ironic for our conference because one of the themes of some of the presentations (including mine) was that the people's lived experiences with age-related memory challenges are much richer than the attempts we make as physicians to label, i.e. diagnose, people with words like Alzheimer's and Mild Cognitive Impairment.

My own engagement with art has been to collaborate with a variety of organizations that are trying to enhance the development of contemporary and participatory art like the National Center for Creative Aging. A great concern in this community of professionals is convincing funders that art is valuable. They lament that they are required to do rigorous evaluations and, if possible, controlled studies. Having done many randomized controlled studies of drugs myself, and as someone concerned about the dominant influence of scientific approaches in the world, I actually look in a different but complementary direction. I am exploring the commonalities of the aesthetic experience in art and science – the use of creative process, the search for holistic perspectives, and the potential for cultural transformation. But I am also searching for art to challenge science. In some ways, I am looking for the Ai Weiwei of dementia; in other words artists to challenge the dominant ways that we are thinking about brain aging. Ai Weiwei himself produced art about a subdural hematoma that resulted from a head injury

that occurred in the custody of Chinese authorities. But my most memorable engagements with his art were around the research that he did to identify the names of children killed by the shoddy, corruption-ridden construction of schools during earthquakes in China in 2008. His artwork included spreadsheets of the names of the children, an installation of their backpacks made into snake-like forms, and faulty, substandard steel rods harvested from the quake sites made into sculpture.

In the current conversations between art and science, science clearly seems to dominate. Yet as a scientist, I believe that science has lost some of its soul through its alliance of unbridled capitalism and unskeptical science. Can art help science rediscover its aesthetic dimensions as they both look for patterns, holistic perspectives, and beauty in the world?

In a world that is transforming aging, it is essential that we pay attention to the well-being and health of children as well as seniors. Children are, after all, essential to the future and will become the future elders eventually. I often think of museums as some of the most intergenerational learning environments that our communities currently possess. Grandparents and grandchildren with or without parents visiting a museum are common sights. They may be taking in the ambience and building relationships with each other, rather than paying much attention to the exhibits. Museums are as much about building human connections as they are about relationships between people and the things they produce. Some of the older people in the museum will be docents, likely volunteers. They actually represent a new phase of aging that we are developing in the same way that we developed adolescence at the turn of the last century. We don't have a good name for it yet so let's

call it *Adulthood II*, although perhaps the *young old* or *Third Age* might work. Some call this phase of life *Encore*. In a career development mode it's a phase of life when, if one has done well enough in a first set of work experiences, one can choose work and/or volunteerism that is more meaningful in the latter phases. Aging is changing. We seem to be unable to just use the word *aging* without modifying it with words like successful, productive, optimal, positive or conscious. I once invented the term *Just aging* with the double entendre of saying let's just talk about aging, but also the critical issues of justice and aging. But it is clear that aging is being appropriately viewed more and more as a life course activity. Everybody is aging all the time. Hence a long-term intergenerational perspective suggests that we need to look at museums in the context of visitors of all ages, including visitors of the future who will have different attitudes about museums and aging than current visitors.

Stories surrounding brain aging are evolving particularly rapidly. We are abandoning the overly simplistic notions that the world is full of people who either have Alzheimer's or don't. The word dementia is replacing Alzheimer's in global discourse as we become more honest about the lack of clarity that we have around the use of this over 100-year-old eponym. Alzheimer's is not one condition, and it is related to aging. It is not going to be cured, but we can develop more community and public health approaches in which museums can play a role to help think people reflect on their own memories and age-related changes.

The future will be different for museums as well as elders. All learning organizations are being challenged by digital technologies. With the Internet of Things and the World Wide Web

why do you need to go to a museum to see in high resolution the image of an art object? What is the sense of a place that creates more powerful learning? How does interacting with other people in real-time face-to-face lead to the creation of more powerful stories and collective wisdom?

The chapters in this timely and enjoyable book clearly help us reimagine what museums are today and could become. The focus on the nature of the visitor, just as we speak of focusing on students in schools (or patients in hospitals), is fundamental to the reinvention of museums as well as other learning organizations. Organizations are looking to who they serve for guidance: dare-I-say our customers and end-users. Interfaces with the community physically and culturally are becoming absolutely critical as the museum extends its boundaries beyond its usual walls. Thinking of museums as providing new services, such as reminiscence "therapy" and interfacing with the health system by being a kind of social prescription represent new ways on envisioning the role of museums in aging and health. Incorporation of technology is key. Specific programming for particular kinds of visitors, such as older people with physical and cognitive disabilities, is essential. And once again, and most importantly, museums can reimagine themselves as places where intergenerational learning and relationships can be built in new ways. The recently released New Media Consortium report on museums for further is a good source for visions of the future of museums.[1]

My own work in learning organizations has focused not just on so-called higher education but also public schools. We need to start early helping children become empowered learners, creative storytellers, and spirited citizens. The engagement

of adults and elders in our three intergenerational schools in Cleveland[2] is essential to realizing our vision of contributing to learning communities. We have enjoyed collaborative partnerships with museums, such as the Cleveland Museum of Art and others, as well as with other forms of experiential and service learning programs, such as nature centers and botanical gardens.

The essential task for human communities today is the re-imagination and reinvention of how we live together. Globalization and digitalization, and before them agriculture and industrialization, are enormously powerful forces that changed how humans relate to each other and to our planet. We are indeed in the Anthropocene – a planet shaped by human activity. Yet there are significant dangers ahead as we have become enamored by our own power and have lost the humility that comes from our heritage. Museums can tell us from whence we came and the challenges we faced and the cultural inventions we made to address those challenges. This source of artifact-based wisdom combined with the experiences of aging offer great promise for human flourishing.

Please forgive these informal musings. By their nature, musings are subject to loose associations, random wanderings, and dead ends prompting retracing steps. But such is the process of creativity – nonlinear, sometimes disruptive, and full of unexpected turns. I coined a very academic sounding composite term for this kind of intellectual activity – *transdisciplinary intergenerativity*. More than interdisciplinary, transdisciplinary asks for deep conversations among the disciplines and how academia relates to the problems of modern society. Intergenerativity is a neologism that calls for integrating sources of

creativity in the world to find new inspirations for innovation. We must go "between" in order to go "beyond". Museums have a special role to play as we explore the particulars of human culture while searching for the universals. Looking at what we have created, both ideas and objects, in the past can help us produce the memes we need to survive and flourish in the future. Aging is a part of our individual and demographic future and caring for each other has always be essential and will become even more so. Museums can help us imagine new ideas about aging and new ways of caring.

I wish to thank Dale Hilton and Yoko Hayashi for helpful feedback on an earlier draft of this Preface.

NOTES

1. www.nmc.org.
2. www.tisonline.org.

INTRODUCTION

Hamish L Robertson

THE WORLD'S POPULATION is ageing. This has implications for cultural heritage institutions from museums to galleries, archives and beyond. The people who visit museums, who would like to visit and cannot, those who perhaps felt excluded in the past, and those who currently work and volunteer in them – all these groups are gradually ageing. This is especially the case across the more affluent developed world, but the pattern is increasingly global. Ageing is a cultural as well as demographic, political and economic phenomenon. It is also now a media topic as societies struggle to deal with the issues that population ageing presents: including pensions, healthcare, housing, social services, labour supply and even consumer demand. A key issue for museum professionals to be concerned about is the dominant ways in which age and ageing are represented to us through the media and in political and medical discourse. Ageing is often depicted as being all about decline – mental, physical, personal, institutional and social – with little or nothing beneficial in the equation. Yet the reality is much more positive, complex, and nuanced than these often simplistic representations would suggest. This collection of chapters and briefer case studies offers some key insights on these issues seen from the perspective of museums and museum professionals responding to the changes that population-level ageing will bring.

We know that ageing is highly correlated with a range of health and disability conditions but this is because we are seeing more people live to ages that few of us did in the past. Ageing is a success and population ageing is indicative of successful societies. Age does present challenges as well, but these are readily prepared for if we accept ageing as a positive

outcome for the future and not as a threat to the way things were in the past. Of course, there are many things to prepare for with population-level ageing. Health and social care services are one focus, but in reality every aspect of society needs to be age-ready. Our social mythologies of youth will do little to meet the needs, wants and interests of our ageing populations and this volume addresses a variety of these issues in the context of contemporary museums, their operational concerns and their long-term goals.

Growing older increases the need for the provision of social support to often isolated and increasingly vulnerable elderly people in community settings. The dementias, especially Alzheimer's disease, have gained prominence as a major concern for older people, their families and for health and social care providers. The serious challenge of the dementias often lies in the clinical features of these progressive, degenerative age-related conditions, including loss of mobility, of affect, of cognitive abilities and associated behavioural problems. Current health and social support systems care are challenged by these issues, while many museums and galleries are already rising to the challenges, as several authors in this volume attest.

On the other side of ageing equation, many more people are living longer than ever before in recorded history and generally living well. This is to reconsider what age and ageing are at a cultural and social level. The cultural idea of ageing is increasingly dynamic because where past life expectancies saw very few people live beyond their sixties, now many more live into their seventies, their eighties and beyond. The phenomenon of the centenarian, and even super-centenarian, is growing so quickly that researchers are struggling to keep up with our

understanding of truly advanced older age. A number of authors in this volume note that some of their volunteers, for example, include people well into their eighties who are themselves often providing assistance and support for others in their own and even younger cohorts. In other words, old age is a plastic concept and one which is diversifying rapidly, with the pattern in many countries being at once both general and highly particular. We can observe populations ageing from the Americas, across Europe and into East Asia but the timing, rates and specific responses to those ageing processes vary considerably.

This volume draws together a selection of chapters and case studies which explore the involvement of older people in the museum sector and cultural heritage more generally. This is not a passive collection of positive stories but one which recognizes the ups and downs of making the effort to engage with older people. As with disability, with which ageing often intersects, thoughtful responses require the development of new knowledge and techniques for understanding and engagement with the spectrum of issues with which museums are being and will continue to be presented. Ageing is diverse and complex, which means that long-term strategies are required as well early interventional projects. In addition, everyone involved is learning as they go because there is no endpoint to this process. We will live in ageing societies for the foreseeable future and the issues discussed by the authors here can only grow in scope and importance as that process develops. I present these in brief in the following paragraphs to give the reader a sense of the sheer variety of issues and positions our authors are taking in regard to the issue of older people and the museum.

Eszter Biro from Hungary discusses the phenomenon of older women who have no remaining family and the physical fate of family photographs, as well as their deeper background social context and meaning. Her work with older women highlights a range of issues, including not only individual experiences and circumstances, but the isolation which changing social patterns can produce. People who lived under various forms of repression may already have difficulties with trust and openness. The processes associated with ageing can further complicate engagement with such people and the collection of certain types of cultural heritage information. Knowing who to approach and how to approach them proved to be just the beginning because trust takes time and feelings are easily affected by illness, memory problems or a lack of contact between researcher and participant over the time it takes the researcher to finalise a project.

Memory work can attempt to capture what might otherwise be lost to individuals and society but it can also be used to build social connections and reach out into communities, including those who are isolated or institutionalised. The Oxford Museums' reminiscence programme is one example of how engaging with older people is opening up new domains of work, research and co-operation for museums. Helen Fountain's chapter explores how the local history of a place, such as the centenary of Oxford's Morris Motors establishment, can engage with emerging technology and innovative practices to build social capital through the traditional business of museums exploring cultures and their artifacts. Partnerships can be established not only between museums and visitors but between museums and other service providers - and between

visitors and visitors. The process of engaging with older people and the issues of ageing expand the role and nature of the museum and the museums experience in new and often highly innovative ways.

Dale Hilton and colleagues at the Cleveland Museum of Art canvas both the older visitor and the older volunteer as dual aspects of their programme development. In our increasingly diverse societies they note the need to address issues of culture and language as the older visitor is a diverse visitor and so too, increasingly, are volunteers. The Cleveland Museum's programme is extensive and illustrates both how all those involved benefit from their engagement with the development of a strategy for involving older people, as well as how well-managed programmes create their own momentum through participation, suggestion and co-production. Deliberate engagement with older visitors and outreach activities are changing the shape, form and dynamics of the traditional museum.

Manchester is a UK city which was at the heart of the Industrial Revolution. Now it is positioning itself as an age-friendly city and one aspect of that age-friendliness is being achieved through the activities of the city administration, its museums and galleries and through direct linkages with the public health system. The Culture Champions programme, discussed by Esme Ward and Andrea Winn, seeks to go beyond established approaches to co-production in museum environments and build an older volunteer base who advocate, lead, develop and programme activities for older people. In Manchester this is increasingly about the principle of "by older people, for older people", and as such goes beyond conventional notions

of inclusion to the key issues of representation which affect older people in society at large.

Sonja Power looks at the issue of sustainability in the context of museum volunteering at Montacute House, part of the National Trust in the United Kingdom. Traditional museum management techniques have often taken a static approach not only to historical artifacts but also to the way in which volunteers support their exhibitions and visitor engagement programmes. Identifying and maintaining the necessary number of volunteers is clearly a potential issue even in the context of an ageing society. Older people are making choices, where they can, about how to spend their time and the ways in which they are engaged temper such choices. Montacute House has had to address this issue directly and their Changing Rooms project shows how population ageing and sustainability are central to emerging issues in museum management. Sonja points to the untapped potential of volunteers as a growing issue in how museums approach their roles and in how older people choose to engage with museums. The era of volunteers as silent sentinels of the static exhibit appear to be rapidly becoming a thing of the past.

The Yale University Art Gallery is also addressing a number of groups often poorly connected to the cultural heritage sector. Jessica Sack discusses how her institution has been developing programmes that reach out to older people with dementia and veterans with visual impairments. One of the key points she emphasises is that the while it is clear that visitors gain from these tailored experiences in a variety of ways, museums and museum professionals also develop through such engagement. Traditional exhibiting practices are of

limited value to such groups and, as we see with other sce-
narios in this volume, in adjusting to meet such visitors' needs,
the museum acquires new knowledge and experience which
expand its institutional role. This is clearly a field rich with
possibilities because the caring museum is both a contributor
to broader social inclusion and a site of knowledge production
about ageing and its consequences.

Ronna Tulgan Ostheimer presents the collective experience
of the Clark Art Institute which was approached by an aged
care facility to partner in a visiting programme for residents
with dementia. They drew on the MoMA project and its sup-
porting materials as well as directly seeking medical advice
and conducting their own research to develop a suitable pro-
gramme. The result was Meet Me at the Clark for people with
dementia and their caregivers. Perhaps uniquely, the Clark
decided to open the museum to this group on a day they were
normally closed, thus emphasising the special nature of the
programme and the visiting experience to everyone involved.
This also supported the organisation's own development
process by allowing a complete focus on the programme and
visitors, which is a clever strategy in the early stages of such a
development. As well as the success of the programme itself
it is also clear from this case study that there is considerable
latent demand amongst service providers in the ageing sector
for partnerships with cultural heritage institutions because
they have so much to offer older people – and the growing
skills to implement such programmes.

Elizabeth Sharpe and Maria Miller point out that ageing
is a social concern and that museums, galleries and even
historic sites have an obligation to respond to this growing

demographic phenomenon. They discuss the impact of work done in Amherst, Massachusetts with older visitors in an area well-known for, and well-resourced in, higher education and cultural heritage institutions. Two key points emerge: visitors want the challenge of thinking and reflection, as well as the pleasure of remembering, but there are also unexpected consequences of opening up institutions to ageing. Sometimes new artifacts emerge as connections are made between exhibits and visitors. We need also to be thinking about the impact that museum staff with experience in this field will have as they progress in their careers and change institutions as those careers develop.

Population ageing was first experienced in Europe and Japan, with many other countries now facing this progressive demographic change. At the Lehmbruck Museum in Duisberg, Germany, the issue of intergenerational contact and understanding is being developed through engagement with and through the museum. Sybille Kastner explores how the museum is working with a Medical School in Hamburg to develop a number of projects which engage people with dementia, at the same time as adding new programmes to the museum's repertoire and beginning a research partnership. Reaching out to older people can include helping them to engage with younger people, addressing their specific needs and interests, or even raising the issue of ageing as a subject for exhibitions and activities in the museum. Co-production takes on a new dimension when it goes beyond the confines of age cohorts and is a basis for engagement in and of itself. The results for the museum frequently exceed initial hopes as these initiatives grow far beyond their planned parameters and lead

in new and unexpected directions.

Industrial and organisational change are so prevalent in contemporary society that it is important to capture artifacts and knowledge before they are lost forever. Fiona Kinsey and Liza Dale-Hallett in Melbourne, Australia, have been involved in two major industrial projects which combined significant industrial changes with workforce knowledge and expertise as well as the threat of the loss of major collections but for the, sometimes clandestine, advocacy of individuals with commitment and foresight. The Kodak and H. V. McKay heritage collections tell two major stories of Australian industry, one photographic and one agricultural equipment manufacturing, which were almost lost to the public for good. Volunteers proved central to both projects and illustrate how people can remain committed to the knowledge and skills acquired over a lifetime of work long after those jobs have gone.

Helen Chatterjee and Linda Thomson address the concept of social prescribing and show how museums can become sites for health improvement and development. As we have already observed, older people can experience loneliness, isolation, depression and even mental illness as their social networks shrink and their own health and mobility decline. In their review of a variety of social prescription programmes already underway in the United Kingdom, they posit the concept of "museums on prescription" which links well to many of the projects surveyed in this volume. As the role of museums changes in the context of population ageing, older people can be provided with more choices for improving their preventive and prescriptive healthcare, and healthcare providers can prescribe things other than medications. Social prescribing

points the way for integrating cultural and heritage offerings as central to the health and well-being of older people in our ageing societies.

Susan Shifrin has been involved with the organization ARTZ: Artists for Alzheimer's in Philadelphia in the United States for many years. A key point she makes is that the dementias are a growing concern as much for organisations as for individuals and their supports. Given that no cures are yet available, how are our societies going to adapt to meet the needs of those people who experience the memory and related problems we associate with the dementias? One strategy is to be accepting of the changes that can occur and rather than pathologising those changes, adapt to them in the way we reach out to and engage with older people and their carers. Framing older people in general, or those with dementia in particular, as simply the sum of their "deficits" is an increasingly inadequate approach. Museums are used to dealing with varied and variable interpretations of the same artifact, event or experience and are thus well-placed to work with people who experience age-related changes, restrictions and illnesses. More importantly, she suggests, accepting and working with their worlds as they are will be central to our own individual and institutional adaptation to living in an ageing world.

Ann Rowson Love and Maureen Thomas-Zaremba share some early results (including their survey instrument) on a major volunteer research project they have undertaken at the Ringling Museum in Sarasota, Florida. Here too volunteers tend to be older, often retired people, many with significant educational backgrounds and work experience who turn to museums as a focus for intellectual stimulation, social

interaction and a wide variety of related reasons. Knowing who your volunteers are, what brings them to the institution and what they gain from the experience is likely to become increasingly important as these groups age. This research, the analysis of which is ongoing, indicates that volunteers feel they have other contributions to make to museum operations and that there are also new skills and knowledge they would like to acquire in enhancing their roles as volunteers. The research also acknowledges that the motivations for one generation or cohort of volunteers may not be the same as the next and deepening our understanding of both volunteers and the volunteer experience are crucial to the sustainability of these programmes in museums.

This issue of age cohort differentiation is elaborated by Sithiporn Thongnopnua who takes this idea of segmenting audiences to new theoretical places by developing an approach aimed specifically at the sustainability of art museums in an ageing world. A review and analysis of the managerial and psychological literature is used to build a four-stage model that art museums can potentially use to develop sustainable audience research and engagement as well as competitive analysis of other providers in their field. The stages of the CACE Framework are: Contemplate, Associate, Collaborate and Evaluate. The model proposes that the same visitors may exhibit different motivations for different visits over time, making general assumptions about their behavior risky and potentially misleading. Generational changes and dynamics also mean that the motivations of visitors, as we have already seen with volunteers, may shift significantly over time. These in turn can require the processes of engagement by art museums to

be much more finely nuanced and iterative than has often been the case. Individual and social changes are driving visitor behaviours and strategically aware organisations need to be collecting and using this kind of information.

Kerry Wilson takes the issue of strategy in a different direction, pointing to the deeply political nature of the museum and its role in contemporary society including policy changes that address the issue of societal-level ageing. More specifically, the House of Memories programme provides multi-modal training and support for a wide variety of health service, housing and social care workers (more than 5,000 participants to date) that aims to support those with dementia and their carers. This programme, launched in 2012 by National Museums Liverpool, emerged in a broader context of challenges, problems and outright failures linked to healthcare provision. Some serious patient safety inquiries had identified older people as a highly vulnerable group in particular healthcare contexts. This has produced a policy environment more conducive to the kinds of interventions museums already produce and advocate for, including issues of prevention, inclusion and co-production through collaborative and sustainable approaches.

Tine Fristrup and Sara Grut propose a review and critical analysis of a number of concepts operating in the contemporary politics of ageing, education and museums through their exploration of self-care. Their chapter critiques the ways in which ageing is frequently addressed in our societies through a mix of both positive and negative constructions that can effectively limit the choices and options of older people in terms of their own self-representation. Their aim is to explore and encourage the dismantling of strategies that use

chronological age as a technique for social differentiation and that we move instead towards age integration. This requires a critical analysis of common ideas in ageing such as "ageing well" and even "life-long learning" because structural ageism functions through such seemingly benevolent constructions. Museums, they suggest, have the capacity to support, explore and enhance approaches to older people's self-development, self-construction and even self-care through their work. Museums can become "gerontopedagogical sites" which support these processes through breaking down traditional barriers between the institution and the older visitor.

Ageing is thus both a highly individual and a shared, collective experience – it is not simply a matter of birth dates and cohorts. It matters to everyone at some stage and the sooner that is understood the better prepared we are for the changes necessary to make our societies more supportive of and safer for older people. The projects in this volume illustrate just how motivated many museums already are in terms of their commitment to opening up their institutions to older people who may have found them inaccessible in the past. The emphasis on, firstly, dementia and, secondly, volunteers show that this commitment is addressing significant issues for both museums and their local communities. Older people are major contributors to museums as volunteers and visitors but in many other ways as well.

The involvement of older people in enjoyable, socially engaged and customized programmes is clearly very satisfying for them. However, this often relies on good health and positive previous experiences with museums and other cultural institutions. These are, therefore, the relatively easy successes

a museum can have. Reaching out to less engaged groups can present more of a challenge. Dementia programmes show how outreach can become a collective learning experience for the institutions involved, their staff and the visitors and their carers. The excitement and enthusiasm amongst many of our authors is palpable. They want the reader to share both their successes and their satisfaction in achieving this kind of engagement for and with older people experiencing dementia. They also want to emphasise that these approaches benefit many more people than the "target group", including their various supports such as family, care homes and even other service providers.

Social prescribing looks set to change the way mental and social health issues are mediated in our societies and museums are well-positioned to benefit from this innovation with their expanding service programmes for older people. This shift also suggests that museum professionals will need to know more about health and disease generally and about the issues affecting older people in particular. The links between the museum sector and health and social care providers look set to expand at a considerable rate including specific areas of intersection such as the neurosciences where cognition, perception, mobility and related issues are central research foci. A key issue in the wider context of this emerging scenario will be research and evaluation. Some museums are already partnering with aged care facilities, hospitals, medical schools and research institutes to build their knowledge base and their capacity for interventions. This trend is in the early stages but we can expect to see significant growth in coming years as the need for a reliable information base is demanded by funding and

regulatory bodies amongst others.

These changes will also draw museums into the broader politics of ageing and the ways in which older people are represented in our societies. Many older people, especially those with dementia, are often represented as a drain on finite health and social resources. A considerable discourse has developed around why older people should plan for their own old ages, including their retirement and eventual death. Others emphasise a competitive gap between the generations; in contrast, this book often presents museums as sites for building constructive intergenerational links. These representations are a part of the broader politics of our age and they will increasingly impact museums as providers of a huge range of often free services. This can have negative consequences as we have seen with budget cuts, austerity programmes and the push for more funds to be provided through "business models", private donations and the like.

As I noted at the beginning of this introduction, population ageing is a global trend and a global concern. As our populations grow older, our societies themselves are ageing. Having many more older people should, if we really are needs-driven, start to change the way we approach factors such as the design and delivery of exhibitions, programmes, services and even employment and volunteering opportunities. Many cultural heritage institutions were originally designed to educate, inform and even indoctrinate younger populations in the values of a previous era. They are large and impressive physical spaces that can overwhelm the senses and physical capabilities of people as they age. It is clear from this collection that museums need to change in order to be remain relevant and

engaged in the context of population ageing. This volume sets the scene for many of the issues museums already face and it offers some insight into the issues to come and how to address them. One thing all of our authors point to is the opportunity that ageing represents to museums – the opportunity to re-invent themselves for an ageing world.

PARTIC

PATING

WORKING WITH OLDER WOMEN WITHOUT FAMILIES

Eszter Biro

FRAGMENTS WAS A practice-led research project on family photograph albums, specifically on the oral-photographic history of 20th century Hungary and it was conducted with the collaboration of five elderly women.[1] The theoretical background of the research came from Canadian researcher Dr Martha Langford's theory on the oral-photographic framework.[2] She suggests that in order to fully understand family photographs a storyteller is needed. My hypothesis was to expand her theory, to identify the unique cultural information only family photographs hold. The aim of the research was to find ways to identify and collect this unique information. I decided to conduct the research with the help of elderly women with no remaining immediate family. I chose this group partly because my work has always focused on female narratives. This particular group's photographs are especially at risk of losing their function as family photographs because the common treatment of these photographs after the death of their owner, is their disposal.[3]

In conducting this research, I also met some people who had offered their photographs to a collection or an archive in order to preserve them for posterity. But here too the original function of the photographs, their family photo function, would be lost, along with the unique cultural information the photos possess. It was also crucial for the research to make sure that the participants could express their opinions freely, without being afraid of how it might affect their family members. This is an important condition, as my participants were born in the 1920s-1930s and socialized in an era which repressed, and often punished, the freedom of speech and opinion. The Rákosi era introduced a new beginning, a *tabula rasa*, after the

FIG. 1: Seemingly unimportant photographs can become more powerful.

Second World War, which prohibited citizens from talking about their losses and their past traumas. The same process was used after the revolution of 1956. Due to this policy, family photographs in many households were boxed up and hidden away in cupboards.

The project was divided to two parts. The first focused on the story behind each photograph. I collected the family photographs, scanned them, recorded the stories behind them, transcribed those stories and finally edited the stories and photographs together. The second part focused on each individual storyteller. My aim was to introduce the person behind the story. I photographed them in session, in their surroundings, with their personal possessions, which were themselves often part of the story itself. In the next few pages I present the project's structure and my findings. Then I describe the broader process of working with elderly people in this type of cultural research activity, from searching for participants, to developing trust and understanding, and ending with the unexpected issues and surprises that emerged.

The collected raw material for *Fragments* consisted of some 2000 photographs and 250 pages of raw text, which came from around 50 hours of recorded interviews with the participants. After editing, about 30-50 photographs were used per participant, and the final stories were about ten A4 pages long. The initial aim of the interviews was to open up the participants emotionally because in this way their memories and recollections became much more detailed. I explained to my participants that what I was interested in was their stories, not just the identification of spaces, places and people. This approach and process was new and unusual to them. What I

was looking for were stories which could be read next to other, connected in a chain by a subject. This quite naturally produced a lot of surplus information, context and meaning. My editing method was therefore to identify and locate the possible "story chains" in the photographs and interviews that I had collected. These were often recovered when the storyteller wandered off from the direct content within a specific photographic frame, changing topic on numerous occasions, and connecting that picture with other photographs. My first participant, for example, talked about her childhood and family while we were looking at photographs related to her education. She had been a very disciplined person, one who followed the rules; her sister, on the other hand, had disobeyed rules and created her own. The participant was working in a factory during the Second World War eventually arriving back home starved and sick with typhus.[4] Her sister was rounded up by the Nazis but jumped out of the line and spent her time in hiding throughout the rest of the war. The viewer's understanding of the impact of this conflict and its effects deepens when their stories are read in the correct order. It also makes seemingly unimportant photographs become more powerful (Figure 1). It reflects her experience in the context of her family's dynamic. She was always to one side, doing what her parents expected of her, while in the centre was her sister doing what she liked.[5]

Through these kinds of stories and narrative chains I was able to identify the unique cultural information I was looking for. It is produced through a "filtering system", which is inherited through family tradition, and the oral photographic framework which brings it to the surface. It is free from repressive ideologies and it is the phenomenon behind the

decision-making, moral judgement and what moves people. Not only whether they can or cannot accept certain enforced rules but also how they prioritise and how they construct their own ideas of happiness (Figures 2-6).

I have to admit, I was very lucky to find five participants whose stories and value systems were so different from each other. However, finding them wasn't easy and I had many rejections. From the beginning I was looking specifically for participants who had no family left. I was introduced to my first participant through her caretaker, who was also looking after my grandmother. The caretaker of my second participant was my best friend's mother. It was easy to start working with these people. When I finished recording and editing their material, it was midsummer. I already had a list of names for potential participants but all of them refused to even talk to me on the telephone. Summer was simply not the right time to work with this group. They closed all of their blinds which also made it impossible to photograph them effectively. The extreme heat of the summer made most of the people – even younger generations – impatient and unwell. They just simply didn't want to be bothered with me at that time.

I also found that many people who live alone are very protective of themselves, I got the impression through these calls that they felt threatened by my presence and by the outside world I was bringing to them. I had to appreciate that I found my two participants through very close relations, where I was already introduced by someone that they trusted. Because of this, they were already waiting for my call. The people on my list were recommended by a third person and therefore these were weak connections. Therefore I decided to change my

FIG. 2: Ágnes is a Jewish intellectual from Budapest. Her filtering system is following orders, not giving up her class. Her narration style is disciplined.

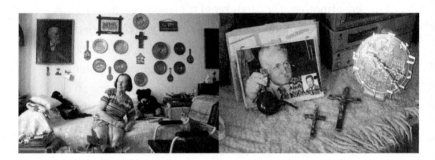

FIG. 3: Edit is a Catholic working girl from Budapest. Her filtering system is keeping her marriage alive. She began each session with the story of how she met her husband.

FIG. 4: Ibolya is a peasant from rural Hungary. Her filtering system is to following orders, and avoid from conflict to keep the peace. Her narration style is modest.

FIG. 5: Zsóka is a factory owner's daughter from rural Hungary. Her filtering system is surviving, reinventing and owning possessions. The most hectic narrator, she often needed to be reminded to finish a story.

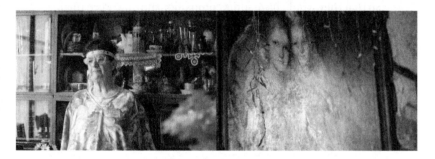

FIG. 6: Julia is an intellectual from Budapest. Her filtering system is adapting to situations, while not giving up her culture. She is a conscious narrator.

recruitment methods and searched for institutions that were looking after elderly people.

I then got in contact with Bisitz Johanna Integrated Human Provider Center which runs many nursing homes and organizes a variety of programmes for elderly people.[6] A meeting was organized with the heads of the homes, who introduced me to some potential participants.[7] This first meeting was an opportunity for each of us to figure out whether we could trust each other to work together and also for me to assess whether a participant was a suitable candidate for my project. On many occasions I had to understand that the ladies met with me just so that they would have some companionship and keep themselves occupied. However they often actually had no intention of participating in and nor did they really care about the project itself. In these instances there were sometimes signs of incoherence, or not building stories but just identifying people and spaces, or they just simply wouldn't sit down and work with me.[8] It became clear that the kind of participants I was looking for were not just providers of material but actual collaborators in developing the project. This means that they had to have an active role in the project. This activity start from the act of mutual caring. Those I worked with were interested in how I would edit and how I would make the material work. They were interested in whether the information they gave me was useful. Often only after five or six sessions would they tell me something crucial which they now felt they were ready to share with me.

The sessions were tiring. From the first few interviews I learned that a session couldn't be longer that 90 minutes. The process physically exhausted them but also remembering this

type of material has an extreme emotional charge because we covered many traumas from their lives as well as pleasant memories, all of which were reminders of their personal solitude and loss. I stopped a session if I sensed shaking, difficulty in forming words or sentences, and holding their hands over their chest, as these could all be signs of exhaustion or high blood pressure. I had to appreciate that they needed to rest, to catch their breath and also to distance themselves from the stories they shared. I only had one session per week with each person; even so we developed intense and close relationships. When I went away to transcribe and edit their material for a period of weeks, they often felt abandoned. They had shared with me something very intimate which they would normally only share with family, even though they knew from the start that it would be shared more publicly. The most appropriate person to publish and exhibit this work for them was someone with the role of a family member.

It is clear that to create this body of work, with such a deep level of collaboration, that honesty and trust were central to the foundation of our relationships. Of course I had permission to work with them and consent to work with their material from their caretakers and head of homes. I also followed my university's code of ethics. I was also always open towards them as they were to me. The whole process was in a way an exchange between us. I told them at our first meeting why I was doing the project, what it was about, how I depended on them and also that it would eventually be exhibited and published (Figures 7-8). They opened their doors to me; let me in to their private sphere and gave me access to their private memories. They always had the option to tell me not to use some material.

FIG. 7: Ágnes' collected family photographs and stories.

I would often read back parts and ask permission to use or not use specific material if I felt it might be out of place or too harsh due to it's extremely emotional nature. In these instances we would go over the story again, often changing strong expressions to lighter ones. This was necessary as on many occasions they had already forgotten that their speech was being recorded because by this stage they were simply telling stories to a trusted family member. When the stories were edited I went back and read it to them. If there were mistakes we fixed them at this stage of the process.

The entire process took about a year and it came with some unexpected effects. During that time two ladies were hospitalized for several weeks, and I wasn't allowed to visit them nor was I given any information about them. Once when I arrived for a session, I found a participant passed out in her room. One of my participant's Alzheimer's become quite severe. Another one's dementia resulted in significant mood swings. There was also a change in legal copyright and publishing law during the period the research was conducted. Prior to that time, a written consent was not needed for publishing a photograph, if the act of permission could be deduced from the work, such as the fact that they had let me into their flat to photograph them or that they have given me their photograph to scan. The new law required a consent form to be signed by two witnesses. I received permission for the final edited material from all my participants including the Alzheimer's patient. Only the one with dementia and mood swings rescinded her consent. She initially gave me her consent, later that day I received a phone call in which she sounded tormented and she rescinded her consent. I respected that decision. A few months later I called

FIG. 8: Installation at Kunsthalle, Budapest, 2014.

her again. She was happy to hear from me, she had forgotten the previous phone conversation and gave me her consent again.[9] Throughout the process, I followed both legal and ethical rules, yet I still feel bad about the situation. I keep asking myself – did I exploit her illness for my own benefit?

In this chapter I haven't specifically discussed the importance and the benefits of working with or engaging elderly people in cultural or creative projects. However, I believe my attitude to these issues will be apparent from the text. It is as important to engage with and include the elderly in activities as it is any other generation, and to include groups who might otherwise not be included in creative cultural projects.

It may sound as if it was difficult to find participants who cared about the project or who were conscious of their own contribution. However, as a former teacher, I recognise this as being equally true of the adolescent generation. The difference between the two age groups is mobility and engagement. Health issues and concerns do need to be considered when working with elderly people. They may think twice about whether they have the energy to participate in an activity like this. I felt that while working with them I could not go too fast in trying to collect the material, partly because they were getting weaker every day and partly because they could not take *my* pace of work. *Caring* meant that they wanted to live for another day to finish what they started with me and that their days were spent well. All the participants expressed throughout the sessions that they were waiting to pass away. It was not a suicidal wish but the expression of their struggle with existence, living in solitude and with poor health. *Caring* from my point of view meant that I made them want to live for another day.

NOTES

1. The project was founded by the Ministry of Human Resources, Hungary by a Pécsi József photography grant, 2013.

2. Langford, Martha, *Suspended Conversations: The Afterlife of Memory in Photographic Albums* (Montreal: McGill-Queen's University Press, 2008).

3. The disposal is either executed by a staff of a twilight home or the owner of the flat they lived in. This is how photographs end up in fleamarkets as well. Hungarian photographer Lilla Szász's series *Mrs Biro and I* (Budapest, 2013) is such an example. Szász moved into a flat, where the previous – deceased - owner's (Mrs Biro's) possessions were still around and she tried to make sense of her situation, of having moved into someone else's living space.

4. Factories were priviliged places compared to camps. Her family organized this work through favours. Her circumstances were still dire, she was exhausted by the extreme amount of work. She wasn't fed well, and when the Russians came into the country, they were left behind by the Germans without any food.

5. From Eszter Biró, *Fragments – Story of Ágnes*, (Budapest: self0published 2014), page 74.

6. I was surprised at how open they were to my approach. Later it turned out that this was because a few years back I had won a photography contest on elderly people which they had organized. This meant I was one of the few people they trusted.

7. At the first introductory meeting with my participants it turned out that only fragmentary information had been given to them about the project and they were really expecting to be interviewed a bout their lives.

8. One of the more obvious signs was that they asked me to walk with them down the corridors. This was to signal to other residents that they had a visitor.

9. She asked me to make structural changes that would have resulted in jeopardizing the whole project. On the phone I tried to explain what I was doing and why. She didn't accept my reasoning no matter how many times we discussed it. I gave her examples where she seemed to understand what I was talking about. I'd like to

believe that while she was working with me her mind was clear, and that when she rescinded her consent it was a manifestation of her disease. I tried finding her legal guardian to resolve this situation, but she didn't have one. I called the head of the home she was living in. But it turned out that she owned a flat in the building but she wasn't a tenant of the home.

INVOLVING SENIORS: MULTIPLE PERSPECTIVES

Dale Hilton, Karen Levinsky, Trina Prufer, and LeAnne Stuver

MUSEUMS INCREASINGLY understand their role in serv-
ing entire communities and developing programs to engage
participants of all ages. The Cleveland Museum of Art (CMA),
located in Ohio, with its encyclopedic collection, commitment
to multiple avenues of learning, and a nearly century-long
tradition of educational programming offers several ways for
seniors to become involved and to contribute. Our experience
with mature adults centers in the following areas: outreach,
knowledge transfer, and volunteering. These categories can
be described in some detail within the context of three pro-
grams in particular: Art To Go, Art in the Afternoon, and Dis-
tance Learning. While the three programs increase access to
museum resources, they are also supported by the time, talent,
and life experiences of the program presenters, many of whom
are over 60 and several who are much older. Many of these
dedicated presenters are volunteers, and some are paid staff
or contractors, but all are crucial to the successful operation
of the programs they represent. Our chapter will introduce the
programs, with overviews provided below, discuss evaluation,
highlight the experience of senior volunteers or staff with the
aforementioned initiatives, and finally, note the museum's
additional steps toward serving the community as it ages.

Program overviews
Art To Go began as a "suitcase in the schools" program in which
docents take authentic works of art to schools or other sites
for object-based learning experiences. This enables partici-
pants, wearing gloves and with supervision, to see and touch
genuine works of art from the museum's distinctive Educa-
tion Art Collection. In schools, libraries, retirement homes,

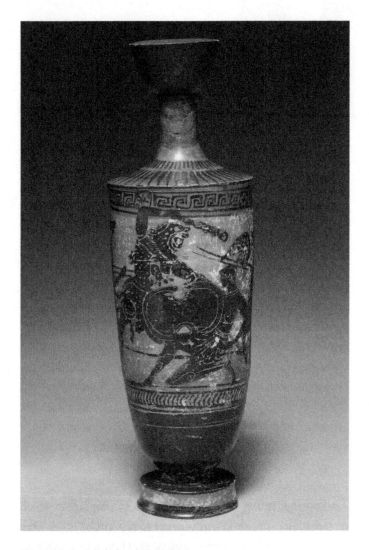

FIG. 1: *White Ground Lekythos*, about 500 BC. Greece.
Ceramic; 25.44 x 7.62 cm (10 x 3 inches).
The Cleveland Museum of Art, Bequest of Samuel L. Mather 1932.194.

and community centers learners of all ages informally explore thought-provoking objects, spurred by their own curiosity and guided by docents using inquiry as a teaching method. The Art To Go team consists of museum staff and trained volunteers, most of whom are seniors.

Distance Learning is an award-winning program that connects the museum to lifelong learners and students from all over the U.S. and beyond to enrich their study of history, languages, and the visual arts. Through live videoconferencing, participants in retirement communities, libraries, or schools view global art and artifacts from the permanent collection while sharing in two-way conversations with museum educators. The program offers approximately fifty topics as well as presentations in English, French, Spanish, and German. These languages are the ones most frequently taught in schools which comprise a large percentage of our clientele. Now in its sixteenth year, the program has received the highest awards in its field: the Center for Interactive Learning and Collaboration's (CILC) Pinnacle Award and the Teachers' Choice award. Three out of four regular on-camera presenters – a mix of staff and paid contractors – are over 60.

Art in the Afternoon began in 2010 as a partnership between the Cleveland Museum of Art, the Cleveland Clinic, and the local Alzheimer's Association. It provides specialized gallery tours for those with memory loss and their caregivers. The program is designed to lift the spirits, engage the mind, and provide a relaxing and enjoyable social experience. Specially trained docents are sensitive to the interests and abilities of all visitors and encourage conversations, sharing memories, and the enjoyment of art. All the regular program presenters are over 60.

Outreach

Outreach involves a number of components: delivery of services to those seniors and others who may find it difficult or impossible to reach the museum on their own, access to the collections, and interaction with museum educators. Outreach is fundamental to the museum and each of the three programs identified previously – Art in the Afternoon, Art To Go, and Distance Learning – support this goal as articulated in the institution's mission statement of bringing "the pleasure and meaning of art to the broadest possible audience in accordance with the highest aesthetic, intellectual, and professional standards..." (Cleveland Museum of Art, Mission Statement, 1996). Further, the museum cites accessibility as one of its core values and states in its long-range plan that it will "encourage greater participation by all members of the community and eliminate all barriers – physical, social, and intellectual – that hinder the museum from achieving this goal" (Cleveland Museum of Art, Long Range Plan, 2010).

In what ways do program participants gain access to the museum's collections? As indicated, Art To Go docents take specially selected authentic works of art into retirement communities and engage residents in conversation about these pieces as they are passed from hand to hand. Examples of Art To Go objects include a sixth-century BC Greek ceramic *lekythos* (oil flask) and a sixteenth-century German gauntlet that participants can actually try on as they imagine how it would feel to wear an entire suit of armor (Figures 1 and 2).

During a Distance Learning videoconference participants might see images of fifteen or more objects from the museum – thus providing access digitally and through interpretation

to many of the roughly 40,000 objects that comprise the permanent collection. Close-ups, side views, graphics such as timelines, definitions of specialized words, and maps may also appear via green screen with the presenter who is live, speaking with the participants and seeing them in their community activity room. Together the on-camera presenter and the participants share impressions of works of art, information, and memories sparked by these objects. This type of accessibility to the collection can reach seniors and others whether they are in locations down the street or across the world; the Distance Learning program routinely connects with sites in the United States, Canada, Mexico, and Australia (Figure 3).

Finally, Art in the Afternoon presentations take place in the museum's galleries, so that participants in this program react to pieces in the collection on display before them. Each of these programs, with their own locations and delivery methods, provide access to the collection as well as lively engagement between participants and presenters.

While the numbers of participants served for these programs is impressive (over 125,000 for Distance Learning from 1999-2014, over 28,000 for Art To Go since 2009 and approximately 850 for Art in the Afternoon since 2010) the program managers strive for fine qualitative experiences rather than higher numbers of participants. Distance Learning and Art To Go suggest limits of 25 people per presentation and Art in the Afternoon accepts up to eight participant/caregiver pairs for its sessions. Keeping these groups at a manageable size permits greater opportunity for interaction between participants and the presenters. It also allows more time to connect with each art work. As educator and art historian Jennifer Roberts

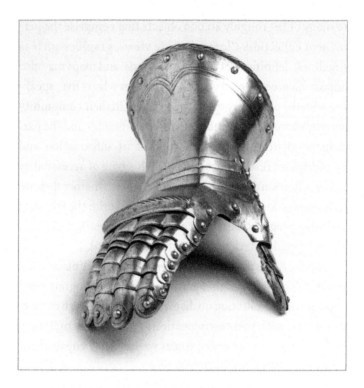

FIG. 2: *Gauntlet*, late 1500s with some 1800s restoration.
Germany. Steel; Overall 31.2 x 13.45 cm (12 1/4 x 5 1/4 inches).
The Cleveland Museum of Art, Gift of Mr. and Mrs. John L. Severance 1916.1933.

writes, "Just because something is available instantly to vision does not mean that it is available instantly to consciousness… What turns access into learning is time and strategic patience" (Roberts, 2013). In summary, these programs aim to provide meaningful engagement with the museum's collections and are fundamental to the goal of serving the community. The museum "recognizes that civic engagement is central to its mission and imperative to its future" (Cleveland Museum of Art, *Join and Give*, 2014).

Knowledge transfer

Knowledge transfer may be approached from the perspective of seniors receiving content and includes those seniors who are also presenting and shaping the information that is offered to audiences. Because many of the museum's volunteer teacher (docents) and paid staff are seniors themselves (defined here as aged over 60) the influence on content is something that occurs daily at the Cleveland Museum of Art.

Two veteran educators serve as contractors with the Distance Learning program. Each is over 70 years of age and presents foreign language video conferences in two languages each. One offers programs in French and in German, for example, *L'Art de L'Afrique* (The Art of Africa), and the other instructor presents in both Spanish and Italian (*Dagli etruschi al moderno: una panoramica dell'arte italiana del Museo d'Arte di Cleveland –* Italian Art from Etruscan to Modern). In addition to presenting in foreign languages, these energetic on-camera teachers have also created content. Just one of many possible examples follows.

A school wishing to provide students with Spanish

FIG. 3: Residents at Menorah Park Center for Senior Living engaging in a videoconference with the Cleveland Museum of Art.

conversation practice approached the museum with a request to develop a program that involved an element of competition. In response, the presenter of Spanish (and Italian) videoconferences conceived ¡*Te Toca A Ti!* (It's your turn!). In this presentation student teams vie to see which group can speak with the most complete and correct Spanish to describe unfamiliar works of art. The paintings and sculptures by Spanish artists that are shown in the videoconference serve as visual prompts to conversation. The comprehensive lesson plans for ¡*Te Toca A Ti!*, also developed by the presenter and posted on the museum's website, include a list of useful adjectives, academic content standards, preparatory material, hints for responding to art works, and sample images. The museum is delighted that this program has received the highest rating – exceptional – by teachers who have used and evaluated this videoconference topic.[1]

The Art of the Alphabet, a new Art To Go topic, serves as a further example of seniors creating content based on their expertise. With funds available from a partnership with a local community college, museum staff decided to revitalize an Art To Go subject that had gone somewhat fallow. Art To Go program managers turned to a museum tour docent who also happened to be a linguist, former Fulbright scholar, and professor who had retired from Cleveland State University. The docent worked tirelessly for over a year, selecting exemplary objects from the Education Art collection and developing a deeply informative booklet that traces through object-based learning "one of humankind's most spectacular inventions, writing."

Content suggestions also come from senior audiences.

Residents at a continuous care community and another group of life-long learners who videoconferenced with the Cleveland Museum of Art from the communications center at a community college asked for the following additional topics to be developed: art connected to the Bible and a tour of the Cleveland Museum of Art for those unable to physically visit the museum. They also requested a program related to the book and movie *The Monuments Men*, as they were aware that former curators at the museum had been involved in the effort to rescue art works stolen and hidden by the Nazis. As a result the Distance Learning program has now added to its slate of topics the following new videoconferences: Biblical Representations in the Collection of the Cleveland Museum of Art: The Old Testament; Biblical Representations in the Collection of the Cleveland Museum of Art: The New Testament; Cleveland Museum of Art Tour; and Monuments Men: The Cleveland Connection.

Additionally, the content is shaped by the participants in these programs in dialogue with the presenters. Staff and docents strive for audience engagement through inquiry and interactivity and acknowledge that the most rewarding presentations occur when the audience is not passive, but rather, enrich content through their experience and personal interpretation.

Volunteering

Volunteers shoulder much of the presentation work of museums and at the Cleveland Museum of Art they conduct the Art To Go and Art in the Afternoon programs as well as the majority of school and public tours. As mentioned, these docents are

nearly all retired or of retirement age; 73% for Art To Go, 100% for Art In the Afternoon, and approximately 80% of the school and public tour docents are over 60. Art To Go has spawned a smaller scale program called Art Carts that takes objects suitable for being handled by visitors into the museum galleries (as opposed to school rooms or community centers) and 100% of these docents are of retirement age as well.

These programs are enriched by the participation of docents and in turn provide benefits to them and others, including seniors who are often recipients of the content. Volunteering at the museum enables senior docents to remain involved in something outside of themselves, and offers them a gratifying, ongoing way to use their skills. Indeed, their professional and life experiences yield important resources with which they infuse and personalize their presentations. The following details demonstrate how senior docents' perspectives, social engagement, interests, maturity, and empathy contribute to museum programs.

The attitude that induced them, after retirement, to seek out and meet the new challenge of joining the museum's docent corps underlies the upbeat way in which they approach the entire undertaking. For example, their constant quest for understanding fuels their efforts to prepare presentations on any of the 21 varied Art To Go suitcase topics, which are scheduled at random. This means that they must always be ready to present any of these thematic suitcases that contain up to ten objects each. Several modes of training such as informational sessions, written materials provided by museum staff, modeling, mentoring, and independent study all give the docents opportunities to learn and improve and provide intellectual

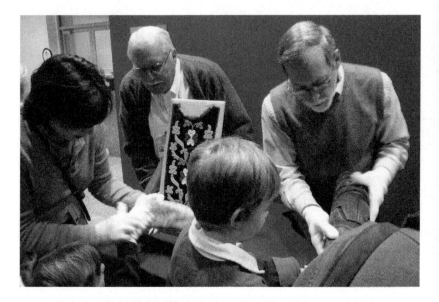

FIG. 4: Art To Go docents in action.

stimulation. Docents research their topics, share information and techniques, and guide each other as well. Their ever-evolving competence gives them confidence with which they approach each assignment, not only during the days of preparation but also during their presentations.

Besides forming relationships with each other, Art To Go docents draw on their careers, and broad life experience in connecting with the suitcase objects and the cultures that created them. A few of the docents were born in other countries and have relocated to the United States; several speak languages in addition to English and can make presentations in Spanish or French. Many of them travel extensively and collect art, books, historical objects and documents, and are practicing artists – all of which contribute to their continual learning. Teaching in the Art To Go program provides an outlet for these seniors to share their perspectives and interests with their audiences and each other. Docents are scheduled in pairs to make Art To Go presentations in teams. As they discover information and find things in common personally, friendships grow. The supportive environment, one which has deepened over time, continually enhances their knowledge, teaching, involvement, and the program as a whole. Indeed, the social aspects of volunteering are an important factor in keeping them engaged and deriving satisfaction from the time they devote to the program. At this point in their lives, several of the Art To Go docents are living alone. Many have commented on the meaningful interpersonal ties that develop through regular volunteer days, meetings, and professional development visits to artists' studios that expand their training (Figure 4).

Art To Go presenters in action

The Art To Go program benefits clearly from the maturity with which the docents honor their commitment. They devote a day a week, every week of the year to teaching in the program. They diligently report their travel plans to enable staff to schedule events around their absences. Most Art To Go docents have been with the program for five or more years. They attend every presentation for which they are scheduled, arrive on time, and are prepared to present. Over the years many have broadened their involvement with the museum, becoming volunteers in other initiatives such as: Vital Signs, the Cleveland Museum of Art Programs for Healthcare Professionals; the gallery docent; International Baccalaureate docent; or Art in the Afternoon programs. Recently, a group of Art To Go docents formed an ad hoc task force to discuss ways to augment their presentations with new supplemental materials. The professionalism with which these docents treat their volunteer positions is advantageous to the museum, since they are the ones who enable the institution to deliver the community engagement so crucial to its mission.

Docents' life experiences also provide empathy for their audiences, whether they be school children or senior citizens, and further the impact of the programs in which they teach. In 2014 a longtime Art To Go docent approached staff with a proposition. Having recently received the benefit from a class action law suit resulting from the wrongful death of her husband, the docent presented to the museum her desire to honor his memory, and commemorate the fact that at the time of his death the couple, then recently retired, were docents serving in the Art To Go program together. Having previously dedicated

her career to teaching elementary school in the Cleveland Metropolitan Schools District (CMSD), the docent established a fund to support Art To Go presentations in five CMSD schools each year, selected the schools, identified grades four and five as the target audience, and contacted the principals. In addition, the docent requested that staff develop hands-on art projects to leave behind for classroom teachers to do with their students as a follow-up to the Art To Go experience.

On the other end of the life-long learning continuum the docents presenting Art To Go in senior facilities readily help participants, particularly those with disabilities, put on the gloves they need to handle the art objects. If certain participants are unable to grasp the objects at all, docents hold the objects for them and move about the circle, engaging participants one on one in guided observation and discussion.

Many of the docents have spent their lives visiting the museum and are delighted to be a part of it. The same is true for several Art To Go paid staff who are working at the museum in their second careers following their retirement from professions such as advertising and teaching. A former teacher who is now employed by Art To Go has said that the program has "made art come alive" for him. He reflects further that "there is a story behind objects and pictures, and beyond your own perceptions. Art is more interesting, more connected to the world and more diverse" than he imagined. He now views the museum as "an environment of activity, not just a place." He also noted that one of the hard parts about retiring is leaving fellow workers. Having a second career at the museum, or volunteering here, enables these seniors to reconnect to people and to an organization.

The comments of the docents and staff of the Art To Go program accord with the findings of the American Society of Aging-MetLife Brain Health Poll which states, "Volunteer activities offer an excellent framework for socialization. Volunteers may be motivated by the opportunity to help others without realizing that simultaneously they are improving their own cognitive function. The time spent helping others strengthens self-esteem, while the mental challenge of adapting to the needs of the organization for which one is working can be stimulating" (Johnson, 2006: 36).

Art in the Afternoon, another museum program, deeply involves seniors and amplifies the outcomes and experience described in conjunction with Art To Go. As previously noted, Art in the Afternoon provides art tours for those with dementia and their caregivers. Begun by CMA's Department of Education and Interpretation in 2010, it is managed by senior volunteers who are responsible for the day-to-day operations of the program, docent training, content delivery, and evaluation.

The initial training for the program was delivered by the Museum of Modern Art through their ground-breaking Meet Me at MoMA initiative, which provided a model for Alzheimer's programs to museums throughout the country. Building on this training, several docents (seniors themselves) were asked to design a program of this type for the Cleveland Museum of Art. The museum supported the effort by providing staff assistance, classroom space, and marketing materials, and as the program unfolded, attendees were provided with free parking and fee waivers for special exhibitions.

The two senior volunteers currently managing this program are both retired mental health professionals, docents

in other Cleveland Museum of Art programs, and have had previous experience working with seniors and/or people with disabilities. One is a retired geriatric social worker, and the other is a retired school psychologist. Together they serve as liaisons between the museum and the local Alzheimer's community. The Alzheimer's Association, Cleveland Area Chapter proved to be an invaluable partner, facilitating training, accompanying docents on the very first Art in the Afternoon tours, referring clients to the Art in the Afternoon program, and registering visitors for gallery tours.

The ultimate goal is to create a safe, welcoming environment for both the partner needing memory support and the caregiver as well. The docents who manage the program draw on their professional backgrounds to meet these objectives and certain principles remain constant in their planning. Typically, tours are limited to a specific area of the building to reduce fatigue and to ensure that there are no barriers to wheelchairs. The subject matter and objects presented embody topics that would be of interest to a general audience and involve many opportunities for discussion and sharing of memories. Perhaps some of the main differences between an Art in the Afternoon tour and those designed for a general public are the number of objects presented (typically no more than five, unless the tour involves a special exhibition) and the docent's use of both open-ended questions and multi-modal techniques designed to engage and enhance the social experiences of the group. Docents are encouraged to use their creativity and imagination and might incorporate techniques involving movement, storytelling, singing, improvisation, exaggeration, props, costume, music, and humor, as well as many others. The spirit of

FIG. 5: Discussion prompts: image and props – pillow case and clothes pins.

the group involves camaraderie, acceptance, and enjoyment. In fact, the group has been known to spontaneously break out in song, much to the surprise of general museum-goers.

Some examples of tour topics have included: Come to Tea (with a tea party afterwards), Supersized! (examples of larger contemporary works), Life in the 1940s, A Trip to Paris (with participants invited to wear an article of French clothing), Mystery and Intrigue in the East Wing, Glorious Sounds (art objects are paired with audio clips), as well as other topics that suggest a narrative and invite participation. Also, the metaphor of travel through time and foreign lands is often used to draw the audience into the tour topic and tie the objects together. For example, in a tour entitled Woman's Work, the group was introduced to a portrait of an early twentieth-century society beauty by John Singer Sargent and asked to imagine themselves at a party in Venice hosted by the sitter. On another stop during this same tour, the group discussed a painting by John Sloan in which a woman is observed hanging out laundry on a city fire escape. A vintage linen pillowcase and old-fashioned wooden clothespins were passed around with the intent of sparking memories and conversation (Figure 5).

Evaluation

Evaluation of Art in the Afternoon is both informal and anecdotal. Although a questionnaire was used during the first year, it was ultimately decided that discussions with caregivers would yield a better picture of what our visitors found helpful and what could be improved upon. Most caregivers indicated that the program was very responsive to their needs and that in particular, the partner with memory loss was in a positive

frame of mind after the tour. Also, visitors report that they enjoy coming to the museum and look forward to the social aspects of the tours. Perhaps one indicator of the success of the program is that several couples have attended tours regularly since the inception of Art in the Afternoon four years ago.

Museum staff members also collect informal data to help evaluate the other programs detailed in this chapter: Art To Go and Distance Learning. Both use a simple questionnaire through which activity coordinators at retirement facilities or classroom teachers rate the presentation in several categories such as presenter's knowledge of content, participants' level of engagement, impact on learning, and ease of scheduling. Occasionally there is an opportunity for more probing qualitative commentary such as the perspective that follows.

LeAnne Stuver, Director of Lifelong Learning at the Menorah Park Center for Senior Living (Beachwood, Ohio), provides this overview of how Cleveland Museum of Art Distance Learning programs relate to her institution's educational efforts:

> Menorah Park Center for Senior Living provides many life-long learning opportunities to the residents/tenants and family members of our campus. The goal of our life-long learning programs is to offer a wide variety of structured, enlightening, and stimulating adult education programs, expanding the options across the Menorah Park campus for continual learning. Current research shows that life-long educational opportunities, and the social interaction associated with them, significantly increase quality of life (Stern, 2002). Educational programs are now being viewed as health promotion

practices for older adults, no different from exercise or good nutrition. Adults of all ages must remain connected to educational experiences throughout their lifetime in order to maintain optimum brain health and wellness. This includes those living on a comprehensive senior living campus such as Menorah Park.

Distance learning programming has been a wonderful addition to the many life-long learning opportunities that are provided at Menorah Park Center for Senior Living. We are the proud recipient of Leading Age Ohio's Excellence in Service for Housing for our Distance Learning and technology programs. Distance Learning programs give our mature students the opportunity to learn and interact with instructors from across the country and experience unique programming without ever leaving the campus. Programs from the Cleveland Museum of Art are the most requested and most-loved programs from all of the providers that we use.

The live, interactive nature of the programs is very appealing to the senior adult audience. When questions arise, they can be addressed immediately. Even though the Cleveland Museum of Art is not that far away from our campus, these Distance Learning programs can reach more participants at one time than an actual visit to the museum. Transportation issues can preclude many interested participants from visiting the museum for a variety of reasons, but attending a Distance Learning program on our campus solves most of these issues.

The technology also allows for magnification of the images so that they can easily be seen when projected on a large screen in our classroom – even by those with visual impairments. Details can be demonstrated and discussed that would be difficult to notice when looking at the art itself at the museum. Having the audio of the program projected through a quality sound system also ensures that those with a variety of hearing impairments can also participate in the program.

Distance Learning programs have also been popular programming for our residents with dementia or memory impairments. Many topics that are presented are easily recalled by students with memory issues. Since most of these topics were learned many years ago (long-term memory), this information is usually still accessible. It is short-term memory that is more of an issue – what was learned or discussed more recently. Many of our residents with memory impairments can participate just as well as those without memory issues in these programs. It is a great opportunity to support quality of life and self-esteem of these life-long learners.

The Rose Institute for Life Long Learning (RILLL), an affiliate of the Road Scholar Institute Network, provides adult education classes to the residents/tenants and family members of the entire Menorah Park campus. Instructors come to our campus to provide a wide variety of class subjects, allowing students to select classes that are of personal interest. Distance Learning staff

of the Cleveland Museum of Art have been instructors for this program as well. Not only do our participants enjoy meeting the instructor in-person rather than on the screen, but these classes are usually several sessions in length, providing opportunities for more detailed discussion than a single Distance Learning program. Collaborative programming between the Cleveland Museum of Art and Menorah Park Center for Senior Living has been beneficial to both parties. Our campus residents benefit from spectacular educational programming and we provide feedback and help fine-tune the museum's programming that is geared to the senior adult audience in order for it to be attractive to additional sites that are looking to enhance their senior adult programming.

Conclusion

The Cleveland Museum of Art values seniors and welcomes their participation in programs as presenters, managers, co-creators, and recipients of content. Their involvement reaches beyond the initiatives highlighted here. There are on-site lecture series for senior groups affiliated with local universities and philanthropic organizations, intergenerational art-making events geared toward grandparents, and a robust women's council program that attracts hundreds of members, many of whom are of retirement age. In order to encourage greater participation by seniors, some museum programs have developed special brochures and areas of the website to more widely publicize the availability of programs for life-long learners. All of these efforts richly benefit the museum, helping it achieve its

community service goals and rewarding the individuals who participate. Though more research is needed, there is preliminary recognition that such activities support healthy aging. "In older adults, arts engagement appears to encourage health-promoting behaviors, including physical and mental stimulation, social engagement, self-mastery, and stress reduction that can help prevent cognitive decline and address frailty and palliative care through strengths-based arts interventions" (National Endowment, 2011: 28).

The combination of the salutary effects of arts programming and our years of working with seniors motivates museum staff to know these audiences even better. Researchers at the Cleveland Museum of Art have begun to draft a stakeholder's questionnaire in hopes of learning more about how participants would like to use specific programs or resources. We may find that senior groups want more involvement in planning programs; they may also desire structures for independent learning such as on line courses. As our experience deepens we will undoubtedly see that this rapidly growing segment of the population (National Institute on Aging, 2013) requires differentiated opportunities for engagement, depending on age cohort and ability, as does any group with whom we interact. We expect that whatever our investigations reveal will be valuable and we hope to share these conclusions broadly. Jointly exploring the needs and desires of seniors for cultural programming will enable institutions to be increasingly purposeful. Together the museum community can learn to be more focused in employing precious resources such as the collection, staff and the opportunity to use art as a connection point for lively, thoughtful interaction.

NOTE

1. Center for Interactive Learning and Collaboration website: http://cilc.org.

REFERENCES

Cleveland Museum of Art (1996). *Cleveland Museum of Art Mission Statement*. Retrieved from http://www.clevelandart.org/about/history-and-mission/mission-statement.

Cleveland Museum of Art (2010). *Cleveland Museum of Art Long-Range Plan*. Unpublished.

Cleveland Museum of Art (2014). *Why Support the Museum?* Retrieved from http://www.clevelandart.org/join-and-give/why-support-the-museum.

Johnson, S. (2006). *A Community-Based Approach for Promoting Brain Health*. American Society of Aging-MetLife Brain Health Poll, 36. Retrieved from http://www.paulnussbaum.com/metlifedoc.pdf.

National Endowment for the Arts. (2011) *The Arts and Human Development: Framing a National Agenda for the Arts, Lifelong Learning and Individual Well-being, 28*. Retrieved from http://arts.gov/sites/default/files/TheArtsAndHumanDev.pdf.

National Institute on Aging. (2013) *Health Disparities Strategic Plan: Fiscal Years 2009-2013*. Retrieved from http://www.nia.nih.gov/about/health-disparities-strategic-plan-fiscal-years-2009-2013.

Roberts, J. (2013). The Power of Patience: Teaching students the value of deceleration and immersive attention. *Harvard Magazine*. Retrieved from http://harvardmagazine.com/2013/11/the-power-of-patience.

Stern, Yaakov. (2002). What is cognitive reserve? Theory and research application of the reserve concept.

J Int Neuropsychol Soc. 2002;8:448-460. Retrieved from http://www.crisisprevention.com/Resources/ Article-Library/Dementia-Care-Specialists-Articles/ Cognitive-Reserve-and-Alzheimer-s-Disease.

CHAPTER THREE

ARTIFACT STORIES: MAKING MEMORIES MATTER

Elizabeth Sharpe and Marla Miller

ONE IN EIGHT AMERICANS are now aged 65 or older, a ratio that will rise to one in five by 2030. (Ortman, 2014). How will our nation's museums and historic sites respond? This important question drove the development of our pilot program, Artifact Stories: Making Memories Matter for Amherst Seniors. This program is a joint enterprise involving the University of Massachusetts Amherst Public History Program, the Amherst Historical Society (AHS), the Jones Library (Amherst) Special Collections (JLSC), and three senior-serving institutions in and near Amherst, Massachusetts, a college town about 100 miles west of Boston.

In the summer of 2012, Artifact Stories worked with seniors in both assisted-living settings and at a drop-in facility, engaging participants with varying degrees of mobility and cognitive health as well as a mix of affluence and life experience. Each week for six weeks, program leaders brought artifacts, images, and texts to these sites. There, they led a lively mix of presentation, demonstration, and conversation. As the artifacts sparked recollections, participants sharpened their memories and saw how their own experiences connected with others and with trends in local and national history. The program explored ways that historical perspective can help as seniors review their lives' successes and challenges, roles and relationships, and offered an understanding of how the changing world has affected their lives and those of their peers.

Program development

The program responded to an opportunity presented by the University's Public Service Endowment Grant Program. UMass Public History Program Director Marla Miller and Elizabeth

Sharpe, a public historian who had developed a similar out-reach program to the Washington, D.C., community while working at the Smithsonian's National Museum of American History, joined forces to pilot a similar program in a smaller community (Sharpe, 1984). Two sites (Amherst Senior Center and The Arbors Assisted Living) were in Amherst, Massachusetts, with a population of just under 40,000. The home of Amherst College, Hampshire College, and the University of Massachusetts Amherst, the place nevertheless retains a strong sense of its agricultural heritage and feels like a small college town. A third site, Loomis Village, a continuing care retirement community, is in neighboring South Hadley, which has a population of 17,000 and is the home of Mount Holyoke College. Higher education is an important part of the regional economy, which draws retirees to the area as well. Our aim, taking a page from the earlier successful program, was to expand the reach of the important collections held by the AHS and JLSC while serving seniors unable or unlikely to travel to these collections. After enlisting our museum partners we reached out to program directors at several area senior-serving institutions, who are always looking for educational and stimulating programs for their clientele.

In the spring of 2012, Elizabeth Sharpe and John Morton, a graduate student studying public history and museum practices, consulted with program directors at the three sites and returned to observe programs to get a feel for these audiences. Conversations with AHS curator Marianne Curling and the JLSC curator and Tevis Kimball shaped the selection of artifacts. The first criterion was to choose affecting artifacts: objects so imbued with meaning that visitors regularly seemed

personally affected by them. The second was to identify objects whose size, weight and condition meant that they were able to travel outside the museum safely. The traveling artifacts were covered under the terms of the museum's insurance policy.

A few weeks later, all the participants (including curators, presenters, and program directors at the sites) gathered to review the artifacts preliminarily chosen for the program and to fine-tune the program plan. The group liked all the proposed artifacts, suggested they be combined along themes, and that spares be available should conversation lag. Program directors cautioned that participants not be put on the spot during the presentation, in case their memory or attention might falter, and that any very personal comments be considered confidential.

Program description
The key artifacts chosen were:

- A Civil War knapsack made of coated canvas stretched over a wooden frame;
- A soft linen shirt made for an Amherst baby in 1769;
- A locally made wire mouse trap from the nineteenth century;
- A manuscript cook book written by an Irish-born domestic servant;
- A Civil War-era shipboard telescope, trumpet, and diary;
- A handwritten draft (facsimile) of Amherst resident Robert Frost's poem *Stopped by the Woods on a Snowy Evening*;
- Early twentieth-century photographs of Amherst schoolchildren.

The presenters' delivery was relaxed and flexible. As John and Elizabeth brought out the artifacts they asked participants to look carefully at one spot and identify something, asking, for example: "Can someone read the name engraved into the side of the shipboard telescope?" "If you look through this magnifying glass, can you see anything special about the fabric on the ruffled cuff of the 1769 baby shirt?" (It is dotted Swiss) "Can you figure out how this mouse trap works?" "What ingredient that we use frequently today is missing from these 1881 dessert recipes?" (chocolate) "Look carefully at Robert Frost's doodle. Any ideas on what that is?" Presenters donned the curatorial white gloves and carried around the artifacts or kept them in their boxes and slid them down the table to pass them among the participants. After reading related journal entries, letters, or poems, showing photographs, and sharing other contextual material, presenters posed questions to the group to reach broader insights, asked questions of each other, wondered aloud about mysteries of the artifacts, and offered evidence from other scholarship and their own research.

Participants freely commented and told anecdotes during all the programs. No one spoke off topic, or dominated discussion. Participants also appreciated being involved in solving mysteries about the use and meaning of the objects. One remarked, "It worked so well because you both (the presenters) were so into the stories and the artifacts." We heard several times "if they had taught history like this when I went to school, I would have loved history instead of hating it. You make it come to life."

Our initial vision also involved reflective writing. At the conclusion of each session, the presenters brought out paper

and pens and asked participants to write about a memory, a reflection, or questions that the discussion sparked. While most wrote, some were self-conscious or weren't in the mood. Some participants who were physically unable to write dictated to the presenters, and some said they didn't have anything to say. Yet, occasionally we had great responses. We concluded that it was important to offer the chance to write and accept that some participants might not write.

After each session, the presenters made table top exhibits on foam core panels with photos of the session, information about the artifacts, and the participants' writing with no attributions. We brought them to the sites where they were displayed until the next week's program. These served as a summary, an advertisement for the next week, and a chance for the participants to read each other's writing.

Program findings

The pilot program yielded several insights. First, the large elderly audience was wildly enthusiastic about seeing museum artifacts up close and one at a time. Several people mentioned surprise and excitement that the museum let us bring objects to them. In museums, we tend to present so many artifacts that people's attention flits from one to the next without focused looking. The fact that participants could really examine these pieces closely with a magnifying glass and while comfortably seated created a sense of intimacy which seemed to make the whole experience feel special.

Artifacts prompted memories in people that questions alone did not, and memories proved contagious in a room full or seniors. For example, seeing a school photo from their

era is more evocative than asking "what was school like?" The artifact become the proverbial pebble dropped in the pond – their stories radiated out from seeing the artifact and learning about it. The mouse trap recalled tricks for catching mice: "I remember my father building an electric mouse trap in the basement," one participant offered. "It was not very kind to the mouse." A linen baby shirt worn in 1769 sparked a discussion of changes in baby care and child-rearing practices in their own lifetimes and across cultures. One woman wrote: "When Suzie was born and I was living in Iowa, I washed 28 diapers by hand every day. Then we had to hang them up in the winter and the wind would blow them, and they would freeze and almost hit me in the head."

Documents and photographs from the Jones Library seemed to have just as much of an impact as three-dimensional artifacts from the Amherst History Museum. The Robert Frost poem and the school photographs stimulated some of our best and most animated discussions around topics like the value of poetry in society, the importance of memorizing poems, changing philosophies in the education of children, the misuse of corporal punishment in schools, and how difficult it was to be a teacher. Finding common experiences among participants was more important, we learned, than the format of the materials we shared.

It was important to allow the conversation to stray away from the artifact if it was bringing up fruitful topics. The telescope led participants into a discussion of the things the United States imported from China and how wealthy ship owners in nineteenth-century Salem and Boston were. The cookbook yielded a long discussion about foods from one's

cultural heritage and about acculturation in general. One woman brought in her Swedish cookbook while another offered: "My [Italian] father would say, 'This is America, we have to eat American.'"

Second, success sprang from focusing on the moment. The joy was the hour spent together and in sharing memories aloud with others. While the writing time and the table top exhibit extended the program's audience, it was the time together that counted. In the evaluation, one participant commented, "I liked the talking and interaction... it triggered all sorts of memories and thoughts." Another wrote, "Just give us more." One site staff commented, "Please come again. We try to do this on our own but it is just not the same without you."

Third, programs are the people. An easy rapport developed between presenters and participants, and presenters stayed after the formal sessions to talk with those too shy to address the group. It was advantageous to pair a male and female presenter. Talking with a younger man was a bonus for participants who often see mostly women in their senior settings, as was the chance to instruct someone younger. Half-way through the six-week series, participants began bringing in their own artifacts related to the week's topic to share with the group. After the pilot project officially ended, some sites continued with their own in-house version of Artifact Stories.

Lastly, the program also had some very direct benefits for the participating collections. For instance, when we brought the knapsack from the Massachusetts 27th regiment, one woman brought letters of her great-great uncle, who served in that regiment during the American Civil War. John copied sections of the letters and read them at the follow up programs.

We put her in touch with the director of the University of Massachusetts Special Collections and University Archives, who added them to the collection. The Amherst History Museum will use them in the future when interpreting that knapsack. The curator was thrilled!

It was quickly apparent that the program ought to be repeated and expanded, and we are seeking funds to do so. While based on artifact stories and memories, the program was ultimately about learning and engagement. As one woman remarked: "That was so good. Memories, yes, but more importantly you made us think." Such mental stimulation and reflection helps seniors age well, and sustains healthy minds; at the same time, such partnerships help museums ensure their centrality in the community. In sum, history museums and older adults are natural partners who share an interest in the past. As our population ages, museums will become critically important resources for seniors, and seniors critically important resources for museums.

REFERENCES

Ortman, Jennifer M.; Victoria A. Velkoff; Howard Hogan. (2014). *An Aging Nation: The Older Population in the United States, Population Estimates and Projections.* Washington, D.C.: U.S. Census Bureau. Retrieved January 25, 2015, from www.census.gov.

Sharpe, E. (1984) Education Programs for Older Adults. *Roundtable Reports: The Journal of Museum Education*, 9(4), 3-5.

MUSEUMS, MEMORIES AND WELL-BEING

Helen Fountain

IN 2009 THE OXFORD University Museums Partnership recruited a Reminiscence Officer to set up and deliver a reminiscence service at Museum of Oxford. The post was funded by the Museums, Libraries and Archives Council's Renaissance in the Regions funding stream (administered by Arts Council England since 2012). The project had dual aims: to broaden the Oxford University Museums Partnership's engagement with the local community and to support the development of the Museum of Oxford. I was the successful applicant for the post and in this chapter I will outline how the Reminiscence Service was set up and has developed to respond to the needs of the local community.

A reminiscence service already existed in Oxfordshire, delivered by Oxfordshire County Council Museum Service's Hands on Oxfordshire's Heritage team. I spent the first two weeks of my new role shadowing colleagues who were delivering reminiscence outreach sessions across Oxfordshire. This proved to be invaluable experience and gave me an excellent model upon which to base the Museum of Oxford's Reminiscence Service. We visited day centres, a sheltered housing scheme and self-led groups of older people. It was a fantastic opportunity and it enabled me to develop a new reminiscence service at the Museum of Oxford. I hope that my experiences will inspire other museums to increase their provision for older people and recognise what a fantastic resource older people are to museum and heritage services.

Reminiscence outreach service

The Museum of Oxford's Reminiscence Outreach Service was established using the same principles as the Hands on

Oxfordshire's Heritage service, taking into account the different locations of the organisations. The Museum of Oxford is situated in Oxford Town Hall and is not easily accessible by car. The Hands on Oxfordshire's Heritage team use small vans to travel the long distances across Oxfordshire to deliver reminiscence sessions. Even if working in this way at the Museum of Oxford had been feasible it wouldn't have been practically possible due to the access issue. The solution came in the form of a large, strong suitcase on wheels – strong enough to hold a small collection of reminiscence handling objects and portable enough to be transported by bus. Sessions were based around themes and older peoples groups could choose from a menu of options including Made in Oxford, Fun, Games and Entertainment, All Dressed Up, Going Back to School and Sunday Best. Digital engagement sessions using iPads have also be trialed. Apps including jigsaw puzzle games, *Bloom* (creating music and patterns) and *iFish Pond* have been used with participants living with dementia, and heritage websites have been explored to search for favourite places and landmarks.

The service leaflet was designed and the task of spreading the word began. I completed a module in digital media during my Museum Studies MA course and could see the potential of Twitter to share information with communities of interest quickly and at no cost. I set up the Twitter account for the Museum of Oxford in early 2010 and it currently has a following of over 11,000. Targeted marketing was also used to identify specific groups who might enjoy reminiscence sessions. The service was free of charge at this stage and was welcomed by groups of older people looking for activities. This direct approach worked well and along with word of mouth

recommendation soon created a high demand. Leaflets were distributed in centres for older people, including day centres, sheltered housing schemes, lunch clubs, voluntary groups and interest groups, to promote the service, with additional information provided on the Museum of Oxford's website. To date the service has not been formally advertised. In 2012 a fee of £10 ($15 USD) per session was introduced but this has not affected the popularity of the scheme which is currently fully booked.

Objects, photographs and documents are built into a session plan to stimulate memories and interest. Sourcing objects and documents is a very enjoyable process. I have visited antique centres, second hand shops, explored car boot sales and vintage fairs, borrowed objects from the County Museum Service, searched the Internet and accepted donations from members of the community. Thematic objects have been collected that are suitable for handling and link to the session topics and are mainly from the post 1940s era and within living memory. There are some objects in the collection that extend back beyond living memory, but these can work as memory triggers for stories about the participant's parents. Historic photographs and documents from the Oxfordshire County Archives at Oxfordshire History Centre are used and on occasion participants have recognised people in the photographs which have enabled us to add further information to the archive records held at Oxfordshire History Centre whose website, *Picture Oxon*,[1] has recently been upgraded to allow the public to add information to the photos stored on the digital archive. This kind of crowdsourcing can be very enriching for local communities, especially the older generation. Participants are always placed in the position of expert, and their

opinion is sought about objects and photographs. The feedback that participants offer provides an invaluable source of information and enables session plans to be developed, in this way the service remains dynamic, participant centred and is constantly evolving. At all times participants are made aware of the valuable contribution they are making to the museum and wider heritage services.

As soon as the objects are passed around the group someone will remember something and share it. For example when nylon stockings were shown to a lady she recalled daily letters from her fiancé during World War 2, each one with a stocking wrapped around it! The lady went on to marry her fiancé. There is a Spong Food Mincer in the collection which raises shouts of "my Mum had one of those" from many of the participants when it is brought out of the suitcase. They recall being told not to put their fingers into the mincer, an instruction which made them fascinated with it!

Top ten tips for successful reminiscence sessions
1. Use a side room or quiet space away from the main activities if possible and arrange the seating so that participants are sitting in a semi-circle. If participants can see each other's faces then they are less likely to interrupt each other as they can see when someone is talking or about to talk. Some participants may have hearing problems and need to lip read.
2. Care staff and group leaders are a great asset to the session and it's important to work with them in a positive way and get them involved. Request that at least one member of staff is present throughout the session; staff know the

participants well and will be able to react appropriately if someone is taken ill or needs help with a personal care task. Sessions can provide bonding opportunities for participants and carers, with anecdotal feedback from carers revealing that they enjoy the sessions as they learn so much about the participants. They also really enjoy joining in and reminiscing about their own experiences

3. Ensure that the objects used in the reminiscence session are clean, free from hazards, light enough to handle, don't have sharp edges and don't contain harmful substances (i.e. old cleaning products).

4. Make sure that all the participants are happy to take part in the session and understand what the activity is going to involve.

5. The ideal maximum number in the group is 15. Smaller groups may work better if the participants are very frail.

6. Base the session on themes (i.e. food and cookery) to facilitate some structure and to help participants focus on the activity and give the session a sense of purpose.

7. Have a session plan but allow the conversation to follow its own natural path – some of the tangential conversations are extremely enriching and the theme can always be returned to at a later stage. This approach rarely fails, but if conversation does dry up then the facilitator can fall back on the session plan and deliver a talk.

8. Use a range of resources to stimulate reminiscence including objects, photographs, documents, music, audio clips of spoken word and smells.

9. Listen actively and show an interest in what is being said. Try to empower the participants by praising their

FIG. 1: Object handling at the Westway Day Centre.

achievements and celebrating their life experiences.

10. Suggest follow up activities with care staff to enable the benefit of the session to be longer lasting i.e. a session on holidays and trips to the seaside in the old days can be followed up by participants sharing old holiday photos or looking at holiday locations on the internet.

On-site reminiscence groups for older people

It became apparent that many of the outreach group participants wanted to engage with reminiscence activities more frequently. To meet this need a monthly on-site reminiscence group called Memory Lane was set up in 2010 based on the format used by Banbury Museum for their popular Times Gone By group. The initial meeting was well attended and participants were asked which topics they would like to reminiscence about. There were lots of brilliant suggestions and the first programme of meetings consisted of the History of the Radcliffe Infirmary (an Oxford hospital that closed down in 2006), Oxford Events, Holidays in days gone by, Oxford Industry and Christmas Past. The group has gone from strength to strength with an average regular attendance of 35 people per meeting and 300 people on the mailing list. There is no age limit for the group but the majority of the participants are in their late seventies and early eighties. To ensure the group is accessible and welcoming participants attend on a drop-in basis with no booking required. The group is free of charge and volunteers help to serve light refreshments to make the environment supportive and comfortable for the participants.

It was felt it important that the sessions be documented as they provide a great source of oral history. Each session is

recorded and a copy of the session recording is offered to each of the participants. A copy is also given to the Oxford County Archive Service at Oxfordshire History Centre so that it can be accessed by future generations and provides a valuable source of living history.

There is some administrative work involved in making the recordings, each time a new person joins the group they have to complete and sign a recording consent form for the Museum of Oxford and the Oxfordshire County Museum Service. These forms are updated periodically. A Zoom H2N recorder is used to make the recordings and the computer editing programme *Audacity* is used to edit the material. Although this process is time consuming it has really paid off in terms of encouraging the commitment and enthusiasm of the participants who know that they are making a valued contribution to the museum, archive service and the preservation of history.

Another positive outcome of the Memory Lane group for participants has been achieved through participation in other Museum of Oxford and museum partner projects. Over the years sessions have been run to coincide with the theme of Oxford Open Doors, an annual weekend event run by the Oxford Preservation Trust which enables the public to explore behind closed doors across the City in a celebration of what makes Oxford special. An Our Sporting Lives Memory Lane session fed in beautifully to a Museum of Oxford exhibition project called *On Your Marks Get Set Go* during Olympic year in 2012.

Memory Lane sessions generate wide ranging content, from sound recordings for exhibition listening posts in temporary exhibitions and permanent galleries, quotes for exhibition

panels, photos and documents for reproduction in exhibition panels for display, objects for exhibition display or accession to the collection and oral history content for radio documentaries. As mentioned above, this provides participants with a tangible sense of worth and enables them to attend exhibition launches with their families and friends to share their successes and contributions (Figure 2).

There have been several unexpected and incredibly positive outcomes arising through participation in the groups, for example the camaraderie and development of new friendships in the group as well as old friendships being rekindled. Group members have offered each other a great deal of support. When we arranged an offsite session one lady, who was in her eighties, offered to drive other members to the session. If participants are unwell then group members offer to help out and have visited each other in hospital. Therefore Memory Lane has contributed to significant positive social outcomes such as reducing feelings of isolation and loneliness and helping to build positive relationships and networks of support in the community. This is a very important outcome.

As with the outreach sessions it is best if participants are seated in a semi-circle. Passing objects and photographs around in the group tends to generate a lot of conversation between people sitting next to each other and can make the overall recording and group facilitation difficult. Therefore, the best approach with this type of session is to use images in a PowerPoint presentation which works well as all the participants are all focusing on the same image at the same time. Facilitating the group has proven to be more successful this way and has enabled participants to take it in turn to talk,

FIG. 2: Hazel Bleay and Sherry Evans admire their contributions to the Head Over Heels project exhibition.

without talking over each other. During the session we have refreshment breaks to enable the participants to socialise.

In order to offer a varied programme and spark new conversations sessions are sometimes delivered at partner organisations venues. As well as being popular with participants it provides as opportunity for our partner organisations to increase their community engagement. Examples of this include a session on the history of University of Oxford Church which took place at the church, a session exploring trees and autumn leaves at the Harcourt Arboretum and a session exploring festive flora at University of Oxford Botanic Gardens. Memory Lane has also enabled us to identify individuals to contribute oral history recordings to the Way Finding Tourist Information signs which are located around Oxford City Centre.

To celebrate the success of the group each summer a gathering or trip is organised for the participants. To date we have visited the Oxford Bus Museum, Nuffield Place, Oxford University Press and University of Oxford Botanic Gardens (Figure 3).

Memory Lane Movers and Shakers

In 2014 we introduced a music and movement group to compliment the Memory Lane programme which further supports well-being for participants. Content from the Memory Lane sessions is used to inspire a gentle dance and music group that meets monthly at the museum. A professional dance practitioner guides the group through a series of movements and dance which can be performed whilst seated. The theme of the session is based on the topics that have been explored at Memory Lane group meetings. For example to compliment

FIG. 3: The Memory Lane group enjoy their summer gathering at the University of Oxford Botanic Gardens.

the Autumn Leaves Memory Lane session Movers and Shakers was based on trees and autumn leaves using props such as silk scarves to interpret falling leaves through dance and movement. Music is also chosen to reflect the theme. The group is in its infancy but is popular with participants who report that they feel energised after the sessions.

Bespoke reminiscence projects
The Morris Motors Centenary Reminiscence Project

To mark the Morris Motors Centenary in 2013 (100 years of car making in Oxford) the Reminiscence Officer worked in partnership with colleagues from Oxfordshire County Museum Service to deliver a series of seven Morris Motors themed reminiscence events across the city and county. The project had three main aims: to collect memories of Oxford's car industry for future generations to enjoy via the Oxfordshire History Centre (County Archives); to find participants for a BBC Radio Oxford documentary on the history of Oxford's car industry; and to create some new, happy memories for all the participants. The project was a great success, a total of 274 people attended the seven events (Figure 4).

The reminiscence events took place at the Oxfordshire Museum in Woodstock, the Oxfordshire History Centre, BMW Mini Plant Oxford, Kidlington Reminiscence group, many of whom had worked at the Pressed Steel factory, the National Trust's Nuffield Place (home to William Morris for the last 20 years of his life) and the final event was held at the Museum of Oxford during Oxford Open Doors weekend. Over the months the group developed an amazing camaraderie which offered a supportive forum for sharing new memories of working in the

FIG. 4: Museum staff and ex-employees from Morris Motors admire the Morris Motors Band Coach.

motor industry. It also resulted in the creation of a new set of memories and stories. Recordings from five of the events are now held in the archives at Oxfordshire History Centre. Radio journalists from BBC Radio Oxford worked very hard in the background to interview lots of the participants for a radio documentary on Oxford Car Industry, which was aired on BBC Radio Oxford over Christmas 2013. One of the most enriching aspects of the Morris Motors Centenary Reminiscence Project was the way strong partnerships were formed between The Museum of Oxford, The Oxfordshire Museum, local media and other heritage organisations. This enabled the project to have a far greater impact than would been possible if the organisations had worked alone. The BBC's *Countryfile* programme contacted us during the project as they were keen to include the Morris Motors Centenary in an episode which focused on Oxfordshire. One of the reminiscence group participants gave an interview on the programme which was a lovely and unexpected addition to the success and popularity of the project.

Intergenerational projects

Over the course of five years of delivering reminiscence activities in Oxford it has become apparent that it is very enriching for participants if projects include an intergenerational element, this is demonstrated in the following case studies.

The Head over Heels intergenerational dance project

The aim of the project was to bring together an intergenerational group to devise a short dance piece inspired by reminiscence memories to be performed at the opening of the museum's *Head over Heels* exhibition. This provided an

additional layer of interpretation to the exhibition, and piloted a method for sharing the memories collected as part of the museum's reminiscence programme.

Head over Heels, was a partnership project between the Oxfordshire County Council Museums Service, the Museum of Oxford and Oxford University Museums. The project explored hats and shoes made and used in Oxfordshire and culminated in a major exhibition at the Oxfordshire Museum, and a Community Exhibition at the Museum of Oxford.

Two Memory Lane events collected memories of hats and shoes worn in previous eras. The beautiful historic Oxford shops where these items could be purchased were also explored. Working with a freelance dance practitioner, the project partnered with Windmill Junior School in Headington to recruit young people to join members of the Head Over Heels dance group. A group of Memory Lane members attended an assembly and delivered a short historical hat workshop, dance activity and talk on what it was like to be a pupil 50 years ago to 400 pupils at the school. Participants were invited to join the dance group. The group listened to the collected memories, looked at archive photos and objects, and then improvised some short dance pieces, which were then developed into a longer performance. Participants fed back that "working with the different generations really added to the experience", and the fact that the histories they studied were authentic caught and sustained their interest. The piece was performed at the launch of the *Head over Heels* exhibition at the Museum of Oxford in March 2012, and then again at the Windmill Junior School, taking it back to the young people at the school.

The performance was well received by the exhibition

audience, which included the Lord Mayor of Oxford. It provided an alternative creative way to access the exhibition and reinforced for members of the Memory Lane group the value of sharing their memories (Figure 5). Participant feedback was very positive with one lady commenting:

> I really enjoyed being involved in the intergenerational dance project. It really pushed the boundaries out for me and was well outside my comfort zone but our dancing instructor and everyone else involved made it so enjoyable that I soon lost my inhibitions. I think working with the different generations really added to the experience and I would certainly do it again. Would I change anything to make it better? No.

Museum of Oxford Recipes and Reminiscences project

The Recipes and Reminiscences project aimed to share and preserve some of Oxford's cookery history through a programme of reminiscence events and intergenerational cookery sessions with a class of children at a local primary school. Other project outcomes included; developing an exhibition to showcase the collected material; a Family Art Day to create a three dimensional food-related artwork for the exhibition; and creating a recipe book to sell in the museum shop.

Two well attended reminiscence events took place, each looking at different aspects of Oxford's food history. Some of the themes discussed included Coopers Marmalade Factory, Morrell's Brewery and Oxford's Wartime Municipal Restaurants. The first event took place at the Museum of Oxford and the second at Taste of the Tropics pop-up Caribbean Café in

FIG. 5: The Head Over Heels intergenerational dance group practice their routine in Oxford Town Hall.

East Oxford. This gave participants the opportunity to try Caribbean cuisine and to experience Caribbean culture.

Participants brought their favourite old family recipes to both sessions which were collected along with memories of why these recipes were family favourites. The project engaged with a class of Year Three children from Windmill School in Headington to create one of the recipes that had been collected at the reminiscence sessions. Each week for three weeks ten children teamed up with five older people from the Memory Lane group to bake a batch of Coconut Pyramids led by the Reminiscence Officer with support from staff at the school. The children took part in a *Bake Off* style competition which was judged by the head teacher. All the children received a prize and the intergenerational contact was much enjoyed by young and old alike (Figure 6).

The next stage in the project was a Family Art Day to create a large 3D Coconut Pyramid and Christmas pudding for an exhibition showcasing the project. Families were invited to drop in and help to create the artworks which then went on display in the Recipes and Reminiscences exhibition. The exhibition also featured a listening post with participants' recorded memories available to listen to and a display case of old fashioned cookery related objects. The exhibition was open for six weeks and attracted 3174 visitors, a very high number for this type of event.

The panels and 3D work from the exhibition are now on display at the school and the recipe book is available to view on the Museum of Oxford website.[2] As well as feeding into the museum's exhibition programme, an innovative element of the project was the potential for income generation for the

FIG. 6: Coconut Pyramids made by pupils from Windmill School and members of the Memory Lane group.

museum through the development and sales of the recipe book in the gift shop. This also gave the participants a meaningful sense of engagement with the museum and sense of purpose in taking part in the project. 126 adults and 77 children where engaged in the project at various stages, some throughout the entire project.

The project had some very positive outcomes including educating a group of 45 year three children in cookery history and cooking skills. The children baked cakes, handled objects relating to cookery in the past and listened to older people talking about their cookery memories. This fostered a greater understanding between different groups, young and older, via creative activities. This intergenerational aspect helped break down preconceptions and barriers by bringing together groups who would not normally work together. It helped to increase understanding and build relationships between the school children and the older people. For some of the children, the experience of getting to know older people was particularly poignant as they did not have regular contact with grandparents. Some of the children told us they would like to go on to become chefs.

The project supported the older participants to develop a greater understanding of other cultures. The group visited the Taste of the Tropics pop-up café, which for many was the first experience of trying Caribbean cuisine. The meal was greatly enjoyed and was followed by a reminiscence session including café regulars and Memory Lane group members. One Memory Lane participant returned to the café the following week as she had enjoyed the experience so much. In October 2013 the organiser of Taste of the Tropics came to the Museum

FIG. 7: A Memory Lane group member helps create a Christmas Pudding for display in an exhibition.

of Oxford to deliver a very well attended talk on the Origins of Black History for Black History Month (Figure 7).

The project was very popular, one participant commented:

> I took part in the Family Art day with my niece. I found it a very positive experience and very interesting. A lot of thought had gone into the preparation and all the children were very engaged in what was there. I am impressed by the thought goes into these activities and the great variety. My niece made cars and painted the Christmas pudding.

Reminiscence in hospital settings

In 2011 the Reminiscence Officer was approached by the Senior Occupational Therapist at the Fulbrook Centre (Oxfordshire Health NHS Foundation Trust, Older Adults Mental Health Unit) and asked to deliver reminiscence therapy sessions with patients at the centre. Object-based, themed reminiscence sessions lasting one hour are now delivered to groups of between eight and twelve patients in the art room. The patients are encouraged to join in, share memories and tell the group about their life experiences and achievements. Members of staff are present at all times to support the Reminiscence Officer in delivering the sessions. Reminiscence sessions are now being delivered at Oxford Community Hospital with patients undergoing rehabilitation and awaiting discharge. Feedback from the Senior Occupational Therapist, Fulbrook Centre, Churchill Hospital, Oxford Health NHS Foundation Trust has been very positive:

Individual people's stories and experiences are stimulated by museum objects, music and discussions. The reminiscence experience has benefits of increasing communication particularly with people with cognitive impairment. This opportunity to share and remember different times in the past is often confidence boosting and fun helping to reduce stress and immediate anxieties. The popularity of the groups is testimony alone.

In 2012 the Reminiscence Officer was approached by the Arts Co-ordinator at Oxford University Hospitals NHS Trust and asked to deliver reminiscence therapy sessions on Gerontology Wards at the John Radcliffe Hospital in Oxford. Object based, themed reminiscence sessions lasting one hour are delivered to a group of between four and eight patients and visitors in the day room. Additional Sessions are delivered on an Acute General Medicine Ward and the Oxford Centre for Enablement at the Nuffield Orthopaedic Hospital. The aims of this strand of the work are to extend the reach of the reminiscence service to older people who cannot come to the museum and to improve the well-being of patients.

Across all the sites the service is reaching approximately 30 people per month and some former patients have visited the Museum of Oxford after being discharged which is a very positive outcome. Feedback from the staff suggests that patients enjoy the sessions and there is a noticeable increase in engagement and interaction in the patients by the end of the session. Indicators such as patients having an increased appetite after attending sessions provides strong anecdotal evidence that reminiscence activity has a positive impact on patients' well-being.

The activities provide an enjoyable experience for the patients during their hospital stay and satisfaction with the sessions has been reported as high. When visitors participate in the sessions (which they are encouraged to do) they also give very positive feedback. A further outcome has been that hospital staff have been able to learn more about their patients. The support of the staff on some of the wards makes a great difference to the outcome of the sessions. If a group of patients have been briefed beforehand and are assembled in a group waiting for the session to start it really helps to them to focus on the activity and produces a better outcome. We are exploring options to enable us to implement a clinical research programme to provide us with a clearer picture of the impact of reminiscence related activity on older people in a range of settings.

Feedback from the Arts Coordinator at Oxford University Hospitals NHS Trust has been very positive:

> The Reminiscence sessions led by Helen Fountain are hugely beneficial to older people in that they encourage them to explore and share their memories in a friendly and supportive environment. They are sociable events which give obvious pleasure to participants and allow them to share memories with younger generations too.

Partnership, evaluation and project development
Partnership working
The Oxford University Museums Partnership comprises Oxford University Museums, Oxfordshire County Council Museums Service, Banbury Museum and the Museum of Oxford. This overarching partnership enables great scope for delivering

museum activities for older people across the region.

There can be no doubt that working in partnership with other organisations has greatly enhanced the reminiscence project in Oxford. Working in this way has enabled us to reach new audiences (such as hospital in-patients), offer our group participants privileged access to sites such as the BMW MINI plant in Oxford, facilitated enhanced outputs for our projects (working with schools to incorporate an intergenerational element into reminiscence projects) and has increased the capacity of community engagement for all partners. Working in this way also enables budgets to be used in a more efficient way by sharing the costs of resources and refreshments and the shared use of facilities. For example, the Recipes and Reminiscences project at Windmill School enabled free use of the school cookery rooms and provided the school with enrichment activities for a group of year three pupils. The most important partners in all of our work are the participants who add tremendous value to the Museum and Heritage service as they have such a broad breadth of life experience and knowledge, particularly in the area of social and local history. In this regard they are an invaluable resource to a local history museums and wider heritage services.

Partnership work has also presented opportunities to showcase the work on partners' websites and at events. Examples of this include contributing to blogs, speaking at conferences, seminars and delivering training events. The reminiscence work in Oxford has been included as a case study in *Museums, Health and Wellbeing* (Chatterjee and Noble, 2013). Opportunities like this create a lasting legacy for the project and enable good practice to be disseminated to a wide audience.

Reminiscence project development

A reminiscence project needs to be constantly evolving and adapting to the changing climate around it and responsive to the needs of the local community. In Oxford, a Prescription for Reminiscence scheme has been developed to enhance the existing offer. The project was formally launched at the Creative Dementia Arts Network conference in Spring 2015. The project aims are to deliver high quality creative activities for older people and to enhance well-being and reduce isolation, targeting hard-to-reach older people including those with dementia and those most at risk of isolation. The project brings together local health, social care and housing services as well as community organisations throughout the county. The older people referred to the scheme are signposted to a range of museum activities available across the Oxfordshire University Museums Partnership. These activities include the Memory Lane Group, which offers a supportive, creative environment, a chance to socialise and make friends, opportunities to share memories and contribute to our exhibitions and archives and most importantly to have fun and share laughter. A person-centred approach is used to direct referrals to activities most suited to the older person's needs and to address any accessibility concerns.

We recognise that the population is ageing and as people are living longer there are increasing numbers of people living with dementias, including Alzheimer's Disease. To stay relevant, museums need to be responsive to the needs of this section of society and to play a role in dispelling the negativity that can be attributed to the ageing process. Museum projects provide a great vehicle to celebrate the talents and wisdom of older

people whilst contributing to their well-being and reducing isolation and associated health problems. These assertions are backed up by research studies and work is on-going to develop robust data to support the value of reminiscence and participation in arts activities to the healthy ageing agenda. In Oxford, services and activities for older people with dementias including Alzheimer's Disease are being developed using sensory reminiscence activities, tactile object-handling experiences, artistic and performance art activities, digital technology and iPads to explore heritage websites and apps designed to stimulate cognitive activity. These types of interventions have been shown to be very effective in increasing well-being and quality of life for older people living with dementia and their carers. A recent pilot project delivered by Age Exchange in London, *Reminiscence Arts in Dementia: Impact on Quality of Life (RADIQL)*, delivered creative arts activities to support people with dementia to access their memories. The project is being evaluated by Royal Holloway College. Early findings are very positive with a significant increase in well-being reported during and after the sessions.

Evaluating the reminiscence project
Throughout the project we have sought feedback from stakeholders using participant questionnaires, group leader surveys, focus groups and one-to-one interviews. The findings of these evaluations have been very positive, with participants and group leaders reporting a high level of satisfaction with the service. Funding has been secured to work in partnership with colleagues at the University of Oxford Institute for Population Ageing to develop a robust methodology for collecting

data which measures the impact of reminiscence activities on older people.

Conclusion

The preceding pages have demonstrated the enormous benefits that can be achieved in working proactively with older audiences in a museum setting. Groups like the Museum of Oxford's Memory Lane group can be set up at very little cost and can be supported by volunteers. Opportunities for funding outreach work and more specialist interventions in healthcare settings and hospitals may arise through local Commissioning Boards and agencies working with older people. It can be difficult to attract funding of this type, but there is a strong case in terms of the well-being benefits and potential cost savings to the health and social care budgets, whilst keeping older people safe, well and happy.

It is important to pay attention to the access to the building and make sure people can get in easily; also ensure that once they are in the building they receive a warm and friendly welcome. Be user-led, ask your groups of older people what they would like from the service, or go and visit groups in the community and canvass opinion. Get involved in initiatives to equip staff with the skills needed to support older people: the Alzheimer's Society offer excellent Dementia Awareness sessions through their Dementia Friends scheme. Helping your organisation to work towards becoming a Caring Museum is a no-brainer; there is nothing to lose and everything to gain.

The ageing population is often portrayed in a negative light by the media, with references to ageing such "ticking time bomb" and "ageing crisis" but museums are uniquely placed

to challenge this perception and turn it around to focus on the positive aspects of ageing: the wisdom, knowledge and experience built up over lifetimes.

One thing is certain, we are all going to grow older. I frequently ask myself the question, "How would I like to be treated in my older age and what sort of activities would I like to take part in?" I would like to be respected and feel that I can still make a valuable contribution and have something to offer. Reminiscence programmes are vehicles through which this can be achieved and none of us needs any training in order to be able to participate!

NOTES

1. http://www.pictureoxon.com.
2. http://www.oxford.gov.uk/museumofoxford.

REFERENCES

Helen Chatterjee and Guy Noble: *Museums, Health and Wellbeing*. London: Ashgate Publishing, 2013.

VOLUNT

EERING

PERCEPTIONS OF OUR MUSEUM: OLDER ADULT EXPERIENCES AS VOLUNTEERS

Ann Rowson Love and Maureen Thomas-Zaremba

AN ELDERLY COUPLE told me after the tour that before they were "afraid" to take a docent tour because they had a very limited knowledge of art, but that I made them feel so comfortable and they learned so much that they now had the courage to take docent tours on a regular basis.

– A Memorable Experience with Visitors,
Ringling Museum Volunteer Survey Respondent

This chapter presents initial findings from a study conducted at the Ringling Museum in January 2015. The Education and Volunteer Services Departments sought to explore the needs and perceptions of their volunteer corps, largely made up of older adults in a community that embraces life-long learning opportunities for older adult audiences. A mixed-methods evaluation included an online survey and on-site museum interviews with volunteers.

The John and Mable Ringling Museum of Art is the State Art Museum of Florida and Florida State University and is located in Sarasota on the Florida Gulf Coast. Bequeathed to the people of Florida by the circus impresario and art collector John Ringling and his wife Mable, the estate includes the Art Museum with its collection of Old Master works and special exhibition wing dedicated to traveling exhibitions and the Ringling's growing collection of contemporary art; the Cà d'Zan, the Ringling's 1920s era bayside mansion; the circus museum dedicated to preserving and telling the story of the American circus; and the Historic Asolo Theater, which presents a wide range of both traditional and contemporary

John and Mable Ringling Museum of Art [TOP], Cà d'Zan [MIDDLE], and Circus Museum and Tibbals Learning Center [BOTTOM], Sarasota, Florida.

performance. The museum venues are all situated in a park like setting of 66 acres of grounds and gardens.

The Ringling attracts close to 400,000 visitors each year and is currently experiencing unprecedented growth due to museum expansion and year-round tourist population. Tourists, one of the Ringling's primary audiences, both national and international, often comprise older visitors. Likewise, the museum's more than 600 volunteers are also predominantly older adults. The volunteers are crucial to the daily operation of the museum and are recruited from within a 40-mile radius of the museum. The wealth of cultural amenities, the natural beauty, and the mild Florida climate attract a high number of well-educated retired professionals to the gulf coast who are looking for life-long learning opportunities, the chance to pursue deferred interests, and a desire to give back to their community. Identifying meaningful volunteer roles for this rich resource, as well as programmatic and interpretive strategies to serve this population, provides an ongoing challenge to the Ringling staff. Very little research addresses this volunteer base in U.S. museums, yet the need for better understanding volunteer experiences along with their perceptions of the visitors' experiences is timely as the baby boomer generation takes a more dominant role in older adult volunteerism.

The Ringling Museum's volunteer corps and docent-led tour program is one of the largest in the United States. Given the demographics of both the volunteer groups at the museum and Sarasota museum audiences in general, this is one of the first formal studies undertaken by the museum in order to examine the perceptions of older adults' experiences as volunteers and their perceptions of visitor experience at the

museum. This study provides formative evaluation findings and recommendations to assist museum staff with future planning efforts regarding the volunteer corps. Understanding changing needs, learning interests, and satisfaction of overall volunteer experience are important considerations to museum staff. Complementing this interest, museum staff members understand that museum volunteers, in whatever capacity they serve – from visitor pavilion ambassadors to tram drivers to docents – engage with visitors throughout the museum experience in ways that museum staff may lack. Thus, volunteer perceptions about visitor experiences provide valuable insights. This study aims to combine perceptions about volunteer personal experiences and their perceptions about visitor experiences. A third component includes demographic information. All three components were addressed in an online survey sent to all volunteers via email. Additionally, on-site interviews provided an opportunity for volunteers to expand upon their experiences and survey responses.

Purpose of the study

This study is a mixed-methods evaluation incorporating quantitative and qualitative features from an online survey (reproduced in an Appendix to this chapter) and on-site museum volunteer interviews. The overarching research question addressed was: What are Ringling Museum volunteers' perceptions of their experience and interests for future volunteer programming? A subsequent question included: What are volunteer perceptions of museum visitor experience? Related to these questions, the online survey and interviews addressed the following areas:

- Overall satisfaction levels pertaining to the volunteer experience.
- Perceptions and preferences regarding current interpretation practices at each venue.
- Perceptions about visitor way-finding techniques across museum venues.
- Interest and suggestions specific to older adult audiences.
- Interest in digital technologies.
- Community engagement strategies.

Literature review

Very few studies address the nature of older adult volunteers in museum settings specifically, although there are studies which address older adult participation in the arts as a whole, including visual art settings and the use of technology related to arts and museums (National Endowment for the Arts, 2014). The National Endowment for the Arts (NEA) survey included 35,735 adult respondents over 18 years of age. While overall visits to art museums declined for young adults and those who are 35-44, participation rose for older adults. Seventy-one percent of all adults responded to viewing visual art through mobile devices and other forms of electronic media. Over 30% of older adults aged 65-74 and over 13% for those 75 and older reported technology use for viewing art. Mobile technology is a growing interest in museums including the use of handheld devices, social media, and collaboration through crowdsourcing (Johnson, Becker, and Freeman, 2013; Merritt, 2014). Older adult use of online technology and cellphones is on the rise, but behind other adult age groups under 65 (Pew Research, 2014).

Although there are few studies on older adult volunteers

in museums, there are reviews and meta-analyses of research which address the benefits of older adult volunteering (Anderson *et al.*, 2014; Baycrest Center for Geriatric Care, 2014; Corporation for National and Community Service, 2012; Population Reference Bureau, 2011). Compiled findings underscore benefits including physical and cognitive activity, fewer signs of depression, and overall better health. With strong benefits such as these, the Population Reference Bureau advocated including diverse older adults in volunteer positions, especially those who may have disabilities or who are in lower socio-economic conditions, circumstances that may be correlated. The bureau also calls for actively preparing for baby boomers entering the volunteer field:

> Adoption of key practices, such as the matching of volunteers with appropriate and challenging assignments, providing professional development opportunities for volunteers, and treating volunteers as valued partners, can help build organizational capacity to recruit and retain boomer volunteers.
> (Population Reference Bureau, 2011: 2)

Anderson *et al.* (2014) analyzed 73 research studies focused on benefits of volunteering. The authors underscored better health can be achieved by moderate participation, 100 hours of volunteer service per year, or a couple of hours a week. They also highlight the need of older adults to feel appreciated as volunteers and call for further research on the relationship between volunteering and cognitive abilities.

This brief review of literature emphasized key areas of

interest to Ringling staff and helped to focus the study. Taken together – older adult engagement in art museums, use of technology related to museums, and benefits of volunteering – guided the selection of methods. Additionally, volunteer perceptions of visitors might also provide insight into older adult experiences at the museum venues.

Methods

The mixed-methods formative evaluation study employed two data collection strategies – an online survey that featured quantitative and qualitative components and on-site semi-structured qualitative interviews. Analysis of data focused on descriptive analysis of survey questions (quantitative) and content analysis of open-ended survey questions and interview transcripts. The on-site interviews with volunteers complemented the survey with semi-structured conversations in order to offer additional viewpoints regarding survey content and volunteers' own questions or directions. Participants were recruited for the online survey and the on-site, face-to-face interviews through announcements in newsletters and the online scheduling system. Nearly 90% of volunteers have email addresses. Participants self-selected to take the anonymous survey through an email invitation with a link provided; interview participants self-selected for 30-minute face-to-face confidential interviews with the researcher and lead author of this chapter.

Survey construction

In 2007, the Volunteer Services Department conducted a paper-based survey to better understand the needs, perceptions,

and satisfaction levels of volunteers. At that time, staff felt an online survey might not reach all volunteers. Since then, the museum introduced an online volunteer scheduling and information system, ViCky. For the current survey, the researcher and staff members worked together to develop items in three sections – perceptions about volunteer experience, perceptions about visitor experience, and a brief and optional demographic section. The full survey can be seen at the end of this chapter.[1]

Museum staff members were interested in using items from the 2007 survey in order to examine potential trends since that time regarding perceptions about volunteer experience. A few questions were altered slightly due to changes in new technologies and volunteer program structure. By using the existing instrument for the first section of the survey, the staff hoped to identify if there are any changes in the volunteer experience and to see how a new generation of volunteers, baby boomers, experience the volunteer programs. Item construction primarily relied on rating scales and multiple-choice questions to parallel the earlier survey. Questions focused on perceptions regarding overall satisfaction with the volunteer programs; the needs or interests in further training; and preferences for communication and technology. A new question asked volunteers about their preferences for engaging with art or artifacts during their own visits to museums. This question led into the next section.

The second section of the survey concentrated on volunteer perceptions about visitors. Often volunteers are the first, and perhaps only, people to directly engage with general museum visitors (daily visitors, who are not engaged in special programming). Questions included:

- What gallery interpretation methods do you think museum visitors would most enjoy?
- What kinds of questions do museum visitors ask you most often?
- Which of the following museum visitor groups do you interact with most often?
- Which of the following museum visitors do you encounter most?

The questions in this section asked respondents to select a single choice out of a list of options.[2] The volunteers were also asked two open-ended questions in this section – to share a memorable experience as a volunteer and a favorite interaction with a museum visitor or visitors.

The third section of the online survey contained optional questions related to gender, age range, and cultural or racial identity. Also, volunteers could answer questions about how many years and hours a week they have volunteered at the Ringling. This demographic information would allow staff members to see changes over time in the volunteer base and to assist with future planning to recruit new volunteers and build diversity. Two open-ended questions asked respondents how their volunteer experience could be improved and to share any additional comments.

All questions were vetted and approved by department heads and volunteer coordinators in Education and Volunteer Services. Additionally, the Assistant Director of Academic and Student Affairs provided input and approval. The researcher made edits and resubmitted the revised questionnaire to all group members.

On-site interviews

On-site face-to-face interviews invited volunteers to elaborate on survey content. The interviews also offered an opportunity for volunteers, who do not have email, or who do not feel comfortable completing an online survey, to take a verbal or paper version of the survey. The semi-structured interviews allowed for a conversational tone and opportunities for volunteers to guide discussion. Each interview started with the researcher asking if the volunteer had any questions or comments she or he would like to discuss. Following this, the researcher asked interviewees to talk a little more in-depth about survey questions that asked them to "select one" out of a list of choices. These questions included:

- What would enhance your volunteer experience?
- How do you (or visitors) like to interact with art or artifacts when you visit museums?
- What kinds of questions do visitors ask you most often?

The interviews were conducted in a small, private conference room at the Ringling Museum over a three-day period. All interviews lasted 30 minutes each, the allotted time.

Results

The online survey email invitations were sent to volunteers on January 5, 2015. The survey site remained open for two weeks through January 19. Volunteer Services posted a reminder to participate halfway though the survey period. Of the 530 volunteers who had active email addresses, 291 started the survey (55% participation), with 248 completed surveys (47%).

Participants were free to skip questions or quit the survey at any time. Volunteer Services placed paper copies in the volunteer office area with a secure box for depositing responses. Very few volunteers opted to take the paper version. One volunteer took the paper version during an on-site interview. Paper versions are not reflected in this results section. As the analysis of data continues to date, the following are initial findings.[3] During the three-day on-site interview period held on January 8 through January 10 2015, 34 of 36 scheduled interviews were completed.[4]

Overview of survey findings

Overall, volunteers at the Ringling Museum are pleased with their volunteer experience. They are enthusiastic about their work and want to help visitors enjoy their experience. They want to learn and serve their community. Volunteers are pleased with the perks they receive such as the discount on membership and free general admission with their volunteer ID badge. Their preferred communication methods are email, ViCky (online scheduling system), and the membership magazine. They have a strong interest in learning more art history and art appreciation. Volunteers generally receive positive feedback from visitors and they seek to provide more input and feedback to museum staff. Below are results from specific survey questions in each section – volunteer experience, visitor perceptions, and demographic information.

Survey section one: volunteer experience

The first question on the survey asked respondents to select any or all of their current volunteer roles at the Ringling

Museum. Of the 27 different volunteer types currently available at the museum, most respondents represented in the survey data fulfill the following roles:[5]

- Docent (any venue) 30%
- Ringling ambassador 27%
- Tram operator 18%
- Theater usher 18%
- Special events assistant 15%

When asked to rate their reasons for volunteering at the Ringling, a six-point Likert scale represented *not at all important* to *extremely important*. Ten of the sixteen reasons fell between important and very important. The highest mean score related to helping visitors understand the history and relevance of the museum (Figure 1).

A few reasons fell in the "neutral" range including those listed in Figure 2. The least important reason for volunteering was fulfilling a requirement for school, employer, or other agency (1.2), which underscored the nature of Ringling Museum volunteer base: for the most part, retired professionals.

When responding to statements about overall volunteer experience at the Ringling, participants rate the museum highly overall. Mean scores for four statements were ranked between 4.5-5. Respondents perceive the Ringling as an excellent place to volunteer. They continue to learn, are energized and enthusiastic about their experience. They would recommend volunteering at the Ringling to others. Few respondents overall disagreed with any of the 10 statements. The two lowest

means were related to developing new job skills (3.4) and exploring additional volunteer responsibilities (3.65).

Survey participants rated their level of proficiency with computer and technology skills using a 5-point scale from "not proficient" to "highly proficient." Respondents feel most proficient in using email, or somewhere between "somewhat proficient" and "very proficient." Likewise, they reported proficiency in basic computer skills, use of applications such as Google Maps, smart phone use, iPad/tablet and social media engagement (Figure 3).

Lower levels of proficiency are reflected in the means between one and two (Figure 4). These technologies tended to be more data management, presentation, and design oriented. Use of social media, iPod and audio tours along with interactive e-books also received lower mean scores.

Figure 5 highlights responses to questions about preferences for enhancing the volunteer experience.

The next survey question (Figure 6) asked about additional training. Less than half the respondents were interested in the topic options offered. The least interest in tram safety contrasts with the most interest in using digital technologies in the galleries.

More than half the respondents were interested in learning more about historical subjects related to art, the circus, and the Ringling family (Figure 7).

The last question in the survey section on volunteer experience asked how they most like to interact with art and artifacts in museums. Of those who responded, 36% selected docent tours. The next highest response was curator-led tours or gallery talks (16%) followed by audio tours (11%). The other twelve

REASON	MEAN SCORE
Helping visitors understand the history and relevance of the museum	4.9
Serving the community	4.6
Providing a sense of personal accomplishment	4.6
Expanding love of learning	4.6
Using life skills and experience	4.5
Furthering involvement with the arts	4.6

FIG. 1: Reasons for volunteering.

REASON	MEAN SCORE
Exploring a creative side	3.9
Meeting new people and expanding social circle	3.8
Engaging in physical activity	3.3
Occupying free time	3.2

FIG. 2: Reasons for volunteering – neutral mean.

TECHNOLOGY PROFICIENCY	MEAN SCORE
Email	3.7
Basic computer skills	3.4
Microsoft Word	3.2
Google Maps	2.7
Smart phone	2.6
iPad/tablet	2.4

FIG. 3: Proficiency in the use of technology.

options received 5% or less. Mostly the responses offered two selections with statements about how it was difficult to choose one. For example, one respondent wrote, "My two favorites are audio tours and docent led tours. Sorry, I could not choose between the two." Another response listed "multi-language handouts," which was not one of the question options. This last question also helped to transition to perceptions about visitors.

Survey section two: perceptions about visitors

The first question in this section asked about what gallery interpretation methods volunteers think most visitors would enjoy. Again, docent-led tours was most selected (35%) followed by audio tours (21%). All other responses received less than 8%. Two options were not selected at all: focus on the object itself, and games.

Not all survey respondents answered the open-ended questions about visitors. 149 responded to an opportunity to share a memorable experience as a volunteer. 140 responded to a question asking them to share a favorite encounter with museum visitors. A content analysis of this data is currently underway.

Volunteers were also asked what questions do museum visitors most ask. Thirty-three percent of the volunteer respondents said that visitors mostly ask for historical information. The next most selected response was that visitors ask what to see at the museum (23%).This question also featured a write-in, or other, component. Responses included examples such as: Are these paintings real or are they copies? Where should we start? and Again, I cannot choose one. These are all questions asked by our visitors to all volunteers and staff.

TECHNOLOGY PROFICIENCY	MEAN SCORE
Social media	2.0
Microsoft Excel	2.0
Microsoft PowerPoint	1.9
Document layout	1.9
Interactive eBooks	1.8
iPod or audio tours	1.7
Audiovisual equipment	1.5
Adobe Photoshop	1.4

FIG. 4: Lower level technology proficiency.

ENHANCING THE VOLUNTEER EXPERIENCE	PERCENTAGE
More opportunities for training in my current volunteer role	32%
More on the job feedback and evaluation	24%
More scheduled social activities for volunteers	34%
It is rewarding and enjoyable as it is	64%

FIG. 5: What would enhance the volunteer experience?

ADDITIONAL TRAINING	PERCENTAGE
Tram safety	11%
Customer service	37%
Diversity and cultural differences	37%
Assisting visitors with special needs	41%
Gallery interpretation strategies	43%
Using digital technologies in the galleries	44%
Facilitating interactive experiences in the galleries	39%

FIG. 6: What additional training would help you?

When asked about what kind of museum visitor volunteers most encounter, 49% selected U.S. tourists. The next highest selection was seasonal community at 18%.

Section three: demographic information

The demographic information section was optional, but most respondents completed it. Survey takers were 68% female and 32% male (Figure 8).

When responding to the question about cultural or racial identity, participants were asked to type in their responses. The majority of survey takers responded white or Caucasian. One participant responded Asian. A smaller number responded with ethnic origins such as Scandinavian, Irish, Norwegian, Italian, German, and British. A few survey takers listed religious affiliations as cultural identity such as Jewish. One respondent described his cultural identity by his gender, degrees and career background. Another affiliated with region, Northeast, snowbird.

Two final questions asked about how many years the respondents had served as museum volunteers and how many hours a month. Of the 212 respondents, 18% reported being a Ringling volunteer for less than a year; 22% for more than ten years. Out of 206 respondents, 16% volunteer 8-10 hours a month, while 30% volunteer 20 or more hours per month.

Interviews

On-site interviews took place over a three-day period with the outside researcher and lead author. Similar to the online survey, most participants represented the docent, ambassador, and tram driver volunteer groups. A smaller number of interviewees volunteer in the gardens, museum store, Asolo

HISTORICAL SUBJECT INTERESTS	PERCENTAGE
Art history/appreciation	69%
Bayfront gardens and grounds	47%
Circus history	52%
Asolo Theater history	37%
Ringling family history	63%

FIG. 7: What historical subjects are you interested in learning more about?

AGE RANGE	PERCENTAGE
18-13	0.5%
35-54	1.5%
55-64	12.5%
65-74	50%
85+	3.5%

FIG. 8: Respondents' age range.

Theater, or for special projects. With only a handful of exceptions, interviewees agreed to participate in the spirit of volunteering, a desire to contribute to research, or because of their passion for the museum and volunteering. The exceptions included interviewees who wanted to share concerns or grievances, albeit still with considerable passion for the museum and their volunteer work. Rather, most acknowledged an interest in the research and an appreciation of the museum staff for conducting the study. All participants wanted to know how the data would be used at the museum and if the volunteer corps would receive feedback or publications such as reports or presentations of findings. Although content analysis is currently ongoing, there are a few overarching themes that emerged from the interview sessions. They include the following:

- Overall preparedness for interaction with visitors
 – I guide them to their interests...
- Volunteer input – I have expertise...
- Acknowledgment – it's in the little things...

In most interviews, the researcher and interviewee discussed a question on the survey related to what kinds of questions visitors most ask; they agreed it was hard to pick just one option. Volunteers, ambassadors, and tram drivers specifically expressed the ways in which they interact with visitors. Generally, they try to provide options based on the visitors interests, especially when visitors mention time constraints. Volunteers underscored that many visitors are surprised by the number of venues on the estate and often ask for best suggestions for a short visit. Almost all the volunteers ask visitors about their

interests and make suggestions based on their role as volunteers such as routing a visit using the museum map (ambassadors); driving visitors directly to a venue of interest (tram drivers); or engaging with visitors about a work of art that interests them (docents). Generally, volunteers feel adequately prepared to answer questions.

With few exceptions, the interviewees felt there could be more opportunities for volunteer input. Many spoke of their specific background and career experience in order to explain their thoughts. Through the interviews, it was clear to the researcher that the museum volunteers are highly educated and have a broad range of experience in fields such as business management, public relations, education, and research. Volunteers view opportunities for input as meaningful – even if additional volunteer hours are needed. They have a strong commitment to the museum and feel their expertise may assist the staff. They especially acknowledged the multiple responsibilities each staff member performs. At the same time, volunteers also provided examples of decisions made by staff which were not sufficiently explained to volunteers. When describing examples related to this, the interviewees fully acknowledged their understanding that management decisions must be made. They also acknowledged the restrictions or policies the museum enacted as a part of transitioning to a state university system.[6] They appreciated the new policies, which encourage a systematic approach to volunteer program management. Some future decisions will not include volunteer input; however, efforts to explain decision-making and get feedback would not only provide validation, but even enhance ownership of their experience and commitment.

Many interviewees discussed the importance of receiving acknowledgment from museum staff, particularly department heads and senior staff. They felt that the volunteer coordinators in Volunteer Services and Education do an exceptional job acknowledging the contributions of volunteers and provide sufficient communication and organization. They appreciate recognition events. The kind of acknowledgment volunteers seek is often informal: a smile... a wave... a hello... can make their day and underscores appreciation for their service.

Discussion

Overall, the Ringling Museum's study of volunteer perceptions was well-received with over half of current volunteers participating in the online surveys during a relatively short window of time – two weeks. Further efforts will be made to find ways to gain volunteer feedback. Based on current feedback, volunteers are satisfied with their experience at the Ringling. Although the survey did not explicitly ask about perceived health benefits from volunteer experiences, responses to the reasons for participation parallel those listed in research as points that lead to overall health and longevity. Health benefits alone may be a strong incentive for the overwhelming number of volunteer applicants interested in Ringling positions; yet, current volunteers also feel they provide benefits to the museum. They are interested and eager to learn more for themselves and to assist visitors with meaningful museum visits. The demographic information on the survey confirmed that baby boomers are participating and through the on-site interviews, they want to contribute their expertise. Further research into the baby boomer participation at the Ringling

could be beneficial. Already staff are trying to recruit boomers, while balancing the interests and needs of the generation ahead of them. Finding alternative ways for older adults from the traditionalist generation are also needed; staff members are trying to identify new roles and future directions for their large volunteer corps.

Recommendations

At the time of writing, analyses and subsequent recommendations are still in process; however, short-term and longer-term goals have surfaced. First, volunteers enjoyed having the opportunity to provide feedback. In return, a compilation of findings (executive summaries, presentations, or newsletter articles) will be prepared for them. The interest in providing feedback and input reflects developments already underway by the Education and Volunteer Services Department, such as bi-annual interviews with members of the docent corps and volunteer advisor committees. Next steps will include further surveys to delve more deeply into the volunteer experience, particularly guided by new research on baby boomer participation and transitioning older volunteers to roles that better support health changes, such as reduced physical and cognitive capabilities.

Museum staff members acknowledge the rapidly changing environment of the Ringling Museum and are eager to explore further questions related to serving not only volunteers, but also visitors. The questions related to gallery interpretation methods are of continued interest to staff as the museum expands, with a new wing for Asian art and an upcoming reinstallation of the permanent collections.

NOTES

1. The online survey was constructed using Qualtrics through Florida State University.

2. Initially, the researcher drafted a couple of questions that required the survey respondents to rank statements in order and to click and drag statements into categories. Although this varied question types, museum staff felt the survey should have a simple structure for ease of use.

3. To learn more about the completed analysis, findings, and recommendations, please contact the authors at ann.rowson@fsu.edu and maureen.zaremba@ringling.org.

4. Two volunteers had to cancel their on-site interview sessions.

5. Docents give guided tours of museum venues including the Art Museum, Cà d'Zan, and Circus Museum. A new gardens tour option led by docents was recently added. Ringling ambassadors greet visitors at the Visitors Pavillion, where all visitors enter the museum campus, and at each museum venue. Tram operators provide transportation to each venue. Theater ushers assist with all programming at the Historic Asolo Theater. Special events assistants help with public programming events.

6. In 2000, the Ringling became part of The Florida State University. Since then, more structured volunteer corps management includes a more thorough background screening and interviewing process.

REFERENCES

Anderson, N. D., Damianakis, T., Kröger, E., Wagner, L. M., Dawson. D. R., Binns, M. A., Bernstein, S., Caspi, E., & Cook, S. L. (2014). The benefits associated with volunteering among seniors: A critical review of recommendations for future research. *Psychological Bulletin 140*(6), 1505-1533.

Corporation for National & Community Service (2012). Health benefits of volunteering for older Americans: A review of recent research. Retrieved from http://www.nationalservice.gov/pdf/healthbenefits_factsheet.pdf.

Johnson, L., Becker, S. A., & Freeman, A. *The NMC Horizon Report: 2013 Museum Edition.* Austin: The New Media Consortium, 2013.

Merritt, E. (2014). *Trendswatch 2014.* Washington, DC: American Alliance of Museums.

National Endowment for the Arts. *How a nation engages with art: Highlights from the 2012 survey of public participation in the arts.* Washington, DC: NEA, 2014.

Population Reference Bureau (2011). *Volunteering and health for aging populations. Today's Research on aging: Program and policy implications, 21.* Retrieved from http://www.prb.org/pdf11/TodaysResearchAging21.pdf.

APPENDIX: VOLUNTEER SURVEY

FLORIDA STATE UNIVERSITY

Ringling Volunteer Survey

Please indicate all of your current volunteer roles at The Ringling. (Check all that apply.)

- ☐ Gardens Assistant (1)
- ☐ Archives Assistant (2)
- ☐ Painter (3)
- ☐ Special Projects-Circus/Archives (4)
- ☐ Wood Carver (5)
- ☐ Department Assistant-Conservation (6)
- ☐ Department Assistant-Curatorial (7)
- ☐ Department Assistant-Preparation (8)
- ☐ Department Assistant-Registration (9)
- ☐ Department Assistant-Development (10)
- ☐ Department Assistant-Education (11)
- ☐ Docent Advisory Council (12)
- ☐ Docent (any venue) (13)
- ☐ Family Programs Volunteer (14)
- ☐ Special Events Assistant (15)
- ☐ Department Assistant-solo Theater (16)
- ☐ Usher (17)
- ☐ Department Assistant-Library (18)
- ☐ Community Outreach (19)
- ☐ Department Assistant-Marketing (20)
- ☐ Media Escort (21)
- ☐ Membership Advocate (22)
- ☐ Museum Store Customer Assistant (23)
- ☐ Ringling Ambassador (24)
- ☐ Tram Operator (25)
- ☐ Department Assistant-Volunteer Services (26)
- ☐ Volunteer Services Advisory Council (27)

Consider your reasons for volunteering at The Ringling. Please rate the factors that motivate you to volunteer.

	Not at all Important (1)	Somewhat Important (2)	Neutral (3)	Important (4)	Very Important (5)	Extremely Important (6)
To use my life skills and experience as a volunteer (1)	☐	☐	☐	☐	☐	☐
To serve my community (2)	☐	☐	☐	☐	☐	☐
To attend performances at the Historic Asolo Theater as an usher (3)	☐	☐	☐	☐	☐	☐
To fulfill a requirement for school, employer, or other agency/organization (4)	☐	☐	☐	☐	☐	☐
To occupy my free time (5)	☐	☐	☐	☐	☐	☐
To meet new people and expand my social circle (6)	☐	☐	☐	☐	☐	☐
To provide a sense of personal accomplishment (7)	☐	☐	☐	☐	☐	☐
To further my involvement with the arts (8)	☐	☐	☐	☐	☐	☐
To expand my love of learning (9)	☐	☐	☐	☐	☐	☐
To explore my creative side (10)	☐	☐	☐	☐	☐	☐
To meet people from around the nation and the world (11)	☐	☐	☐	☐	☐	☐
To share my expertise with others (12)	☐	☐	☐	☐	☐	☐
To build pride in my community (13)	☐	☐	☐	☐	☐	☐
To engage in physical activity (14)	☐	☐	☐	☐	☐	☐
To foster mental sharpness (15)	☐	☐	☐	☐	☐	☐
To help visitors understand the history and relevance of the museum (16)	☐	☐	☐	☐	☐	☐

Please share your opinion about your overall volunteer experience with The Ringling. Please rate the following statements:

	Strongly Disagree (1)	Disagree Somewhat (2)	Nuetral (3)	Agree Somewhat (4)	Strongly Agree (5)
I feel valued by the staff (1)	☐	☐	☐	☐	☐
I am energized and enthusiastic about my experience (2)	☐	☐	☐	☐	☐
I have the support and training needed to fulfill my volunteer role (3)	☐	☐	☐	☐	☐
I continue to learn as a Ringling volunteer (4)	☐	☐	☐	☐	☐
I use my skills and abilities doing meaningful work (5)	☐	☐	☐	☐	☐
I have developed new job-related skills (6)	☐	☐	☐	☐	☐
I would like to explore different/additional volunteer responsibilities (7)	☐	☐	☐	☐	☐
I would recommend volunteering at the Ringling to a friend (8)	☐	☐	☐	☐	☐
I am fulfilled and satisfied (9)	☐	☐	☐	☐	☐
The Ringling is an excellent place to volunteer (10)	☐	☐	☐	☐	☐

Please rate your level of proficiency with each task or technology.

	Not Proficient (1)	Somewhat Proficient (2)	Proficient (3)	Very Proficient (4)	Highly Proficient (5)
Basic personal computer (1)	☐	☐	☐	☐	☐
Email and internet usage (2)	☐	☐	☐	☐	☐
Microsoft Word (3)	☐	☐	☐	☐	☐
Microsoft Powerpoint (designing presentations) (4)	☐	☐	☐	☐	☐
Microsoft Excel (data management & spreadsheets) (5)	☐	☐	☐	☐	☐
Document layout & design (6)	☐	☐	☐	☐	☐
Adobe Photoshop/Graphic design (7)	☐	☐	☐	☐	☐
Audio/Visual equipment (projectors, SMART board, etc...) (8)	☐	☐	☐	☐	☐
iPod (audio tour) (9)	☐	☐	☐	☐	☐
Smart phone (10)	☐	☐	☐	☐	☐
Social media (Facebook, Instagram, Twitter, Flikr, You Tube...) (11)	☐	☐	☐	☐	☐
iPad/Tablet (12)	☐	☐	☐	☐	☐
Interactive e-book (13)	☐	☐	☐	☐	☐
Mobile apps (14)	☐	☐	☐	☐	☐
Google Maps/GPS mapping (15)	☐	☐	☐	☐	☐

Please rate your interest in receiving training on each task or technology.

	Not at all Interested (1)	Somewhat Interested (2)	Nuetral (3)	Interested (4)	Very Interested (5)
Basic personal computer (1)	☐	☐	☐	☐	☐
Email and internet usage (2)	☐	☐	☐	☐	☐
Microsoft Word (3)	☐	☐	☐	☐	☐
Microsoft Powerpoint (designing presentations) (4)	☐	☐	☐	☐	☐
Microsoft Excel (data management & spreadsheets) (5)	☐	☐	☐	☐	☐
Document layout & design (6)	☐	☐	☐	☐	☐
Adobe Photoshop/Graphic design (7)	☐	☐	☐	☐	☐
Audio/Visual equipment (projectors, SMART board, etc...) (8)	☐	☐	☐	☐	☐

Please rate the importance of perks provided to eligible volunteers.

	Not at all Important (1)	Somewhat Important (2)	Neutral (3)	Important (4)	Very Important (5)
Member-for-a-day passes for hours served (1)	☐	☐	☐	☐	☐
Discount at Museum Store (2)	☐	☐	☐	☐	☐
Discount at restaurants (3)	☐	☐	☐	☐	☐
Annual volunteer recognition/appreciation events (4)	☐	☐	☐	☐	☐
Museum Store gift certificate (5)	☐	☐	☐	☐	☐
Cards, letters, and other acknowledgments from staff (6)	☐	☐	☐	☐	☐
25% discount on any level of museum membership (7)	☐	☐	☐	☐	☐
Free general admission to The Ringling for active volunteers with an ID badge (8)	☐	☐	☐	☐	☐
Lifetime Service Hours badge (9)	☐	☐	☐	☐	☐

What would enhance your volunteer experience with The Ringling? (Check all that apply.)

- More opportunities for training in my current volunteer role (1)
- More "on the job" feedback and evaluation (2)
- More scheduled social activities for volunteers (3)
- It is rewarding and enjoyable as it is (4)

Please rate your preferred methods of communication from staff.

	Not at all Useful (1)	Somewhat Useful (2)	Neutral (3)	Useful (4)	Very Useful (5)
Volunteer Meetings (InfoSessions, trainings, Recognition Event...) (1)	☐	☐	☐	☐	☐
Volunteer newsletters (2)	☐	☐	☐	☐	☐
Publications (Members Magazine) (3)	☐	☐	☐	☐	☐
Email (4)	☐	☐	☐	☐	☐
Postal mail (5)	☐	☐	☐	☐	☐
Ringling Museum website (6)	☐	☐	☐	☐	☐
VICky (7)	☐	☐	☐	☐	☐
Blackboard (8)	☐	☐	☐	☐	☐
Facebook pages/posts (9)	☐	☐	☐	☐	☐

Apart from the training received during the initial orientation, what additional training do you feel would help you or your fellow volunteers? (Check all that apply.)
☐ Tram safety (1)
☐ Customer service (2)
☐ Diversity and cultural differences (3)
☐ Assisting visitors with special needs (4)
☐ Gallery interpretation strategies (5)
☐ Using digital technologies in the galleries (smart phones, iPads/Tablets, touch screens...) (6)
☐ Faciltating Interactive experiences in the galleries (7)

What historical subjects are you interested in learning more about? (Check all that apply.)
☐ Art history/art appreciation (1)
☐ Bayfront gardens and grounds (2)
☐ Circus history (3)
☐ Asolo Theater history (4)
☐ Ringling family history (5)

How do you most like to interact with art/artifacts when you visit museums? (Select one statement.)
☐ I like little to no information so I can focus on the aesthetic qualities of the object (1)
☐ I like to read short labels (2)
☐ I like to read in-depth labels (3)
☐ I like gallery brochures/handouts (4)
☐ I like digital interactives (touch screens, mobile apps, e-books...) (5)
☐ I like audio tours (6)
☐ I like video/multimedia (7)
☐ I like docent-led tours (8)
☐ I like curator-led tours or gallery talks (9)
☐ I like visitor guides (booklets) (10)
☐ I like family guides/kids activities (11)
☐ I like creative activities (make something in the gallery, DIY...) (12)
☐ I like games (13)
☐ Other (type in below) (14) _____

What gallery interpretation methods do you think museum visitors would most enjoy. (Select one statement.)
- ☐ Little to no information to focus on the object itself (1)
- ☐ Short labels (2)
- ☐ In-depth labels (3)
- ☐ Gallery brochures/handouts (4)
- ☐ Digital interactives (touch screens, mobile apps, e-books) (5)
- ☐ Audio tours (6)
- ☐ Video/multimedia (7)
- ☐ Docent-led tours (8)
- ☐ Curator-led tours or gallery talks (9)
- ☐ Visitor guides (booklets) (10)
- ☐ Family guides/kids activities (11)
- ☐ Creative activities (make something in the gallery, DIY...) (12)
- ☐ Games (13)
- ☐ Other (type in below) (14) _____

Share one of your most memorable experiences as a Ringling volunteer:

Q19 Share one of your favorite encounters about an interaction with a museum visitor or group of visitors:

What kinds of questions do museum visitors ask you most often? (Select one.)

☐ How to find the way (example: How far is it to the Ca d'Zan?) (1)

☐ What to be sure to see during the visit (example: What are your personal suggestions about what we see today?) (2)

☐ Restaurant suggestions (examples: What restaurants are at the Ringling? What's a good restaurant in Sarasota?) (3)

☐ Historical information (examples: Who were John and Mable Ringling? What time period is this painting from? Who made this?) (4)

☐ Identification information (examples: What type of tree is this? Which venue is this?) (5)

☐ Duration of the visit (example: How long does it take to visit all the venues?) (6)

☐ Touring options (examples: Do you have tour guides? Are there audio guides? Do you have a Ringling app?) (7)

☐ Family/children's activities (examples: Are there things for kids at the art museum? Is there a play space?) (8)

☐ Considerations for special needs (examples: Are all venues wheelchair accessible? How do we catch a tram? Are there braille or low-vision label copies? (9)

 ☐ Other (type in below) (10) _____

Which of the following museum visitor groups do you interact with most often? (Select one.)

- ☐ Individuals (1)
- ☐ Couples (2)
- ☐ Family groups (3)
- ☐ Adult groups (4)
- ☐ Tourist groups (5)
- ☐ School groups (6)
- ☐ Other (7)
- ☐ I can't say for sure (8)

Which of the following museum visitors do you encounter most? (Select one.)

- ☐ Year-round community residents (1)
- ☐ Seasonal community residents (2)
- ☐ Florida tourists (3)
- ☐ US tourists (4)
- ☐ International tourists (5)

Please tell us your gender:

- ☐ Male (1)
- ☐ Female (2)

My age-range is:

- ☐ 18-34 (1)
- ☐ 35-54 (2)
- ☐ 55-64 (3)
- ☐ 65-74 (4)
- ☐ 75-84 (5)
- ☐ 85+ (6)

This is an anonymous survey; however, we would like to know a little more about you. The following section is OPTIONAL.

What is your cultural/racial identity?

How many years have you been an active Ringling volunteer?

How many hours on average per month do you volunteer?

How can The Ringling improve your volunteer experience?

Please feel free to share any additional comments:

If you would like to leave your name, please feel free to do so. (This option is confidential.)

CHANGING ROOMS: THE VOLUNTEER CONTRIBUTION AT MONTACUTE HOUSE

Sonja Power

MONTACUTE HOUSE IN Somerset was transferred to the National Trust in 1931 by the Society for the Protection of Ancient Buildings as an outstanding surviving example of an Elizabethan period house. Empty of contents, the house has been furnished in the style of a gentleman's residence through the contribution of its supporters, by donation, bequest, transfer, loan and gift. It is open to visitors during the summer and at weekends in the winter, staffed mainly by volunteer room guides. This case study looks at the organisational response to the increasing difficulties in recruiting enough volunteers to meet staffing requirements and shows how the volunteering experience improved at Montacute House as a result of work undertaken by a group of volunteers in developing the heritage offer.

There are between 120 and 160 volunteer room guides at any one time. Most of these volunteers are retired people, coming from a 20-mile area around the house. Aged between 55 and 85, most are white and from socio-economic groups BC1&2 (British NRS social grades): retired or semi-retired professionals. Until 2014, volunteers at the house carried out the tasks of the traditional room guide or steward during open hours in the rooms of the house accessible to visitors. This role primarily deployed to guard against the theft or vandalism of the collection and house, to safely evacuate visitors in the event of an emergency and to help visitors with their questions about the property and chattels. A small number helped the staff of five (three full-time and two seasonal) with preventive conservation tasks. Every additional room that was opened for visitors required another room guide. As a result, fifteen volunteers were needed daily to staff the rooms for the six hours that the

house was open. There had never been a comprehensive review of volunteering at the house.

It has become increasingly difficult to recruit and sustain the numbers of volunteers needed to open the house. Research carried out by the National Trust indicates that people want to commit their time on a more flexible and short-term basis. This is emerging as a common issue and is influenced by broader social trends like the economic downturn and the nature of retirement. Potential volunteers can choose from an eclectic range of volunteering opportunities made much more accessible through digital and social media. The appeal of volunteering for the National Trust as a traditional room steward is waning – during recruitment people have indicated that they do not want to spend their free time standing in rooms, silently guarding national heritage. People want to volunteer on their terms, committing their time as quid pro quo, for example offering to volunteer for a finite period for specific work experience. In addition, organisational initiatives like the extension of opening hours calls for yet more room guides. At Montacute, these changes manifested in shortages of room guides and consequently rooms that were closed and inaccessible to visitors.

In response to these difficulties, the National Trust initiated a project called Changing Rooms to look at alternatives to the traditional room guide role with aims to make volunteering and visiting more enjoyable. Supported by a team of in-house conservators, curators, compliance consultants, visitor service and volunteering specialists, the initiative was taken out to four National Trust properties, of which Montacute House was one. Here, a group of five volunteers was recruited and with two staff members (House and Collections

Manager and Learning Officer) had the task of finding a new way of opening the house with volunteers. Based on the life and work experience they brought to the table and their ambitions for the property, they conceived and crafted a three-pronged proposal: to redefine the volunteer role in the house, identify and establish a new approach to training and to develop costumed interpretation. Their aim was to change the volunteering roles from traditional room guides to the three new roles of Heritage Guardians, Welcomers and Hosts. The roles were defined by their functions, so the Heritage Guardians continued in the role of warder, looking after chattels under existing terms of individual loan agreements and government indemnity conditions. The Welcomers did just that – received visitors in the Great Hall, orientated them, gave some introduction to the house and passed visitors with specific interests on to the Hosts who delivered talks, tours and demonstrations.

The Changing Rooms group chose to pilot the new approach on two days of the week in order to test its effectiveness before rolling it out fully. From March 2014 until November 2014, the Changing Rooms days were Fridays and Sundays, days chosen for their different group dynamic and visitor profiles. This period of testing was considered significant in allowing time to adjust to new ways of working and to develop confidence and capacity among the new teams. Volunteers underwent training to build knowledge, skills and confidence to be able to operate in the new roles. Priority was given to story-telling training, specialist subject training in areas relevant to the house, its themes, spirit of place and its collection and coaching to develop practical handling skills for demonstration purposes.

The new group reduced the number of volunteers necessary to open the house from fifteen to seven, with an ideal number of twelve, by mitigating the security risks to the collection and to visitors. Previously rotas had been planned months in advance; the group now trialed more informal and less structured ways of deployment. They wanted to enable room guides to move from role to role during their sessions, to take longer or shorter breaks, to work two hours, four hours or six hours. They encouraged room guides to communicate more with each other to make these arrangements, instead of relying on ones which had been made for them. The role of room guide was liberated from its anchor points – the rooms – and became responsive instead to visitors. On Good Friday, 18 April 2014, the house was opened to over 700 visitors with just seven volunteers. A daunting task at the beginning of the day, this proved to be exhausting, exhilarating and enjoyable based on the comments of those seven volunteers during the course of the day. Positive feedback was recorded on the National Trust visitor survey too.[1] The volunteer survey conducted in September 2014, showed a rise of 3% in volunteer enjoyment over the previous year, an unexpected result in view of past patterns of volunteer response to change.[2]

The volunteer contribution to the planning and delivery of the Changing Rooms project is evident, but how did the age profile of Montacute House volunteers shape the new offer? When considering how their age is perceived by visitors, the initial response of volunteers is defensive. One volunteer responded, "It seems that older retired people are much the stereotype for the National Trust property at Montacute and other properties."[3] But another Changing Rooms group member is

pragmatic, "Of course life is such that younger people do not have the time nor the inclination to devote their leisure to such activities."[4] Older volunteers have had time to acquire the skills and experience on which to draw in order to engage with individual visitors and to contribute to the work of developing the heritage offer. The Changing Rooms group members brought with them experience, skills and knowledge from the fields of healthcare, teaching, IT, social work and design and were able to apply these abilities to the requirements of the project. As another group member suggests: "Enjoyment of the house and its collections is generated by the experience and knowledge of the volunteer not their age."[5]

People are motivated to become volunteers for a wide range of reasons; one of these is to satisfy a need to continue patterns set by working life including keeping occupied and being with others. The decision to volunteer frequently comes out of a life-changing situation – retirement or bereavement, for example, and is shaped by a current interest. Coupled with social and interpersonal skills these motivations brought valuable experience to planning the development of the offer at the house. The experience of older volunteers helped to identify and support good practice and behaviours and was characterised by confidence in testing accepted processes and encouraging holistic, pan-disciplinary working.

Based on their life and work experience, the volunteers' contributions resonated with their own particular interests, hobbies and skills. There is no doubt that the efficacy and relevance of their contribution relied on good working relationships between both the volunteers themselves and the staff; effective and frequent communication was crucial to this.

Honesty was vital and sometimes painful to acquire at the beginning of the project when some volunteers were fearful of and resistant to change. Trust emerged out of the process and this went far in producing positive ways of working together.

After a year of planning and testing the new approach, the volunteers at the house are now actively involved at both strategic and operational levels, creating, establishing and using new ways of volunteering that are enjoyable, rewarding and sustainable. The current offer at Montacute House has been enhanced by the correlation between the age of its volunteers and the experience they bring. Trained, skilled, confident and engaged guides enjoy their role at the house and help visitors enjoy their time there too.

Questions emerging from the Changing Rooms experience at Montacute are around the dependence of the offer on the particular skill set and dynamic of a volunteer cohort and how much intervention and support may be needed to deliver the offer within organisational parameters. At the very best, as a Changing Rooms volunteer puts it, "If an organisation looks and asks, it will find a volunteer to do almost anything", especially if the volunteer is at the heart of its organisational processes.[6]

Working with older volunteers gave the Changing Rooms project at Montacute House an identity of its own. Involving them from the outset meant that they owned and supported it, democratising the way of working in the house. Before the process began, we identified those volunteers with transferable skills from their life and work experience – it was important to the success of the project that the volunteers were prepared to deploy these on our behalf. We found that older volunteers

had clearly defined expectations based on their own experience of working, so it was crucial to communicate effectively and be transparent about our ambition. We met often and regularly throughout the period, both formally as the project team and informally during the normal course of volunteering. Timescales were prioritised in the training element of the project. We realised early on that our volunteers needed longer notice for training sessions and meetings due to other retirement commitments. The main motivation for volunteers to contribute their time to the National Trust was social, so it was important to foster and build on collaborative working through group dynamics. Instead of starting with the house and collection when reviewing the volunteering model, we reversed this, beginning with the volunteers and building the Changing Rooms model from their point of view.

NOTES

1. *Montacute House.* National Trust Visitor Survey, 18 April 2014.

2. *South Somerset, Montacute House.* National Trust Volunteer Surveys, 2011-2014.

3. R. Wicks, personal communication, 7 January 2015.

4. M. Dove, personal communication, 29 December 2015.

5. B. Webber, personal communication, 30 December 2014.

6. B. Webber, personal communication, 30 December 2014.

A BLIND DATE WITH SCULPTURES: OLDER PEOPLE AS CONTRIBUTORS IN ART PROGRAMS

Sybille Kastner

WELL-KNOWN THROUGHOUT Europe for its outstanding collection of modern international sculpture, the Lehmbruck Museum offers an unusual combination of exceptional architecture placed in a sculpture park, as well as sculpture sited within the urban environs. Besides the lifework of Wilhelm Lehmbruck, the collection of international sculpture and modern object art represents the centerpiece of the museum's collection. It is complemented by sections on painting, graphics, photography and new media.[1]

The Lehmbruck Museum in Duisburg, Germany has a long tradition of programs for adults, youth, children and people with special needs. Starting in 2007, it has included a special offer for people with dementia and their caregivers. Since 2012, the Institute ISER/Medical School Hamburg and the Lehmbruck Museum, have worked together on a model for social participation of people with dementia in museums as part of a research project.[2]

Against this background of experience, the desire for a wider format of programs for elderly people came up, aimed at seniors integrating their expertise and making it visible. The impetus for a new exhibition idea was that in the context of demographic change in Germany and Europe it will be necessary for museums to develop a wider range of forward-looking, innovative and attractive programs for older visitors. Especially in the field of art, intergenerational projects offer an opportunity to benefit from each other's skills, experience and talents: for example, experience with digital tools, differing perspectives on art, or views on being young or old.

FIG.1: Trying out things together: an intergenerational encounter.

It started with an experiment

With *Hey Alter...!* (informal German: Hey old fellow!) the Lehmbruck Museum grasped the initiative in December 2012 by creating an exhibition with intergenerational impact. It showed different artistic positions on youth and age – both contemporary art and works of art from the museum collection. The exhibition presented videos, installations, sculptures, paintings and photography. The project was planned to reflect demographic change and to be a testing ground to encourage the involvement of older visitors by giving them the opportunity to contribute. The project was innovative and its combination of high-level art exhibition and intergenerational exchange has been unique so far across Europe.

The project focused on an intergenerational exchange and encounter between the target groups and was stimulated by a special education program. It encouraged the development of an individual position and the possibility of new perspectives on being young or growing old. The program was based on an interactive experience. Two focus groups were formed, in which interested younger and older visitors were prepared for the exhibition before they got involved as actors in the exhibition, taking roles as mediator or advisor. At weekends, they enriched the museum as *Cicerones*, which means that they provided information about the exhibition to visitors who asked them. They had interesting conversations or encouraged visitors to try something in the show – for example a digital drawing and projection tool, a *TagTool*. They also became an important impetus in the mediation of *BLIND DATES* – guided tours in which two generations met each other for the first time.

FIG. 2: BLIND DATE: a discussion about age.

The project *Hey Alter...!* was an experiment and offered the chance to try out many things with the target groups. Some of them failed, others turned out to be very good and empowering. During the exhibition, space was provided for open questions on the subject of age, a discussion which has just begun in German museums. The project has sensitized museum staff to focus on older visitors as a target group – it was a big challenge for press and marketing too. Years of dedicated work had focused on younger audiences with little emphasis on the elderly. Fear of aging is omnipresent in cultural institutions. They ogle at the young "hip" audience that exudes more "glamour" and "sexiness" – maybe because it's better for the marketing and maybe it's also a kind of personal defense. This exhibition changed perspectives and so paved the way for new projects in which education programs, practical aesthetic experiences, and new media will all play a role.

A wide range of things for *Artgenossen* to do

Many of the older museum visitors who actively participated in the exhibition *Hey Alter...!* continued as contributors. The nature of their involvement is self-determined. They founded a group and called themselves *Artgenossen* (art experts) and now enrich the museum's educational work. In 2014, the exhibition won second prize in the Robert Bosch Foundation's German Senior Citizens' Awards in 2014.[3]

A detailed evaluation now disseminates the lessons learned to other cultural institutions.[4] The exhibition convincingly demonstrated how museums can be places of communication which trigger intergenerational discourse and contribute to changing images of ageing.

FIG 3: Listening to the Generation Guide.

The most successful intergenerational aspect of the exhibition, *BLIND DATE*, now enriches the museum's education programs. These special tours establish the museum as a place of active participation for the elderly and has been extended to temporary exhibitions such as *Taking a Stand Against War*, which commemorates the outbreak of the First World War. In front of a work of art there are many reasons to start a conversation and it is exciting and interesting for young and old visitors to learn more about the other generation's perspective. Both groups' views on art and war are influenced by very different experiences.

How does it work? A professional art educator initiates the moderation at the outset of a tour by introducing the *Artgenossen* and outlines the idea of the exhibition. Then she or he helps to form groups through the selection of photocopies of the exhibits. The *Artgenossen* have already made their own choice before the tour starts. Discussions then start in small groups of mixed ages. There is enough time and space for everyone, for individual ideas and conclusions – and shy students benefit enormously from this intimate environment. Because the *Artgenossen* are not experts in the field of art, it is easier for the younger generation to participate unhesitatingly in the discussions. On the other hand, the older participants are very interested in the opinions and feelings of the younger people. The encounter becomes particularly interesting and stimulating when personal experiences are revealed. In the exhibition, *Taking a Stand Against War*, both old and young spoke about their own war experiences, often very touching for the group. The BLIND DATE finishes with a mutual presentation on the exhibition.

FIG. 4: Art reception for people with dementia – having a good time with art.

An unusual perspective on art with the Generation Guide

For the 50th anniversary of the Lehmbruck Museum, eleventh grade students and the *Artgenossen* developed an audio-tour on the key works of the sculptor Wilhelm Lehmbruck. With this Generation Guide, visitors can follow inspiring conversations between younger and older people in front of fourteen key sculptures. Art lovers of two generations share their personal views on works of art, revealing different and sometimes unusual perspectives. For the listener, the conversations are inspiring and enriching and contribute to a better understanding of the sculptures. The Generation Guide is used by people of all ages, even those who have never used an iPod or smartphone before. The app is available for free download on iTunes.[5]

A good atmosphere for people with dementia

Not all the *Artgenossen* continued to be involved in intergenerational projects – some chose to support the museum's tours for people with dementia and their caregivers. They contribute significantly to the good atmosphere which is very important for the target group and so they help maintain the success of these events. They lend a hand when a chair is needed, or accompany a visitor who is restless and prefers not to stay with the group but instead explores the museum on their own. During discussions they can encourage those participants who want to say something, although it may only be a short exchange – or just between two people. They do not assume the role of a leader, instead allowing participants their own space to comment or contribute.

The *Artgenossen* who help with these tours undergo special training which enables them to feel comfortable in their

FIG. 5: Older people add value and increase the attractiveness of museums.

role and to enjoy dealing constructively with the challenge of dementia. Most of them are familiar with it in their own environment.

The concept of generation encounter works well and it's fun. It takes time to build up, establish and maintain programs with older people as contributors and sometimes it is a hurdle race, but demographic change requires new strategies.

NOTES

1. www.lehmbruckmuseum.de.

2. International Institute for Subjective Research and Experience in cooperation with the Medical School Hamburg. http://www.i-ser.de/en/projects.php.

3. Robert Bosch Stiftung. http://www.bosch-stiftung.de/content/language1/html/57278.asp.

4. kubia-Kompetenzzentrum für Kultur und Bildung im Alter. http://ibk-kubia.de/angebote/publikationen/hey-alter...!/.

5. https://itunes.apple.com/de/app/generation-guide-lehmbruck/id881382905?mt=8.

THE MATERIAL CULTURE AND MEMORIES OF MANUFACTURING MELBOURNE

Fiona Kinsey and Liza Dale-Hallett

VOLUNTEERS HAVE BEEN a key resource in processing and interpreting two significant industrial heritage collections at Museum Victoria, a large, multi-disciplinary and multi-campus museum in Melbourne, Australia. The H. V. McKay Sunshine Collection and the Kodak Heritage Collection both tell important stories of manufacturing in Melbourne. The McKay Collection has enjoyed the attention of a dedicated volunteer team for almost 20 years, while the Kodak Heritage Collection has had a core team of volunteers for about ten years. The volunteer cohort for these collections has largely consisted of former company staff, who bring a unique expertise and intimate understanding of the companies. These volunteer programs have created significant benefits to the broader community in terms of intellectual and digital access to material, as well as nourishing the lives of the volunteers in multiple ways.

The two volunteer teams are just part of the broader volunteer group at Museum Victoria, which has an extensive volunteer program managed by a full-time co-ordinator. There are currently around 530 active volunteers. The History and Technology Collections benefit from the expertise of around 55 volunteers, who provide thousands of hours of work each year assisting the collection managers and curators.

The McKay and Kodak collections

The H. V. McKay Sunshine Collection tells the extraordinary story of the "energy, vision and pluck" of Hugh Victor McKay. At eighteen he built a stripper harvester prototype and went on to create the largest manufacturing enterprise in the Southern Hemisphere, which made agricultural machinery in Sunshine, Melbourne. The stories captured in this collection have been

fundamental in shaping Australia and Australian identity, and they have national and international significance. The H. V. McKay Sunshine Collection consists of 28,000 images, 750 films, nearly 500 artefacts, 43 metres of archives, over 10,000 trade and marketing publications, oral histories and 47,000 product plans. The collection is one of the most significant industrial heritage collections in Australia.

The Kodak Heritage Collection charts the history of the Melbourne-based photographic supplies company Kodak Australasia Pty Ltd, from 1908 until the early 21st century. It also records its precursor company Baker & Rouse and its important contribution to the local photographic industry, in particular Thomas Baker's pioneering photographic goods manufacturing and J. J. Rouse's entrepreneurial marketing. The collection extensively documents the manufacturing and marketing of the equipment and products involved in the now largely obsolete silver halide photographic process. There are over 10,000 images in a variety of formats; hundreds of films and videos; thousands of trade literature, sales and marketing documents; hundreds of business archive documents; hundreds of Kodak products and factory working life artefacts; and 47 oral history interviews with former staff. It is a highly significant industrial heritage collection that is also part of a small global network of other corporate Kodak collections, that have been preserved in heritage institutions in the UK, USA and Canada.

As large, comprehensive collections with diverse artefacts, the H. V. McKay Sunshine and Kodak Heritage Collections both tell rich and layered stories about important historical themes. They have, not surprisingly, attracted interest from scholars, curators, artists, genealogists and the media in Australia and

around the world, and collection material has been drawn on for exhibition and publication.

Volunteers creating and curating collections

The development of the McKay and Kodak Collections into such important historical resources has been underpinned by the critical contribution of current and former company staff at all stages in the museum's processing of the collections – from acquisition and registration to interpretation and promotion. The McKay and Kodak volunteer teams have offered substantial expertise and knowledge and have actively participated in shaping and interpreting these collections – they are co-producers and co-curators. Thus, the story of these collections is also the story of people – in particular the volunteers who have brought these collections to life. The first story is of those who facilitated the acquisition and preservation of the collections in partnership with Museum Victoria.

Acquisition and preservation

The bulk of the H. V. McKay Sunshine Collection was the result of the clandestine work of two employees. In 1991, an astute Sunshine employee, Ken Porter, secretly rescued nearly 100 years of history of the McKay manufacturing enterprise from a dump-master. With the help of a trusted colleague, this "rubbish" was squirrelled away and in 1994 was offered to Museum Victoria with the formal support of the company.

In contrast, the acquisition of material from Kodak Australasia was, from its very beginnings, officially sanctioned and supported, although it too was heavily reliant on a staff member – in this case Kodak's senior legal counsel Kate

FIG. 1: H. V. McKay *General Implement Catalogue*, c.1906.
[TL 002358 – Museum Victoria Collection.]

Metcalf, who had archaeological training in addition to her legal background. When Museum Victoria curator Fiona Kinsey contacted the company about acquiring material after hearing of the factory's imminent closure, she discovered that Kate, with the backing of management, had already arranged to save the company's heritage by locating and storing as much historical material as possible in an empty warehouse at the factory.

Kate also enlisted a volunteer team of former Kodak staff to help the museum identify and select significant material for acquisition from the large warehouse of accumulated items. Even though Kate has now left the company, she, along with other key former executive staff, has maintained high level support for the collection. Kodak Australasia has also continued a supportive relationship with Museum Victoria, including providing some financial patronage for the collection, despite an evolving executive team since the closure of its factory.

Research, registration and interpretation work

Despite their very different beginnings and the divergent levels of corporate commitment to the collections, both the H. V. McKay Sunshine Collection and the Kodak Heritage Collection share one important characteristic – the involvement of enthusiastic, expert and dedicated volunteers who once worked for these two companies.

In terms of the H. V. McKay Sunshine Collection, in 1996 Ken Porter, the employee who had spearheaded the collection's rescue, conscripted the expert assistance of over 20 ex-employees to help identify and document it. They represented an accumulated company experience and knowledge base of over 800 years. These volunteers provided the expertise and

FIG. 2: Kodak Australasia Pty Ltd Factory, Coburg, c.1965.
[MM 98743 – Museum Victoria Collection.]

energy to sustain the project for almost 20 years. Ken Porter also secured input from some 200 ex-employees across Australia, who helped with identification and documentation and wrote a number of essays on the operations of the company.

Drawing on the initial Kodak volunteer team put together by Kate Metcalf, the museum has developed a core team of some ten key people with engineering, manufacturing and executive backgrounds, who are involved in documenting the Kodak Heritage Collection. More than 140 others have been involved in the oral history program, some of whom continue to be called on to answer research queries.

The McKay and Kodak volunteers have participated in a range of tasks including helping with the initial selection, assessment and sorting of the collections; identifying and documenting the collections; registration; creating company timelines; providing technical descriptions of factory operations and products; documenting marketing campaigns; responding to public enquiries; describing the interior of the factory departments; writing essays on the experience of working with the company; and promoting the collections through lectures and presentations. Many of the volunteers also contributed directly to the collections by being the subject of oral history interviews and by donating personal items.

The methodology of the two volunteer collection projects varies. The H. V. McKay Sunshine volunteers typically meet once a week at the museum, to work through the documentation of the collection. The larger group of Sunshine contributors across Australia work from their homes and send information, expert advice and essays via mail, email and phone. In contrast, the Kodak Heritage Collection volunteers

were already an active social entity of retirees who integrate some of their volunteer work into their existing schedule of retiree lunches and catch-ups where they discuss and identify the content of historic photographs, with occasional visits into the collection store to look at artefacts and discuss the project.

Old hierarchies of workplace relationships were sometimes invoked in the volunteer groups, with former managers often co-ordinating the teams. For example, the lead volunteer for the McKay collection, Ken Porter, was easily able to identify and link across Australia to ex-employees, as his previous role as Transport Manager meant he knew many people across the organisation. Similarly, in the case of Kodak, two popular and influential former executives who had volunteered from the beginning were subsequently able to encourage many of their former colleagues to participate, while a former engineering manager became a natural leader for a team of retired engineers who contributed their expertise describing and dating the technology and activities depicted in photographs.

The challenges of volunteer projects

These two projects are large, complex and long-term – and inevitably they also have presented significant challenges to the museum, including developing representative historical narratives, managing an ageing volunteer cohort and matching institutional capacity to community expectations.

These two company histories inevitably have been, and will continue to be, shaped by the characteristics of their community contributors. Both the Kodak and the McKay volunteers and oral history interviewees consist of former staff, from senior executives and professional staff such as chemists and

engineers, to blue collar workers like canteen and warehouse staff. However, it is recognised that these cohorts might not be as diverse as desired: for example, the McKay team is predominately male, as is the Kodak team, and some divisions of the companies are better represented than others.

It is a truism that volunteer projects are reliant on the community to enrol themselves, and while the museum does actively seek out volunteers (there was a media campaign to attract new Kodak volunteers with specific work experiences) there is a bias in who ultimately becomes involved.

Also, contributors who voluntarily participate in recording history often have positive stories to tell which sometimes overshadow other perspectives. For example, although many McKay stories provide critical insights into working life, almost all the Kodak volunteers had overwhelmingly fond memories of the company – consequently the lack of representation of former staff with criticisms or alternative perspectives of their company means that diverse viewpoints are lost from or diminished in the historical record.

It is incumbent on curators to ensure not only that they are empowering people to realise their agency in history making, but to ensure that competing narratives and hidden histories are documented in other ways.

Another critical factor shaping the nature of these two volunteer projects is the finite reality of time – the need to capture the expertise and clear memories while they are available. In the McKay project, few of the original twenty volunteers are still able to contribute. Many have died, and the others have reached an age when their capacity has substantially reduced. While the majority of the core Kodak volunteer team is still

able to actively participate, a number of the broader group have passed on and there is an urgency to access stories and expertise while we can.

Finally, before embarking on these large volunteer projects the museum had to have the capacity to match the enthusiasm, commitment and expectation of its volunteers. The curators who have led these projects had to first secure ongoing internal commitment and investment in technologies, resources and training to enable all the participants to work effectively and achieve outcomes of mutual benefit. They have also actively secured external funding, new partnerships and ways to give the project profile, to help the project achieve its larger goals.

Continuity and commitment

There is a very high level of volunteer commitment to the Kodak and McKay projects, which is a reflection of the significance of the collections, the tasks involved and the meaning they hold for each individual volunteer. Many volunteers worked for the companies for lengthy periods of 25-40 years, and have a loyal attachment to them. Former staff see themselves as part of a corporate family, and this project extends that sense of family through the ongoing connections within these teams.

The volunteers' involvement has offered them an important way in which their working lives are affirmed and acknowledged. These projects are deeply personal – through documenting their company they are writing their own biographies, reflecting on their own histories. This voluntary work has become an important extension to their long-serving paid work.

The first, foundational, way in which volunteers are affirmed

and acknowledged is through the museum giving priority and status to these industrial histories and the lived experience of these ex-employees. Museum Victoria also acknowledges volunteer contributions in other ways: formal museum industry awards; celebrating milestones in the hours worked as volunteers; profiling the work of volunteers in articles and conferences; special afternoon teas to celebrate significant outcomes; newsletters documenting and profiling their work on the collections; involvement in fieldwork to assess potential acquisitions; and key volunteers being awarded Honorary Researcher status.

The long-term nature of these projects has meant that pastoral care has emerged as another important way to acknowledge and support volunteers. This has included enabling museum email connections so that volunteers can respond to public enquiries from home; visiting volunteers while they are in hospital; keeping in touch by cards, phone and flowers; meeting volunteer families; providing material for eulogies and attending funerals.

Securing the long-term commitment and involvement of expert volunteers is helped by having a single point of contact through the relevant curator. Our professional investment in the projects and commitment to maintaining good and productive relationships, have been essential ingredients in engaging and retaining our volunteer teams.

Creating outcomes of mutual benefit

Both the H. V. McKay Sunshine and Kodak Heritage Collection volunteer projects have created outcomes of mutual benefit to the museum and to each volunteer. As noted, the contribution of volunteers has had enormous impacts on the preservation,

documentation and accessibility of these collections. The expert contribution of volunteers has exponentially increased their historical significance and potential.

Over the 20 years of work on the McKay collection, volunteers have identified and documented tens of thousands of collection items. They have also developed rich databases that describe the 84 factory departments and the hundreds of types of farming equipment manufactured by the company, and written over 100 stories relating to working and social life in the company. Similarly, the Kodak volunteers have contributed to the documentation of hundreds of images, provided narratives, answered numerous queries and pieced together historical timelines, the outcomes of which have been published on the museum's collections website.[1] The McKay core team's expertise and dedication were also essential in developing the Sunshine Harvester website,[2] and earned them the 2002 award for the most outstanding volunteer project in the Victorian museum sector. Kodak volunteers were also recognised by the local museum sector in 2008.

One of the other important, reciprocal outcomes of the two projects has been the immense enjoyment and satisfaction which volunteers have experienced. They have affirmed their working lives, enriched their memories, rekindled associations and friendships, and created stimulating opportunities for discussion and reflection. They have given voice to their own histories, for which there is a broad, public audience. A surprising and very interesting outcome for a number of volunteers has been significant health and personal benefits from their regular involvement, including retaining intellectual abilities, and improvements in well-being.

The outcomes of these two volunteer projects have

enriched both the volunteer participants and the museum in many ways. The expertise of former staff has been instrumental in shaping our understandings of the histories of the McKay and Kodak enterprises. It has been critical in accurately and meaningfully documenting the complex technological and social stories embedded in the material culture and the lived experience of former employees.

The volunteers' enjoyment and personal rewards have also generated considerable goodwill towards the museum, which has then been shared with the volunteers' broader networks. This opens up new opportunities and potential partnerships for these projects, and for others yet to be developed.

The projects have empowered volunteers, and given them agency in the history-making process, to write their own life narratives as well as those of their employers. The expertise of the volunteer teams has created rich layers of meaning and enhanced the historical and interpretive value of these collections. Museum staff have also benefited from their interactions with the volunteers, whose enthusiasm for the project has helped sustain curatorial motivation for the project over the long-term and whose unique skills have enhanced those of the staff.

Finally, both projects highlight the personal nature of history – its making and its meanings – and the race against the finite resources of time and memory.

NOTES

1. http://museumvictoria.com.au/collections.
2. www.museum.vic.gov.au/sunshine.

CAR

THE MUSEUM AS A SITE OF CARING AND REGENERATION FOR PEOPLE LIVING WITH DEMENTIA

Susan Shifrin

IMAGINATION MAY WELL be what distinguishes cultural arts interventions... from other dementia care practices.

– Kate de Medeiros PhD and Anne Basting PhD

A trip to an art museum for someone living with dementia is not just "a field trip" ...This is really an exercise in self-expression... This isn't a "go look at the art"; this is a "go look at yourself" and the art is just a stimulus for that.

– Richard Taylor, PhD

The statistics relating to Alzheimer's Disease and other dementias are stark. More than 44.4 million people worldwide are currently living with dementia. (Alzheimer's Disease International, 2014.) Over 5.2 million live in the United States. Every 67 seconds, someone else in the United States receives the diagnosis. (Alzheimer's Association, 2014.) Since 1970, the world's best and brightest scientists have been working to find a cure for Alzheimer's Disease. $500,000,000 in public funds alone is spent annually in the U.S. on finding a cure. *No cure has yet been found.* Nor has a cure been found for the more than 100 other equally devastating dementias. Those who receive the diagnoses are condemned by them to increasingly isolated and stigmatized lives, often emptied of creativity and community.

It is incumbent upon us to ask: *What are we doing for them? Now?*

We have learned much in the last few decades about the potentialities of non-pharmacological, "life-enriching" therapies for people living with Alzheimer's Disease and other

dementias. Pharmaceuticals have plateaued at only partial efficacy, with a cure probably still decades away. Necessity, introspection, creative thought and research, and common sense – in more or less equal measures – have resulted in advances that may not put an end to the diseases' ravages but do, importantly, point the way to a more engaged, integrated, and meaningful existence for those living with them (and, in turn, for their care partners, families, and friends.)

In this chapter, I will explore the theoretical and practical contexts within which such therapies have been developed. I will then focus on the efforts of one organization – ARTZ: Artists for Alzheimers (with which I am affiliated) – to design and implement museum-based programs for people living with dementia in the United States and consider the ways in which those programs have contributed to an increasingly enlightened understanding of the role that museums can play in regenerating sense of self and self-worth for people living with dementia.

"For the benefit of the community"

In 2002, the board of directors of the American Association of Museums (now the American Alliance of Museums) (AAM) passed a Museums & Community Resolution. The prologue to this resolution declares that:

> ...museums are community cornerstones. They are cultural symbols and contributors to community enter-prise, stewards of collections, and providers of edu-cational experiences. They are treasured places where memories are created and shared. But museums can also

transform the way people view the world... They foster research and life-long learning and encourage the expression of differing points of view. These strengths accord museums the opportunity to assume an expanded civic role in society. (American Association of Museums, Prologue, 2002.)

The list of operating principles that follows the prologue further elaborates:

Museums are defining new relationships with communities based upon *expanded mutual understanding, recognition of common concerns and interests, and a desire to collaborate for the benefit of the community.* [Author's emphasis.]

This process of expanded participation by museums in community life, and by communities in museums, is invigorating but hard work and requires an ability to take risks and entertain new ideas.

Collaboration between museums and communities requires sharing creativity, vision, responsibility, and resources. (American Association of Museums, Principles, 2002.)

Today, more than 14% of those comprising the communities with whom the AAM enjoined museums to enter into "expanded mutual understanding... and a desire to collaborate for the benefit of the community" are over the age of 65. (United States Census, 2013.) This compares to only slightly

FIG. 1: Intimate conversation during an ARTZ Philadelphia program at the Woodmere Art Museum, near Philadelphia. Photograph: F. James Conley.

over 6% under the age of five, a common target audience for museums' children's programs. Almost 14% of people in the U.S. over the age of 71 are now living with dementia. (Alzheimer's Association, 2014.) For these reasons among others, museums throughout the United States and Europe began efforts during the last decade to integrate into their community initiatives programs designed specifically with this ever-growing audience in mind.

"Step into their world"
But what does it mean to design programs that include and engage people living with dementia?

From 2001-2006, Gene Cohen, MD – a geriatric psychiatrist and leading figure in the study of intersections between aging and creativity – conducted the first longitudinal study to investigate the nature and implications of those intersections. Cohen became the founding director of the Center on Aging at the National Institute of Mental Health in 1975 and founded the Center on Aging, Health, and the Humanities at the George Washington University in 1994. His ground-breaking longitudinal *Creativity and Aging Study* evaluated how "general health, mental health, overall functioning, and sense of well-being in older people" might be affected by "active participation in cultural programs" relating to the "visual and literary arts, music, and other... domains." (National Center for Creative Aging, 2006.)

The study's theoretical foundation built "upon several major bodies of gerontological research [on the]... underlying mechanisms that promote health with aging – especially those of (1) sense of control and (2) social engagement." (Cohen, 2006.)

While the findings of the study were complex, reflecting the dynamics of multiple study sites throughout the country – each with its own intervention and control groups – they demonstrated conclusively that professionally run community-based art programs "achieved overall health and disease prevention effects among participants whose average age was greater than life expectancy [in the U.S.]." The same programs appeared to stabilize and even increase community-based activities among participants, thus heightening their level of social engagement and reinvigorating their sense of control within their own daily lives. (Center on Aging, Health, and the Humanities [CAHH], 2006.)

The potential of such findings for people living with dementia is evident in an interview with Cohen conducted at the Museum of Modern Art, in which he discussed his research on memory and the imagination and noted that just as babies are born without memories but immediately respond to things that "stir" their imaginations:

> [similarly], when memory is going, the capacity for imagination is still there, so even in the absence of understanding something from the perspective of specific memories – concrete facts – the imagination helps people enjoy what they're looking at... the imagination is stronger than the memory. (MoMA, Cohen, n.d.)

The centrality of imagination in the lives of people living with memory loss forms the crux of a story presented on the radio show *This American Life* in 2014. During the second act of an episode titled *Magic Words*, we hear the account of Karen Stobbe

and her husband Mondy as they "search for a new way to talk to [Karen's mother Virginia], looking for some magic words to say to her mom as her mom is losing her memory, words that will keep them connected." (Chicago Public Media [CPM], 2014.) The three live together, their communal lives shaped by Virginia's diagnosis of Alzheimer's Disease.

Karen describes her yearning for a structure within which she would be able to maintain meaningful communication with her mother. "I had this moment where I Googled the rules of care giving for someone with Alzheimer's. I wondered, for some reason, if they were even out there... And when I read one of them that said, literally, step into their world, I went, bam." (CPM, 2014.)

As the reporter narrating the story tells us, "step into their world" is a mainstay of improvisational comedy. Karen and her husband are both improv comedians. "You walk on stage, another actor says something, and you step into their world, whatever world they've just created. You don't ever say no. You don't question their premise. You just say yes. And..." The world of dementia, Karen realized, is "a whole 'yes, and' world." (CPM, 2014.)

Conceived in this way, the strategy of "stepping into their world" is not one of placating or patronizing the person with dementia. It is one of respecting, dignifying, and engaging with the power of imagination. When Virginia Stobbe and her son-in-law share an extended conversation about the monkeys Virginia sees outside the window – when Mondy proposes that the monkeys be invited into the house providing they are appropriately trained and given pants to wear, and Virginia laughingly admonishes him that monkeys can't be brought

FIG. 2: An ARTZ Philadelphia program participant gestures eloquently, making a compelling point during a group conversation in the galleries of the Woodmere Art Museum.

into the house – they are connecting through shared imaginative experience. The fact that that experience was initiated as the result of hallucinations brought on by dementia becomes secondary to the enjoyment and mutual engagement of stepping into each other's worlds.

Defining and assessing quality of life and well-being

Gene Cohen may perhaps have envisioned creativity and imagination demonstrated through the somewhat different (and more conventional) means of visual art-making, poetry writing and musical performance. Nonetheless, Karen's, Mondy's and Virginia's story provides a useful starting point for considering how we can best define and assess quality of life (QoL) and well-being, standard criteria used in qualitative studies of the impact of cultural arts interventions on people living with dementia.

Several recent studies – including one led by Linda Thomson and Helen Chatterjee, authors of another chapter in this volume – have helped to clarify this notion of QoL and how it can best be achieved for people living in residential care facilities. Though the studies discussed in this section excluded people with cognitive impairment or dementia diagnoses for ethical reasons, the studies' results can still be extrapolated to include them in principle.

Bollig *et al.* report that "in-depth, semi-structured interviews" carried out with the residents of nine Norwegian long-term care facilities – along with focus group interviews with their family members – revealed certain ethical prerequisites to the residents' quality of life within the facilities. "Acceptance and adaptation," "well-being and a good life," "autonomy

and self-determination," and adequate staffing resources were assessed by the respondents as essential to their well-being. (Bollig *et al.*, 2014.)

The authors note "there are profound ethical challenges when people have to move into a nursing home. One major challenge is to preserve dignity." Respondents reflected on the necessary trajectory of accepting their situations, but also "told about hope." "Participation in daily life and social contact" are described as the two essential components of well-being and a good life named by respondents. Well-being was not viewed exclusively as reliant upon environment or interactions with staff and other residents, but "was described to be achievable by active behavior of the residents themselves... To think positively and to do something on one's own seemed to be important." The residents made clear in their interviews that "to be seen as a human being and to be engaged in some kinds of social interaction were crucial factors for well-being and the preservation of their dignity." (Bollig *et al.*, 2014.)

Thomson and Chatterjee (2014) carried out thematic analyses of audio recordings made during facilitated sessions in which 40 older adults in acute care, residential care or psychiatric care settings participated in interventions revolving around their handling of museum objects. The study's authors draw distinctions particularly relevant to our subject between QoL and well-being as measurement standards. They write, "unlike health-related QoL measures linked to medical outcomes, well-being focuses on positive aspects of mood and cognition, is typically self-reported, and connects to positive psychology." (So-called "health-related QoL measures" are generally associated with such factors as physical health, energy, living

situation, memory, ability to do chores around the house, and financial situation.) Thomson and Chatterjee further differentiate between the "objective" definitions of well-being determined by material and social circumstances and its "subjective" definitions based on individual self-assessment and incorporating such attributes as life satisfaction, positive mood, and realization of potential. (Thomson and Chatterjee, 2014.)

Finally, Tuominen *et al.* (2014) examined perceptions of care facility residents over 65 regarding their "actualization of free will" in their care settings. The authors define actualization of free will as "freedom from obstacles to carry out one's desires and also a right to determine one's interests, values and life free from unwarranted interference." The small sampling of residents from four care facilities provided their own definitions of free will as actions "consistent with their own mind[s]," including freedom of movement, spending time as and where they desired, and making their own decisions. Actualization of their own free will was expressed as "older people's satisfaction or possibility to influence personal matters in nursing homes." Some envisioned this as designing harmonious relationships with the nursing staff in order to "promote their free will"; others determined to exercise "passive resistance... refusing to talk or eat" or active protest. "...[Expressing] one's own opinion, needs... and holding on to one's own rights" were perceived as ways of enhancing free will. Perhaps most significantly for us, the study authors note that:

> ...[promoters] of free will associated with external factors included meaningful activities when they were arranged according to older people's needs. External ser-

FIG. 3: An engaged, focused participant in ARTZ Philadelphia's first multi-sensory version of ARTZ on the Road. Residents at one of our partner care facilities looked at art works with us, handled and smelled objects chosen specifically for their connection with what the residents had looked at, and then made their own work in response.

vice providers were experienced as important promoters fulfilling older people's needs. (Tuominen *et al.*, 2014.)

Why museums?

As Thomson and Chatterjee (2014) have written:

> ...reviews of arts-in-health interventions indicate positive therapeutic and medical outcomes, including reduced stress, anxiety, depression, and blood pressure. Similarly, museum interventions aim to improve patients' well-being and QoL, widening access to arts and culture.

Richard Taylor was an internationally-renowned activist who worked to raise awareness about those living with Alzheimer's Disease and other kinds of dementia. A psychologist, Taylor was diagnosed at age 58 with early-onset dementia "probably of the Alzheimer's type." That was more than a decade before his death from cancer in July 2015.

He advocated passionately for the importance of a "whole person" approach – of treating the person with dementia as a complex, multi-faceted person, rather than reductively, as the bearer of a diagnosis – and of reinvigorating a sense of community among those living with dementia, to whom the diagnosis threatens alienation from all they have known, especially from their friends and family. He was an ardent supporter of arts- and museum-centered experiences for people living with dementia.

Asked by a staff member at the Museum for Modern Art in New York (MoMA) what people creating museum programs for people living with dementia should take into account, Taylor responded that:

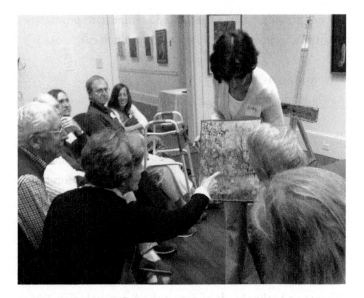

FIG. 4: ARTZ Philadelphia program participants relishing the opportunity to examine and discuss at very close range a painting by Ursula Sternberg in the collection of the Woodmere Art Museum in Chestnut Hill, near Philadelphia.

[they] should be thinking about their belief in the possibilities within people who have dementia for original thought, for a metaperspective on themselves, for personal growth. People who have dementia are not perceived as having the capacity to learn anything new. They're just hanging on to what they had, and everybody's job is to hang on for them or with them. ...I see it as potentially very satisfying to people who know that they're failing [cognitively], that they can also realize they still have the capacity and the desire to learn something new, feel something new, to have an insight that is original and that other people honor.

(MoMA, Taylor, n.d.)

We are reminded by Taylor that meaningful encounters with the world outside can be tremendously significant to people living with dementia. The museum venue and – more importantly – its staff have proven to be among the most transformative of "external service providers."

Camic *et al.* (2013) specifically address outcomes relating to evidence of the kind of "new learning" described by Taylor in their study of the impact of multi-session art-gallery-based viewing and making programs at the Dulwich Picture Gallery and Nottingham Contemporary. It is worth noting at the outset that, unlike many other investigations, this particular study *required* dementia diagnoses ("mild to moderate range") in its inclusion criteria.

As Camic *et al.* reiterate, the question of whether people with dementia diagnoses are able to learn new skills and acquire new knowledge is a contested one. The results of their

study seem fairly clear in what they reveal, however:

> ...in the present study, we were able to substantiate that
> the PWD [people with dementia] were able to demon-
> strate new learning within a gallery setting. The carers
> welcomed it in particular... The PWD were often sur-
> prised that learning about art and making it was enjoy-
> able and worthwhile... Variations in memory function-
> ing during and after the gallery sessions were another
> area identified. For the PWD, memory enhancement
> often came as a welcome surprise and likewise for the
> carers. (Camic *et al.*, 2013.)

Camic *et al.* likewise address the unique benefits of the museum
and gallery setting itself for visitors with dementia, allowing us
to read in their study participants' own words about the distinc-
tiveness of their experiences during gallery-based programs.
Participants in this study provided unequivocal affirmation of
the notion that the gallery setting in and of itself was viewed as
an "empowering and special environment that helped... [them]
to feel like active members of the society, who were socially
included and valued as individuals." (Camic *et al.*, 2013.)

Participant assessments of their experiences included the
following:

> I was treated so well, it made me feel I wasn't a drain...
> I've never been made to feel this welcome in services...
> I was very conscious at the gallery that we were people
> working together and were treated as equals and not as
> a person with a memory problem but as two people with

something to contribute, and that was a good thing...
To be actually engaged in looking at art in a small group
and being asked to comment about it, and be in your 70s
or 80s, when let's face it, there isn't much society values
you for, is very powerful. (Camic *et al.*, 2013.)

A constructivist museum model provides the grounding for
the approach in Camic *et al.*:

...how visitors learn within a museum... is based on
co-construction of knowledge from an interactive
experience with a gallery educator, the artwork and
visitor-group discussion, analogous to a "triangle of
knowledge". (Camic *et al.*, 2013.)

This model, today, of necessity, shapes most successful arts-
based programs for people living with dementia. The dissemi-
nation of factual information in a top-down lecture format
would be both a futile and counter-productive way of engag-
ing an audience comprised of visitors with memory loss. The
study's equally significant emphasis on maintaining a non-
hierarchical relationship between museum facilitator(s) and
visitors addresses the criteria for a "good life," well-being, and
the actualization of free will revealed in the interviews with care
facility residents described in Bollig *et al.* and Tuominen *et al.*

Case study: ARTZ: Artists for Alzheimers
In 2002, a newly-founded organization called ARTZ: Artists
for Alzheimers took up the challenge of readying museums
to provide hospitable and stimulating environments for the

FIG. 5: One of our most enthusiastic ARTZ Philadelphia "regulars," focusing on the conversation during an ARTZ at The Barnes program at The Barnes Foundation. Photograph courtesy of The Barnes Foundation.

kinds of arts-centered programs that Gene Cohen's study had demonstrated could deepen the well-being of people as they aged and as they lived their lives with the onset of dementia.

Sean Caulfield, previously the executive director of an Alzheimer's residential program and a support group facilitator for care partners, co-founded ARTZ with John Zeisel, a sociologist whose research interests in how natural and built environments shaped human behaviors had led him to focus more specifically on the impact of environment on the quality of life experienced during the aging process. Zeisel's research ultimately turned to investigating how the study of spatial dynamics and architectural design might improve the quality of life of people living with dementia in residential care facilities. The environment, he argues, if thoughtfully designed, can act "like a prosthesis for those who have difficulty carrying a cognitive map." (Karpf, 2008.) Caulfield and Zeisel advocate for a "person-centered" approach to providing surroundings and life experiences for people with dementia that emphasize "what is still there" rather than what their illnesses may have taken away.

In 1992, Zeisel joined with another colleague to establish a system of residences for people with dementia known as Hearthstone Alzheimer Care. Hearthstone employs his principles of prosthetic and therapeutic environmental design as well as activities and programming informed by the teachings of physician and educator Maria Montessori, emphasizing (among other elements) independence and freedom of choice within a reassuringly structured environment. Zeisel describes the nature of these therapies and the evidence-based research and evaluation that underlie them as the *I'm Still Here* approach. (Camp, Zeisel, and Antenucci, 2011.)

Caulfield and Zeisel co-founded ARTZ, based in the Boston area, "to create and sustain environments that foster relationships and engagement through the arts. Through the design and implementation of inclusive programming, ARTZ has discovered new ways in which the arts can measurably improve the quality of life for people living with dementia." (Facebook, n.d.) Among its goals are the alleviation of what Zeisel refers to as "the four As" associated with dementia: anxiety, agitation, aggression, and apathy. He is quick to point out that these are by-products rather than symptoms of dementia, the fallout from stress-inducing environment and circumstances that he believes can be abated. ARTZ and its work are evidence-based, drawing on research ongoing at the Hearthstone I'm Still Here Foundation as well as on the work done every day through ARTZ programs in Massachusetts and its affiliate organizations in California, Ohio, and Pennsylvania.

ARTZ first began with simple but meaningful interactions between volunteer artists and people living with dementia – visiting, talking, sharing their creative ideas, engaging those they visited and listening to *their* stories. Artists were asked to volunteer one hour per year; many of the volunteers never left the program because their initial experiences not only enriched the lives of those they visited, but enriched their own lives in ways that they might not have anticipated. Core programs developed soon thereafter include partnerships with regional museums and movie theaters.

ARTZ museum programs (Meet Me at the Museum and Make Memories) are organized around regional networks of museums, in the United States and in various European cities. Museum visits organized by ARTZ staff are designed to

generate as much interaction as possible. Works of art, generally selected on the basis of pre-visit group conversations with participants, serve as conduits for discussion, memory-generation and the creation of community and confidence among the participants. The first program developed on the ARTZ model of museum visits designed specifically to engage visitors with dementia was launched at the Museum of Modern Art in New York City in 2006 and is now a permanent component of MoMA's Community and Access programs.

In 2006, ARTZ also inaugurated its first international museum program with the National Gallery of Australia; and in 2007, the ARTZ Museum Program at the Louvre Museum in Paris was launched – the first program in Europe designed specifically for museum visitors with dementia. It became a bi-weekly program offered through an ongoing partnership between ARTZ and l'Hôpital Bretonneau in Paris. In 2008, ARTZ began to expand its museum network in the United States, increasing its Massachusetts-based museum partners to twelve and establishing ARTZ affiliate programs in Sacramento, Philadelphia, and Cincinnati, where the affiliates continue to build and expand their own museum networks and community partnership programs.

Just as Zeisel's approach to the design of the Hearthstone Alzheimer Care residences integrates philosophies of "person-centered care" and "what is still there" in the residents with Montessori's values of independence and freedom of choice; so too, the philosophies that have grounded the creation and development of ARTZ museum programs similarly integrate these values.

In Philadelphia, both our Meet Me at the Museum… and in-care-facility (ARTZ on the Road) programs are based on the

constructivist models discussed earlier in relation to the study carried out by Camic and his colleagues. The programs not only subscribe to the notion of "stepping into the world" of those who participate in them, but also establish *a priori* that it is the participants rather than the facilitator(s) who will more or less autonomously drive the conversation, taking it where they are inclined to go with it, whether that is a lofty formalist discussion of a painting or an intimate, sentimental session of reminiscences triggered by the same painting. Groups of museum program participants include both people with dementia diagnoses and family members, friends, or outside caregivers. The groups are designed to be small in order to ensure participants safe, intimate experiences and to cultivate a sense of communal and personal well-being by virtue of individualized attention from facilitators and other participants.

The following quotations give a sense of the impact of Meet Me at the Museum… on our program participants.

The daughter and primary family care partner of one of our "regulars" describes her visits with her dad to our programs as: "a terrific opportunity for Dad and I to connect with each other and others, including some of his caregivers. The museum [programs] are amazing. Such a different way to view art. Observations from the group are often fascinating".

A social worker who was involved in the very first ARTZ Philadelphia museum visits with a group of residents from the care facility at which she worked commented: "I've been a social worker all my life. But I have to say, [this] experience was the best… just celebrating the joy of the human person with dementia, with whatever problems exist – there was still joy, there's still wonder, still connection to other people."

And another one of our regulars, who has attended our programs almost every month for the last year with his wife and primary care partner, announced to the group during his second visit: "What's interesting is that I go with [my wife] to art museums a lot because she loves it. I go along... and I think this is the first time – in my own head – that I'm thinking seriously about what's going on here, and actually verbalizing it, because I've never done that... So for the little while we've seen things [today], I've enjoyed it a lot more."

In the words of Richard Taylor, "this is an opportunity for self-expression. People participate in this; they help define it rather than just observe it. They are not just a part of it, they are it. They are what's happening in it. It just happens in front of a piece of art." (MoMA, Taylor, n.d.)

The theory of caritative caring in the museum setting

It seems fitting to conclude this chapter with a little more attention to a particular aspect of the context within which ARTZ museum programs and other museum-based interventions function: that is, the context of caring.

Tranvåg et al. (2014), in a remarkable study focusing on how people living with dementia perceive what the authors describe as their "dignity experience," indirectly provide a compelling set of guidelines for those of us developing museum and cultural arts programs for people living with dementia.

According to the authors, eleven people living with mild to moderate dementia and still in their own homes were interviewed as a means of seeking qualitative information regarding their experiences of their own dignity and dignity preservation. The reported results of the study indicated that

interactions with others involving "love and confirmation"; "social inclusion and fellowship"; and "humane warmth and understanding within a caring culture, while being met as an equal human being" were requisite for the preservation of the respondents' sense of dignity.

Dignity is defined at the outset of this article as "being of value or worth because of the presence of some necessary characteristics." The Finnish theorist Katie Eriksson's Theory of Caritative Caring is presented as a useful framework within which to examine the character and sustainability of dignity. Eriksson's notion of the *ethos* of caritative caring derives etymologically from the Latin *caritas*, meaning "love" and "charity." It is said by the authors of this study to "constitute a fundamental motive for true caring for suffering human beings." (Tranvåg *et al.*, 2014.)

Eriksson is described as distinguishing between an "absolute dignity" granted to the individual by an inherent human and inalienable right; and "relative dignity" which is predicated upon the:

> ...experience of self-worth and human value in relationships with others. Relative dignity is modifiable, influenced by relational interactions of daily living, and can therefore either increase through external support and confirmation or be torn down through external violation. (Tranvåg *et al.*, 2014.)

Thus people living with dementia are understood to experience through "caritative invitation" that family, friends, and other people in their extended networks are welcoming them into a "caring

communion characterized by closeness, tolerance, and respect."

Several more observations by the study's authors have direct bearing on the design of the kinds of programs I have explored in this chapter. They note that having confidence in others was identified by respondents as a crucial basis for dignity experience; that inclusive and acknowledging interactions with others felt meaningful and could strengthen their sense of self, of belonging, and of dignity; that feeling oneself to be a contributor in interacting with others and making others happy were also essential aspects of dignity experience; and finally, that integrating their individual life-stories into "here-and-now" interactions with others also preserved their sense of dignity.

The theory of caritative caring makes abundantly clear – despite the small sampling in this particular study – that by acknowledging and treating our museum program participants with inclusiveness; by facilitating their contributions to conversations and their active participation in enriching the experiences of others; and by inviting our participants to integrate their own identities and their own life-stories into our interactions we will deepen and make more meaningful their engagements with our programs.

Come write our labels for us – what we can do for each other
So, in the end, what do programs like Meet Me at the Museum and Make Memories contribute to our museums? While it has been the aim of this chapter to explore the theories and practices that contribute to our meaningful engagement of people living with dementia and their families through our museum programs, none of the practices investigated or espoused in these pages are exclusively beneficial to just those target

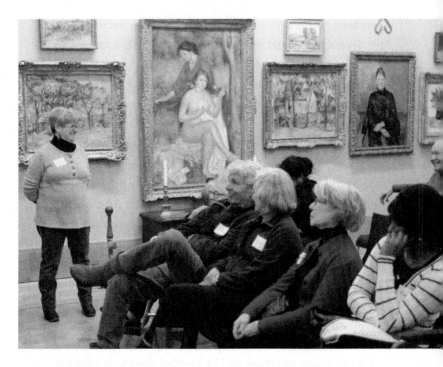

FIG. 6: Smiles shared by facilitator and participants during an ARTZ Philadelphia program at The Barnes Foundation. Photograph courtesy of The Barnes Foundation.

audiences. Rather, it is our increased awareness of the needs of our visitors living with dementia that will help us in the end to be more engaging, stimulating, and caring with *all* museum visitors.

The curator at one of our partner museums for ARTZ Philadelphia routinely says to our visitors at the close of our monthly Meet Me At the Museum... program: "We should have *you* come and write our exhibition labels for us!" This is no empty flattery; she means it. The novel observations and keen insights articulated by our program participants – who happen to be living with dementia in various stages – would stir the intellect of any perceptive and engaged curator. And it is because of the inclusive, caring way in which she and her institution host our programs that our participants feel digni-fied to express themselves as they do.

> Aging is a project, a work of existential art, a story that one continues to write until one can write it no more – it does not end when one is diagnosed with Alzheimer's by a doctor.
> – Peter Whitehouse, MD, PhD.

REFERENCES

Alzheimer's Association. (2014). Alzheimer's Disease Facts and Figures, *Alzheimer's & Dementia: The Journal of the Alzheimer's Association 10*(2), e47-e92. doi: http://dx.doi.org/10.1016/j.jalz.2014.02.001.

Alzheimer's Disease International. (2014). *Dementia Statistics.* Retrieved from http://www.alz.co.uk/research/statistics.

American Association of Museums. (2002). *AAM Board of Directors Museums & Community Resolution, Principles.* Retrieved from https://web.archive.org/web/20120113064241/http:/www.aam-us.org/sp/m-and-c-board-resol.cfm.

American Association of Museums. (2002). *AAM Board of Directors Museums & Community Resolution, Prologue.* Retrieved from https://web.archive.org/web/20120113064241/http:/www.aam-us.org/sp/m-and-c-board-resol.cfm.

ARTZ: Artists for Alzheimers Facebook Page. Retrieved from https://www.facebook.com/ArtzAlz/info.

Bollig, G., Gjengedal, E., Rosland, J. H. Nothing to complain about? Residents' and relatives' views on a 'good life' and ethical challenges in nursing homes. *Nursing Ethics.* December 8, 2014. doi: 10.1177/0969733014557719.

Camic, P. M., Tischler, V., & Pearman, C. H. (2013). Viewing and making art together: a multi-session art-gallery-based intervention for people with dementia and their carers. *Aging & Mental Health, 18*(2), 161-168. doi: 10.1080/13607863.2013.818101.

Camp, C. J., Zeisel, J., & Antenucci, V. (2011). Implementing

the 'I'm Still Here'™ Approach: Montessori-Based Methods for Engaging Persons with Dementia. In P. E. Hartman-Stein *et al.* (Eds.), *Enhancing Cognitive Fitness in Adults: A Guide to the Use and Development of Community-Based Programs* (pp. 401-418). New York: Springer Science + Business Media.

Caulfield, S. (2011). Arts, Museums, and Culture. In P. E. Hartman-Stein *et al.* (Eds.), *Enhancing Cognitive Fitness in Adults: A Guide to the Use and Development of Community-Based Programs* (pp. 301-323). New York: Springer Science + Business Media.

Chicago Public Media. (2014). Glass, I. This American Life, Episode 532. *Magic Words*. Act 2. Retrieved from www.thisamericanlife.org/radio-archives/episode/532/transcript.

Cohen, G. D. (2006). *The Creativity and Aging Study, Final Report*, April 30, 2006. Retrieved from Center for Aging, Health & Humanities, The George Washington University Web site: http://cahh.gwu.edu/arts-aging-study.

Cohen, G. D. (2006). Research on Creativity and Aging: The Positive Impact of the Arts on Health and Illness. *Generations, 30*(1), 7-15.

de Medeiros, K. & Basting, A. (2014). "Shall I Compare Thee to a Dose of Donepezil?": Cultural Arts Interventions in Dementia Care Research. *The Gerontologist 54*(3), 344-353. doi:10.1093/geront/gnt055.

Karpf, A. (2008, December 2). People who are losing their past still deserve a future; care homes, arts projects and other innovations in dementia treatment could save people from a life of bland reassurance.

The Guardian. Retrieved from http://www.theguardian.com/commentisfree/2008/dec/03/comment-alzheimers-healthcare-zeisel.

Langer, S. (1966). The Cultural Importance of the Arts. *Journal of Aesthetic Education* 1(1), 5-12.

Museum of Modern Art. (n.d.) Conversation with Gene Cohen of the Center on Aging, Health & Humanities and Gay Hanna of the National Center for Creative Aging. *Perspectives*. Retrieved from http://www.moma.org/docs/meetme/Perspectives_GCohen-GHanna.pdf.

Museum of Modern Art. (n.d.) Conversation with Richard Taylor. *Perspectives*. Retrieved from http://www.moma.org/docs/meetme/Perspectives_RTaylor.pdf.

National Center for Creative Aging. (2006). *The Creativity and Aging Study: The Impact of Professionally Conducted Cultural Programs on Older Adults*. Retrieved from http://www.creativeaging.org/publications-research/research/creativity-and-aging-study-impact-professionally-conducted-cultural.

Thomson, L. J. M. & Chatterjee, H. J. Well-Being With Objects: Evaluating a Museum Object-Handling Intervention for Older Adults in Health Care Settings. *Journal of Applied Gerontology*. November 24, 2014. doi: 10.1177/0733464814558267.

Trahan, M. A., Juo, J., Carlson, M. C., & Gitlin, L. N. (2014). A Systematic Review of Strategies to Foster Activity Engagement in Persons With Dementia. *Health Education & Behavior* 41(15), 705-835. doi: 10.1177/1090198114531782.

Tranvåg, O., Petersen, K. A., & Nåden, D. Relational interactions preserving dignity experience: Perceptions

of persons living with dementia. *Nursing Ethics*. October 15, 2014. doi: 10.1177/0969733014549882.

Tuominen, L., Leino-Kilpi, H., & Suhonen, R. Older people's experiences of their free will in nursing homes. *Nursing Ethics*. December 8, 2014. doi: 10.1177/0969733014557119.

United States Census Bureau. (2014). *QuickFacts*. Retrieved from http://quickfacts.census.gov/qfd/states/00000.html.

Zeisel, J. (2009). *I'm Still Here: A New Philosophy of Alzheimer's Care*. New York: Avery-Penguin.

Zeisel, J. (2006, rev. ed.). *Inquiry by Design: Environment/ Behavior/Neuroscience in architecture, interiors, landscape, and planning*. New York: W. W. Norton.

ENGAGING WITH ART, ENGAGING WITH PEOPLE

Ronna Tulgan Ostheimer with Sharon Lazerson, Peter Mehlin and Lydia Littlefield

THE MISSION OF THE Clark Art Institute is to extend the public's understanding and appreciation of art. At the Clark, we really believe that engaging with art enhances a person's life. We work with a variety of audiences, shaping programs differently for different groups. Our goal is to reach as many people as we can and we are happy to make special accommodations as needed whenever possible. So it was an easy decision to work with Sharon Lazerson, activities director at a local nursing home, when she asked me if the Clark would consider developing and hosting a program for people with dementia. Luckily, there was a well-established program model and training opportunity not far from us, at the Museum of Modern Art (MoMA) in New York City.

MoMA began their Meet Me at MoMA program, designed for people with Alzheimer's and other dementias, and their caregivers, in 2006. The program was extremely popular and in 2009, MoMA received a large grant from the Met Life Foundation to expand their program and to develop a curriculum manual to share their model with other museums. More than 100 museums, including the Clark, have learned from the MoMA model and are now hosting programs of their own. In addition to the support from MoMA, our preparation included learning more about dementia and the different programs available in the area for people with the condition. We talked with a medical expert as well as conducting our own research. As it turned out, the docents who were interested in leading this program all had personal experience dealing with a loved one with dementia. This first-hand experience was probably the most significant of all.

In the fall of 2013, worked with Sharon to bring a group

from her nursing home to participate in a pilot Meet Me at The Clark program. The group included a mix of residents, professional caretakers and family members. The program was so well-received that we hosted three more sessions. In 2014, we began offering Meet Me at The Clark to the general public as a regular (and free) program at the museum. The sessions take place once a month on a day when we are closed to the general public, between 10:00 am and 12:00 noon. In order to accommodate the needs of this group, we stagger the start time so people can arrive at their own pace. Once we have a group of sixteen (eight pairs), a Clark educator will bring the group into the galleries to begin their conversation. We can facilitate multiple groups of this size during the course of a morning.

In many ways, Meet Me at The Clark is very much business as usual once we get into the galleries. Our gallery talks involve guided conversations about a series of art objects, often chosen to relate to a particular theme and they last for about an hour. All members of the group are encouraged to participate – to look, to think about their own reactions to the works, to make connections with the object, to listen to others and contribute to the discussion. These are real conversations in which people engage at their own level; all contributions are valued and the different perspectives offered by members of each group enhance the discussion and expand everyone's thoughts about the works of art. Gallery talks accept people as they are. Participants are not required to know certain things or to come up with a "right answer". The educator guides the conversation, validating responses, connecting ideas back to the object and offering clear and interesting information, when appropriate, to enlighten and invigorate the conversation.

Gallery talks at the Clark are a positive and affirming experience for most of the people who engage in them (certainly for the educators involved!). For people with dementia and their caregivers, it may be one of the only positive and affirming experiences that they are still able to participate in together. Visual experience can trigger memory and people who may typically be non-verbal often contribute to the conversation in their own ways. Educators are trained to notice and respond sensitively and respectfully to all forms of participation as well as other behaviors that may accompany dementia (repetition, withdrawal, hostility). Caregivers can relax – everyone is welcome to participate in their own way; there are no judgments or expectations. Gallery talks assume and honor the integrity of all involved, and the person with dementia and the caregiver can interact as equals, validating the relationship that they may have had in the past.

Of course, there are some differences in how we manage the Meet Me at The Clark program compared to our other talks. Probably the most unusual thing about the program is that we host it on a day when we are closed to the general public. Paying for security on a closed day is actually the only real cost of the program for the Clark. The privacy and privileged time in the galleries seem to communicate the specialness of the program and a respect for the group. It also allows for a more relaxed and open conversation. Also, as many of the participants in the program have walkers or wheelchairs, it is much easier to move from one space to another, adjusting the pace when necessary, when we do not have other visitors in the galleries. Given the mobility issues, we bring a temporary coat rack into the admission lobby because our cloak room is a bit of

FIG. 1: Berthe Morisot, *The Bath*, 1885-86, oil on canvas, 36¼ x 28⅞ in. (92.1 x 73.3 cm), Sterling and Francine Clark Art Institute.

a distance away. In general, we try and have a lot of extra staff on hand to help with ushering; it's probably the most "high touch" program that we offer (not necessarily physical touch).

In a typical gallery talk, we might discuss six or seven objects. In a Meet Me talk, we are more likely to look at four or five works and we are much more comfortable with, even welcome, seemingly disassociated comments. In fact, many of the high-points come from these tangential conversations. One of my favorite stories about the program offers a perfect illustration of this. We were looking at art with the theme of Women in Society and began with Berthe Morisot's painting *The Bath* (Figure 1) and then looked at Renoir's *Blonde Bather* (Figure 2). I was shaping the conversation around the idea of the "gaze" and how the differences in these two paintings might be affected by the fact that one of these works was painted by a woman and the other was painted by a man. Instead, one woman who had not yet said anything out loud exclaimed enthusiastically, "Oh, it reminds me of how good it feels to be naked out in the sunshine." This comment sparked a long and lively conversation about nudity. People shared stories from their youth in the 1930s and 1940s about pretty regular experiences of same-sex, non-sexual nude activity – from college swim tests to experiences in the military to summer camp outings. We talked about how in today's world nudity is so frequently associated with sexuality and how that was not their experience growing up. The conversation was fun and funny. I am quite sure that it was more interesting than a feminist comparison between Morisot and Renoir. Without a doubt, many of the caregivers saw their loved ones in a completely new light after this discussion.

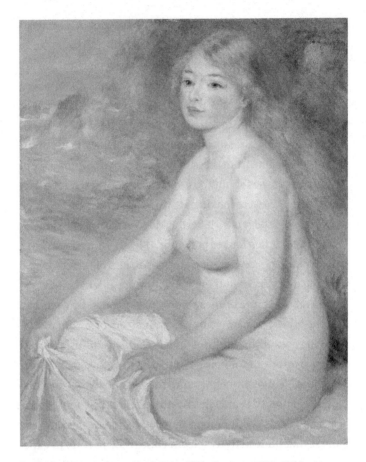

FIG. 2: Pierre-Auguste Renoir, *Blonde Bather*, 1881, oil on canvas, 32⅛ x 25¾ in. (81.6 x 65.4 cm), Sterling and Francine Clark Art Institute.

Engaging with art can be an incredibly powerful and humanizing experience for anyone. It is an honor to be a museum educator and to be able to facilitate such an important and exciting experience with museum visitors. It is especially an honor to be able to facilitate such an important opportunity with people who might find it difficult to participate in other public programs, and who seem to benefit so greatly from the experience. Based on feedback, Meet Me is a meaningful program for all involved.

From Sharon Lazerson, nursing home activities director:
It has been a joy to help launch Meet Me at the Clark and I have been most fortunate to find in Ronna Tulgan Ostheimer a colleague who mirrors my passion for bringing the arts to people with dementia. We are all aware that despite intensive research efforts, there is as yet no reliable medical approach to curing or halting progression of dementia. In my work as Activities Director in a small and progressive dementia community, I have witnessed again and again the effectiveness of art as treatment. Surviving all the losses that dementia brings, the human capacity for wonder and creativity remains. Residents who have participated in the sessions at the Clark enter a space dedicated to uplifting the human spirit, reserved just for them once a month. Many of them were museum, theater, and concert-goers in their pre-dementia lives. Like improv artists themselves, Ronna and the other docents are trained and prepared to accept and affirm any and all responses to the artwork.

This is a program where the caregiver partners are not just tag-alongs trying to spend some relatively pain-free time with a family member. Both people are genuinely nourished. Some

FIG. 3: Frederic Remington, *Friends or Foes? (The Scout)*, 1902-05, oil on canvas, 27 x 40 in. (86.6 x 101.6 cm), Sterling and Francine Clark Art Institute.

regularly make a trip of two to three hours in order to attend. On our van ride home, the discussion of art continues. The relief in the relationships is palpable. It's obvious to me that light is brought into the wearying task of caring for a loved one with dementia. What a special joy and privilege it has been to be involved in this spectacularly generous program! I hope it reaches a wide community audience and has the health-bringing impact it promises.

From Peter Mehlin, Clark docent:
When Ronna first told our docent meeting about the Meet Me program I expressed an interest in becoming involved. She loaned me the MoMA handbook which confirmed that interest. I observed her doing two visits and discussed them with her. At that point I felt ready to try it on my own. I put together an idea of what I wanted to do and Ronna went over it with me, making suggestions and giving support. She observed the program and offered valuable feedback following it. I have now done three on my own and am finding it a richly rewarding experience. Interestingly, I had initially thought of it as a program for the person with dementia but now see that it is as much, if not more, for the caregiver involved. Many times it is one of the few things a family member can do with a loved one who is slipping away from them. As a docent I have had to realize that this is very much not a typical gallery talk. I have had to become comfortable with silences and diminished responses. Sometime a smile or a word is enough to let me know I have somehow reached a person. It is a valuable program for the intended audience and very heartwarming for those of us doing it.

FIG. 4: Winslow Homer, *Undertow*, 1886, oil on canvas, 29¹³/₁₆ x 47⁵/₈ in. (75.7 x 121 cm), Sterling and Francine Clark Art Institute.

From Lydia Littlefield, program participant

On a bright day in mid-June, 2013, my father and I joined about a dozen others on a bus trip up to the Clark. We were a bit late getting on the road: rallying a group of people with varying degrees of dementia and tenuous bladder control is not a simple matter. During the 40-minute drive I talked with Dad, who was musing on clouds and passing scenery. I also spoke with the people seated behind us (a smartly dressed and bird-like older woman and her friend, a woman about my age), and with Sharon Lazerson, our kind, patient, and adventurous leader. Soon after our arrival, we found ourselves comfortably seated in front of Remington's *Friends or Foes?* (also known as *The Scout*). It was during the discussion about this painting (Figure 3) that I began to see the many metaphors within it that pertain to the experiences of dementia: the isolation, the quizzical wondering about the physical and emotional distances between people and places, the intense longing for you-know-not-what.

When we got to Homer's *Undertow* (Figure 4), I was awash in recognition of the many parallels between the images in the paintings and the experiences I was living with my father: the efforts of the rescuers, the struggle and the relinquishing of the rescued, the mighty movement of the sea.

Our group lunch was a pleasant passing of the time, and a further opportunity to witness the relationships of the others in the group. It was on our trip home that I had one of the most profound experiences of all with Dad in his dementia-tinted demise: I was tired (I was often in an advanced state of fatigue then, split between caring for my family and for my father), and I was thankful that, for once, I wasn't doing the driving. I

so badly wanted to just put my head down on Dad's shoulder. I hadn't done that since I was a little girl. The great gift of the day was that I realized that I could simply relinquish myself to the moment, *and I did*. I rested my head on Dad's shoulder for a few minutes, and the years of caretaking and concern were smoothed over, a soothing salve into parched skin.

The Meet Me at the Clark experience helped me to see the dementia, my father, and myself from a new perspective. Metaphor, color, and light wove themselves into our numbered days together. Dad died three weeks later. As I think back on those long days and nights, I can juxtapose the quiet in *Friends or Foe?* and the roar of the waves in *Undertow* with thoughts of Dad, and I hear the sound of gentle lapping at the water's edge. That day was a far greater gift than any of us knew.

The response

The response to the program has been extraordinary; the group size more than doubled from the first session to the last and next year we will increase the number of sessions from four to six. We will also hold the program in the afternoon instead of the morning based on feedback from participants. Certainly we are meeting a need for people with dementia, their caregivers and the agencies that work with this population. It is also important for the Clark and for museums in general. The Meet Me program symbolizes a changing relationship between museums and their communities. Instead of developing programs that celebrate and teach about their collections for an elite few, museums are using their collections to offer meaningful and relevant programs to meet the needs of a variety of audiences. The museum of the future will not only preserve and present the past but it

will also serve and care for humanity in the present. "The Caring Museum" – a new standard!

RESOURCES

Kitwood, T. (1997). *Dementia Reconsidered: The Person Comes First*. Buckingham, PA: Open University Press.

INTERGENERATIONAL TEACHING AND LEARNING IN THE MUSEUM

Jessica Sack

WHAT HAPPENS IN THE MUSEUM, a place where art is collected, conserved, displayed and taught from, when traditional roles are reversed and the young become the teachers and the older visitors become the students?

This case study focuses on intergenerational teaching and learning at the Yale University Art Gallery, in New Haven, Connecticut, through the examination of two programs: one for adults with memory loss and the other for older veterans with vision impairment. Both programs are led by Wurtele Gallery Teachers, Yale graduate students from diverse disciplines, hired and trained to teach in the museum.

Background

In 2005 the Yale University Art Gallery piloted a program that turned the tables on conventional teaching approaches. Instead of following traditional models of volunteer tour guides in the museum, the gallery began a program for Yale graduate students that trained them to be museum educators. Now, the Wurtele Gallery Teachers lead all school, youth, family, and special needs teaching.

In 2008 and 2009 two new collaborations started: one with a local assisted care facility to develop a multi-visit program for their residents with memory loss; the other with the Blind Rehabilitation Center through the Veterans Administration to bring groups to the museum each month as part of their rehabilitation program.

With the development of these collaborations, the museum has become a place for intergenerational exchange, learning, and agency. Older adults, with sometimes newly diagnosed disabilities, spend time talking about art and life with each

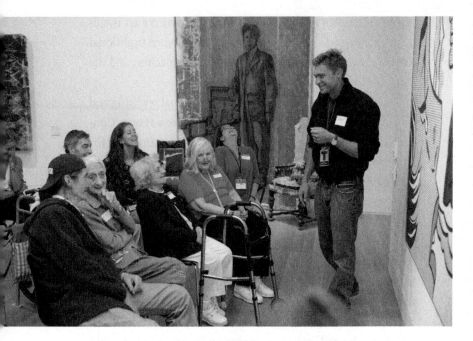

FIG.1: Wurtele Gallery Teacher Tyler Griffith and visitors engage in lively conversation about relationships. Yale University Art Gallery | Photograph Jessica Smolinski.

other and young people who want to hear what they have to say. From the Gallery Teacher's perspective, working with these visitors can be life changing.

Memory loss

In the spring of 2009 Mary Farkas, who at the time was the Dementia Unit Coordinator at a local assisted living community, contacted Jessica Sack, the Jan and Frederick Mayer Senior Associate Curator of Public Education at the Yale University Art Gallery, to suggest that they collaborate on a program at the gallery for adults with memory loss. Together, they developed a two-part training program for teaching staff at the museum and interested area educators. The first part of the training provided a background on memory loss and Alzheimer's disease and the benefits of using the arts as a therapeutic technique. For the second part, Laurel Humble and Amir Parsa of MoMA's Alzheimer's Project demonstrated techniques for working with visitors with memory loss in the gallery.[1]

In the years since the initial training, the gallery has developed free partnerships with multiple assisted living communities. Gallery sessions are led by Gallery Teachers and focus on observation of art and conversation. Sometimes two care facilities come to the museum together. This broadens the social dimension of the experience. Most of the residents who participate have early to mid-stage Alzheimer's. The groups explore up to four objects in an hour. The Gallery Teachers work in teams of three or four per group of up to ten visitors. They take turns leading conversations and helping with the logistics (Figure 1).

Gallery Teachers keep in mind light contrast, travel distance, and space for people to gather when selecting artwork.

FIG. 2: A visitor points to details in a painting she likes.
Yale University Art Gallery | Photograph Jessica Smolinski.

The goal is to have a positive social experience through conversations about the art or ideas that come from their life experiences. As Farkas has noted:

> The general response was one of joy. Residents enjoyed the experience of being participants in an adult environment... In a time when cognition is not dependable, public environments become such a challenge. The gallery provides a paradigm shift here – a public environment in which *remembering* is not the key. Instead, the focus is fostering connection and expression.
> (M. Farkas, personal communication, January 18, 2015.)

Looking becomes the catalyst for experience or memory. The teaching is inclusive, does not quiz people, and encourages conversation. As one Gallery Teacher who has led sessions for many years noted:

> Within a paradigm of education, "teaching" memory loss groups shifts the goals of a lesson from the development of visual articulation skills to a rediscovery of the positive psychological experience of art... Frequently, memory loss visitors leave with a positive attitude, even if they cannot articulate why they feel happy.
> (T. Griffith, personal communication, December 18, 2014).

These positive feelings can happen even if residents have not claimed to like all the art they have seen. The opportunity to express themselves often results in calmness or happiness (Figure 2).

FIG. 3: Wurtele Gallery Teacher Yolanda Richard indicates areas of Van Gogh's *Night Café* which visitors are discussing. Yale University Art Gallery | Photograph Jessica Smolinski.

The multi-visit approach to the program allows for the teaching staff to get to know the participants. Re-visiting the museum feels familiar to some of the residents and some recognize art they have seen on previous occasions. A former Gallery Teacher studying psychology recalled a visitor who had been an art conservator and during visits would stand very close to the paintings to point out the most intricate details about the artists' brushwork. Once the Gallery Teachers realized that he had been a conservator and had worked on paintings by many of the same artists the group was discussing, they invited him to come and explain what he knew and what he saw. As his memory loss progressed he spoke mostly in Italian. The psychology student also spoke Italian and when the resident began to wander, a characteristic of Alzheimer's disease, the Gallery Teacher would join him and they would converse.

This flexibility in teaching is possible because the Gallery Teachers are trained to respond to such moments and also because a relationship has developed with the residents over time. They may see the same resident eight or nine times in a year and deliberately bring the group back to a piece they had seen on an earlier visit because it had been popular.

One group returned to Van Gogh's *Night Café* three times (Figure 3). A member of this group, aged 98, would announce loudly upon entering the museum that being there was "like coming home." He posed questions to his "classmates", as he called his fellow visitors, when he wanted a new direction for the conversation. On the third visit he asked, "Have you changed anything about this painting?" The Gallery Teacher responded it was the same piece; nothing had been added or

removed. The group member asked his classmates if they noticed the young man wearing white near the pool table; was it appropriate for someone so young be in a bar at that hour?

Themes which connect the artworks may exist but are not necessarily stressed, as most of the visitors do not remember them from piece to piece. Some Gallery Teachers have described this as having to be always in the moment, needing to refer to ideas and memories of the individual rather than pieces just visited. They say this is an exciting opportunity to challenge the way they traditionally teach, describing the back and forth of discussions as "exhilarating."

Gallery Teachers also talk about this kind of teaching being the most empathetic and how each resident is seen as unique. They learn about the residents' lives, their interests, and history while learning to be patient with the long silences that may come as the residents' process information.

Veterans

The program for veterans with vision impairment, begun in 2008, is also led by the Gallery Teachers. This collaboration with the Veterans Administration involves a rehabilitation program for veterans whose sight has diminished or been lost due to age, illness, or combat. The veterans come to the gallery for a descriptive tour and conversations about art, the museum, and life.

The rehabilitation program teaches skills in living with the loss of sight. Included in the therapy are visits to cultural institutions and outdoor spaces, the gallery being one of the places to which the group comes. The group is usually new as the rehabilitation program is four to six weeks long and visits

are an hour and a half. Since there is a possibility that some people may have come the previous month, Gallery Teachers are careful not to use the same objects each time.

Gallery Teachers take care to make sure that spaces and artwork have a strong contrast of light and shadow. The ways the building feels and sounds in different rooms is also incorporated into the visit. Some use viewing devices like the monocular telescope to see from a distance; others need to get close to the paintings, sculptures, and objects in order to use their new devices and see. The museum staff, including security, is aware of the group's needs and accommodates them.

As with the memory loss groups, there is a great deal of play in the conversations. Sometimes the art becomes a starting point for descriptions of other works a veteran has seen before losing his or her sight. Other times, it becomes a moment for talking about experiences. A former Gallery Teacher shared:

> Some of my most profound moments at the gallery were had as a first year working with this group. You learn so much about yourself, about ways of seeing, about confronting the hegemony that dominates museum spaces. (C. Wells, personal communication, January 8, 2015.)

One Teacher who worked extensively with the veterans was a public health student who went on to medical school. As he reflected on the impact of teaching the veterans, he has compared his experiences as similar to talking with patients and asks:

> How can you effectively elicit descriptions of a feeling/experience/symptom from someone who isn't

FIG. 4: A visitor poses a new question for his "classmates" to discuss.
Yale University Art Gallery | Photograph Jessica Smolinski.

necessarily equipped with the refined tools to describe? Like I did with the vets, I use ideas of reference with patients in my history teaching – compared to your other headaches, how does this one feel? I'm able to tease out whether this is a typical headache or a brain hemorrhage. "
(R. DiMaya, personal communication, December 5, 2014.)

Conclusion

The place of the museum in both the memory loss and veteran groups becomes a location for exchange though observation, storytelling, reminiscence, and association. These encounters and experiences are unique to the museum because of the art on display and also because the museum is an environment unlike the assisted care facility or the rehabilitation center (Figure 4). The goals of the visits include "increased inter-personal connections, increased bright affect, and autonomy through creative expression." (M. Farkas, personal communi-cation, January 18, 2015.)

The experience of working with older adults can change the Gallery Teachers' approaches to teaching, working with adults, and thinking about art. It has a lasting impact on their appreciation of the contributions of older adults to society. The exchange of information through storytelling or reminisc-ing teaches the Gallery Teachers about history, about other people's experiences, and immerses them in new perspectives. A dressmaker shared her perspective on fashion in portraits. Images of food sparked a sharing of recipes. A painting of Coney Island prompted first-hand experiences of what it had been like to be there in the 1920s and 1930s. Stories of war and

FIG. 5: Wurtele Gallery Teacher Tony Coleman leads a professional development training session with fellow Gallery Teachers and education department staff in the American paintings collection. Yale University Art Gallery | Photograph Jessica Smolinski.

of being a Prisoner of War were shared. Stories of families, of love, of first steps were also elicited because of being in the museum.

Training gallery staff to work with adults with special needs is now part of the annual professional development (Figure 5). Gallery Teachers who choose to specialize in working with these audiences describe gaining a greater level of empathy toward older adults. Some of the Teachers go on to careers in healthcare, teaching, and pastoral care among others. Working with these museum visitors helps them see older adults as individuals with vibrant histories. In addition, these programs help the visitors have a beneficial experience. They are adults, enjoying time in a public space, spending time with young people who want to hear their stories and observations about life and art and who learn from them. Having an enjoyable educational and social experience in a museum contributes to a full life for all.

NOTES

1. See Rosenberg, F., Parsa, A., Humble, L., & McGee, C. (2009). *Meet Me: Making Art Accessible to People with Dementia*. New York: The Museum of Modern Art. Also see http://www.moma.org/meetme/ for more information about MoMA's Alzheimer's Project.

SELF-CARING IN LATER LIFE

Tine Fristrup and Sara Grut

SOCIETIES ARE AGEING across the world and in 2015 there will be more people over the age of 65 than children under the age of five globally (Powell, 2011). For the first time in history we face a situation where the ratio between the young and the old takes on a new shape with regard to the structure and ordering of society. These demographic changes favour what we call a *(geronto)pedagogicalisation* of ageing societies (Fristrup, 2012a). The neoliberal agenda of choice and agency unfolds as a transformation of the ways in which old age is being experienced by adults throughout the world. The phenomenon of gerontopedagogicalisation is a process of becoming a juvenile and entrepreneurial self in later life, conceptualised as *performAGE* (Fristrup, 2012a). PerformAGE is an approach to understanding the different ways of performing age in later life which favours the performing of this juvenile and entrepreneurial self (Cruikshank, 1999).

The conflicting approach to ageing from the late 1950s emphasised a paradigm shift in the understanding of ageing from "disengagement theories" to "activity theories" and unfolded "a new gerontology". According to Holstein and Minkler (2003: 787):

> The "new gerontology," built on the concept of successful aging, establishes the preconditions for an end product of the process of successful aging. Focused on health and active participation in life, it vests largely within individuals the power to achieve this normatively desirable state. While acknowledging the contributions of the scientific base for Rowe and Kahn's successful ageing model, we emphasize the need for a more careful ex-

amination of the model itself. Using critical gerontology as a primary filter, we critique this normative vision by focusing on its unarticulated (and perhaps unexplored) values, assumptions, and consequences. We argue that these unexamined features may further harm older people, particularly older women, the poor, and people of color who are already marginalized. We conclude by suggesting forms of resistance to this univocal standard.

Despite these critical approaches, conflicting aspects are still being presented as a contrast between:

- active versus passive ageing;
- an engaged versus a disengaged form of ageing;
- a successful versus an unsuccessful way of ageing (Fristrup, 2013).

"The will to juvenility in later life" (Wearing, 2007) enables older adults to perform age as a way of demonstrating a non-dependent form of ageing which doesn't burden society, but is socially distributed as ways of empowering older adults in contemporary ageing societies. Gerontopedagogicalisation becomes the "tragic" (never-ending) process of becoming an ageing but juvenile self in order to maintain the sense of a continuous self (Kaufmann, 1986: 149) in the 21st century's era of pedagogicalisation which followed the 20th century's focus on educationalisation (Popkewitz, 2008: 171).

Gerontopedagogicalisation is, therefore, a perspective which strives to reflect the hegemonic structures of the current discourses on ageing as inevitable and inescapable. It does this

by setting the scene and examining the way we read our lives by posing the statement: "People performAGE by negotiAGE-ING in contemporary ageing but juvenile societies".

The process of gerontopedagogicalisation can be further elaborated as a "juvenilisation" of the way we perform our individuality throughout the entire life course (Schmidt, 1999: 311): we no longer grow up in order to become adults. Instead, we have to work on our competences or capabilities throughout our life span, because "age" no longer determines what we do at each stage. The capabilities of youth such as mobility, sensibility, flexibility, contingency and creativity (Fristrup, 2013) are those needed to develop on a lifelong basis, and lifelong learning becomes the key to securing lifelong development (Schmidt, 1999: 311).

According to the latest research on "feeling old vs. being old", Rippon and Steptoe (2014) conclude that:

> Older people typically feel younger than their chronologic age, and it is thought that those who feel younger than their actual age have reduced mortality.
> (Rippon & Steptoe, 2014: E1.)

The performing of age in accordance with this thesis of juvenilisation demonstrates that if you feel younger than your age, you will be able to live longer, according to Rippon and Steptoe (2014). This is played out in the neoliberal approach to "unburdening" older people as long as they "choose" to live active and healthy lives in later life that result not just in longer lives but in qualitatively better lives.

The question here is whether juvenilisation really aims

FIG. 1: Expanded Model of Riley and Riley's Age-Integration Theory.
[Source: O'Rand, 2005, figure 6.1.]

to offer us choices or whether is it part of an emerging set of techniques for making us self-manage our ageing process and experiences. Juvenilisation could and should be critiqued as the hegemonic requirement, or insistence, that we continue to reproduce youthful attributes across our life course. In some discourses the rise in average life expectancy is being presented as creating the necessity for more of us to actively manage our health, lifestyles, finances and even our deaths as personal, autonomous and highly individualised activities. Those who don't or can't are increasingly represented in a negative light: in some countries funeral insurance advertising encourages older people not to "burden" their families with the cost of their eventual deaths. It is as though preparation for an unburdened death should be the ultimate concern of anyone middle aged and older.

From an age-differentiated to an age-integrated society

In an age-integrated society versus an age-differentiated society (Figure 1), age does not matter as a way of determining the positions (education, work and leisure) you can take up through life. Our point of departure draws upon O'Rand's (2005) expanded model of Riley and Riley's (1994) age-integration theory, which illustrates the limited opportunities that structure an age-differentiated society and suggests ways in which roles could be restructured so that they are more accessible across the life course.

In O'Rand's expanded model she has added one role domain to the Riley and Riley model – health – in order to accommodate political assumptions about the patterns of contemporary lives in which health promotion seems to be the dominant

neoliberal discourse in living longer and better. In an age-integrated society "social roles and status transitions can occur across the life course in all domains and can impinge on each other at any time across the life span, given different life circumstances" (O'Rand, 2005: 113-114). In this sense, the onset of "old age" becomes highly contingent and lacking a fixed social status in relation to chronological age, age stratification and the distribution between the domains of education, work and leisure. According to Katz (2011), it is functional abilities and capacities that become the new markers of "old age", or more precisely what separates "the third age" from "the fourth age" and this is a turn way from the chronological approach to understanding age and ageing that follows the age-differentiated model (see Laslett, 1989).

Laslett presents four major phases or ages: in the first age of life, we are concerned about early socialisation in which a person is heavily dependent on others, usually parents; the second age is one of adult maturity in which individuals typically take on increased responsibilities for social rela-tion- ships, career development, perhaps child-rearing and financial autonomy. In the third age, Laslett refers to renewed opportunities available to adults free from the constraints of the second age: this is a time for exercising greater freedom and creativity, sometimes suppressed in "the peak" of life when duties and obligations to work take precedence. In the final and fourth age, a person prepares for death and may once again become dependent as in the first age.

This ordering of the ages calls for an analytical approach to the meaning of age in order to understand the different ways we "do juvenility" across the life course domains (health,

education, family, work and leisure) and how we are encouraged to balance resources and risks throughout the life course. According to O'Rand (2005), this balancing act can be viewed as a way of developing "life course capital", including human, social, psychophysical and personal capital. These forms of life course capital are interdependent and influence each other over the life span, and can be identified as levels of capital in accordance with status, community and institutional capital (O'Rand, 2005: 115).

Learning through life – a citizens' curriculum
Technologies of citizenship

In order to get a better grasp of the approach to the different forms of age-related capitalisation, we draw on the framework Learning Through Life, developed by Schuller and Watson (2009). We focus in particular on their work on a "citizens' curriculum" as a framing of "societal drivers" that are needed due to the juvenilisation of the subject formations available to individuals. They outline the grounding of the citizens' curriculum as follows:

> Our selection is of capabilities which enhance people's ability to exercise a degree of control over their own lives; to take part with others in decisions that affect the contexts of their lives; and to envisage alternative futures for themselves and their families. They open up space for the creative, the aesthetic, the spiritual and other essential dimensions of personal development and growth. (Schuller & Watson, 2009: 167.)

The set of capabilities which Schuller and Watson (2009) conceptualise can be interpreted as "empowerment strategies" following what Cruikshank (1999) terms "the will to empowerment":

> Individual subjects are transformed into citizens by what I call technologies of citizenship: discourses, programs, and other tactics aimed at making individuals politically active and capable of self-government. (Cruikshank, 1999: 1.)

Activity becomes the central focus of how to govern one's life. Being able to create new kinds of activities that take up "the will to empower" in order to create sites where democratic citizens can be governed by "technologies of citizenship" is central to this empowerment. The citizens' curriculum can be interpreted as just such a technology. When older adults were questioned about their plans and ideas for retirement, their responses frequently referred to activity in general and specific activities as key elements in their lives (Katz, 2000). According to Katz, these activities are mostly linked to minimising the risks of ageing such as those posed by health promotional strategies and understandings of "active ageing" (WHO, 2002; Walker & Maltby, 2012). Activities in later life are linked more specifically to minimising the risks of dependency on others. The citizens' curriculum is termed such:

> ...because citizenship is something almost all of us share, across the social and geographical divides. Citizenship as an inclusive term means that everyone should

have opportunities to take part in different spheres of activity: work, civic activity, and cultural and community life – and in our sense it extends to those living in the UK who do not have a formal citizenship. A citizens' curriculum should be interpreted in very different ways in different contexts and locales, but a common framework should reinforce some sense of common belonging. (Schuller & Watson, 2009: 168.)

Capabilities

Here we elaborate life course capital as a framing of a citizens' curriculum, with a focus on the following specific capabilities: digital, health, financial and civic capability (Schuller & Watson, 2009: 169-183). Capabilities constitute "the capacity to achieve well-being" (Schuller & Watson, 2009: 166) in these different domains in order to "pay attention to the human potential that is there to be mobilised. All individuals and groups should have the opportunity, not only to realise their full potential, but also to raise the level they aspire to achieve". What Schuller and Watson present here can be interpreted as the practice of juvenilisation; becoming a juvenile subject through the development of capabilities according to the citizens' curriculum. We need to develop digital, health, financial and civic capabilities throughout the entire life span in order to become "in order" as an individual in a contemporary juvenile but ageing society. Consequently, our performance of ageing is linked to this acceptable curriculum on ageing and the capabilities it emphasises.

This raises a new question about how and where such capabilities are developed throughout the life course in general and

throughout later life in particular. What kind of arenas can facilitate the continuation of capability development in later life? These arenas that can be interpreted as "governing sites," which in Cruikshank's (1999) vocabulary points to the practice of technologies of citizenship. In the process of contemporary self-caring you gain more control over your own later life, and at the same time you become more responsible for this continual process of developing these desired capabilities. Setting the scene for the cultivation of capabilities throughout life can be taken up by all kinds of institutional settings which aim at framing, facilitating and caring for the self in life in general and in later life in particular. Institutions can support this political agenda even while supporting the interests of older individuals.

Nordic museums as governing sites for self-caring in later life
Governing human capacities

According to Foucault (1976/1998), the administration of bodies and the calculated management of life mark a beginning of an era of "bio-power". This includes the regulated formation of the social body using methods of power capable of optimising life in general, without at the same time making it more difficult to govern. Organised around the management of life itself, new procedures of power accompanied by a long series of permanent interventions at the level of the body, personal conduct, health and everyday life have produced a new ordering of society oriented towards the future, leaving a wide range of possibilities open to the individuals throughout their entire life.

This strategy of constraint framed as opportunity can be seen in the emergence of an accountability discourse. This

discourse makes the subject appear as a consequence of a demand for accountability (Nietzsche, 1969) and unfolds in a new ageing discourse represented by images of independence, social mobility and agency (Katz & Laliberte-Rudman, 2005). In this discourse, the future of ageing societies depends on the plasticity of the individual performance underlying people's personal responsibility for their own ageing and its consequences (Rozanova, 2010).

Caring for the self in later life

The particular position that we want to outline here focuses on how the heritage sector in general and museums in particular can, wittingly or unwittingly, contribute to the overall cultivation, facilitation or management of human resources and capabilities throughout the life span according to the neoliberal and bio-political agenda of contemporary ageing societies.

Today it is commonplace for museums to organise programmes and opportunities targeted at an older adult audience (Kling, 2011; Fristrup *et al.*, 2012b; Grut, 2013; Fristrup, 2014; Nicholls *et al.*, 2013). But what takes place on a practical level in our museums has rarely been the focus of independent research seeking to explore a conceptual framework that can analyse the different activities in museums as "cases of caring for the self in later life". Thus, we are left with a great number of exemplary case studies of older people's participation in museums, but few accounts of this field from a more analytical perspective. We acknowledge the lack of theorisation as a hindrance when it comes to developing this particular aspect of museums' commitments even further.

Museums shape collective values and social understandings.

In modernity this has often implied a rather fixed set of values and understandings meant to build collective identities of a nation, region, town or people. Although this is still true for many institutions across the world, the dawn of the postmodern era has paved the way for new structures of authority and government. Today museums are increasingly being judged and measured in terms of what they do for their communities rather than what they have in their collections. If we go back just twenty years in time, we find that today's museums are also far more open, plural and participatory than they used to be (Watson, 2007: 1).

However, simply by setting grand narratives and truth claims aside, museums have not stopped exerting power over the people they interact with. The shaping of collective values and social understandings has taken a multitude of forms that are often now much more dependent on a particular context. And the context of ageing is one where we see a rapidly growing interest from museums. Our aim here has been to conceptualise this interest particularly in relation to Nordic museums. First, by pointing to the many ways in which museums can facilitate "active" later lives, and second, to better understand the preconditions involved when museums turn into pedagogical sites where the self-caring practices of older adulthood may be cultivated, facilitated, managed and governed.

The first part of this chapter aimed to elaborate a theoretical framework that allows us to examine the different examples in the second part as cases of "how Nordic museums care for the self-caring in later life". The purpose of this is to demonstrate how museums "care for" the development or cultivation

of capabilities through the activities that take place in heritage settings. In this context "the caring museum" is understood as a governing site that "cares for" (i.e. facilitates) the practice of self-care which people in later life are supposed to undertake in a juvenile but ageing society.

Framing the cases as museum caring

When museums become sites for caring, in which you can learn to take care of yourself in later life, then you can understand this process as "self-caring in later life through heritage". This is where "the caring museum" becomes one that cares for the self-caring processes in later life. The activities which take place in the museum establish an environment in which older adults can learn to take care of their ageing but still juvenile self. Technologies of citizenship, like the citizens' curriculum, can frame the requisite activities that take place in caring museums in order to facilitate the development of the different kinds of capabilities that support this process. The question is whether or not the four capabilities that are included in the citizens' curriculum (health, financial, digital and civic) can be facilitated within the heritage settings which museums offer. There is, as noted above, nothing new about heritage institutions engaging with older adults. What is new is the way museums are beginning to think about their aims, roles and methods in regard to this growing audience. The expected outcomes of learning and experiencing through heritage are also more clearly elaborated and wide-reaching than before. Today, museums want to make an impact, in a multitude of ways, on the lives of those older adults engaging with them (Zipsane, 2011: 91).

The programmes and activities described in this section are things which heritage institutions cannot achieve without the collaboration of other organisations. Along with a more "caring" approach comes the insight that collaboration is a prerequisite for museums wishing to make an impact on society and the citizens' individualised self-caring processes. A caring museum is therefore, by necessity, a collaborative and participatory museum – (on this, see for example Simon, 2010). This does in fact seem to be the case – museums understand the need to do different kinds of outreach and internal forms of engagement in order to achieve their aims. This also seems to represent a shift from the kind of critical analysis of museums we were seeing a few decades ago – that they were internally focused, lacking diversity, assuming expert knowledge and so forth. This suggests, as we explore here, that the critiques of museums must shift to accommodate these new and emergent roles as sites of self-care and activity-oriented self-regulation.

The cultivation of capabilities in museums
Developing health capabilities

Maintaining good health or well-being is a fundamental challenge to longevity which faces us all. We need to cultivate our health competences on a lifelong basis in order to "understand and deal with both our own health needs and those of others around us; and this generates a shifting mix of preferences and needs, which changes constantly as we grow older. Health capability is learning to manage the mix" (Shuller & Watson, 2009: 175).

But how do you manage the mix if you suffer from Alzheimer's disease or some other dementias? Museums have not

been slow to act on this issue, and for several decades they have promoted practices that are intended to aid people with dementias to recall their past experiences through the use of artefacts in addition to intangible items of heritage such as storytelling, music and craftsmanship. The central idea is to help people regain control over their lives, and in doing so, also increase their sense of worth, dignity and well-being. During the last ten years Nordic museums have intensified and deepened their commitment to this kind of work, and we will now identify two strands of museum work using a number of separate cases dedicated to increasing the well-being of people suffering from Alzheimer's disease and some other dementias.

The first of the two strands is driven by open-air museums. Open-air museums offer good opportunities for setting up reminiscence activities of different and varied kinds. They possess not only the objects needed but also a whole range of environments designed to trigger the memories of older adults who suffer from Alzheimer's disease and some other dementias. In the Nordic museum community, an open-air museum in Aarhus, Denmark has been conducting pioneering work in this particular field since 2004. In *Den Gamle By* (*The Old Town*), as the museum is called, a special flat has been built to house reminiscence sessions for older adults who led a family life in the 1940s and 1950s. The flat is fully equipped, displaying the style and the objects of this period, but it can also be adjusted to suit future groups of older adults. The aim is described by the initiator Henning Lindberg (2013) as follows: "to give fragile elderly people the opportunity to maintain or regain control over their own life, to hold on to their identity and self-worth, and to master their lives for an extended period" (Lindberg, 2013: 94-95).

Den Gamle By has directly inspired *Jamtli*, an open-air museum in the north of Sweden, to develop a similar approach. Their reminiscence sessions are built up around the life stories of the participating individuals. Occupational therapists who are familiar with the participants explore their life stories carefully by interviewing them and their relatives. Based on this pre-study phase, the themes and activities of the reminiscence sessions are then planned and individualised. At the outset of a programme the participants also receive their own photo book with pictures from places that have had a significance in their lives, for example their home villages, schools, workplaces etc. The photo books are also used to introduce a group of participants to each other while at the same time being reaffirming on an individual level (Borgström, 2013: 107).

The second strand of Nordic museum work dedicated to the well-being of people with dementias originates from the Museum of Modern Art (MoMA) in New York. MoMA started to develop educational training resources for people suffering from Alzheimer's disease and their carers in 2007, something which has since inspired many European museums to develop similar approaches (Adams & Cotter, 2011). Today the museum facilitates workshops for colleagues all over the world. Evaluations of the mother project, Meet Me at MoMA, suggest that participants cherish the opportunity to be intellectually stimulated and to experience art together with others. They appreciate the warm and accepting environment at the museum, and once again feel able to socialise in a way that resembles their lives before they fell ill. Afterwards, a majority of the care givers reported that the programme had elevated the mood of the person suffering from dementias (Epstein & Mittelman, 2010).

In 2011, MoMA was invited to the National Museum in Stockholm, Sweden to share their experiences of this work, and two years later a nationwide project, *Möte med minnen*, *(Meeting with memories)* was launched building on the MoMA methodology. Today, 83 museums all over Sweden participate in this project. Those participating museums receive training from the project but also let their own specific content and the experiences of their own educator influence what is being offered. But regardless of the setting, the special arrangements for this group and their carers are not just about evoking memories through art and heritage. They are about communicating with the healthy aspects of an individual, providing a new experience and doing something together (Svenskt kulturarv, 2014: 20-21). MoMA has also inspired Norwegian and Finnish museums to develop similar approaches, although many of these museums already had their own local programmes for people with dementias (Hostmaelingen, 2011: 38-39). Work which is closely related, both to the reminiscence sessions facilitated by open- air museums and to the MoMA approach, is also being done in Finnish museums (Finnilä, 2014).

Neither the work initiated by MoMA nor the kind of reminiscence sessions that are being developed in open-air museums can restore the health of dementia patients. What museums try to do for both the people with dementias and those around them is to cultivate the process of living with a disease in order to cope with and better understand the elements associated with it.

According to Housden (2007: 92), museums and libraries have in the last ten years taken advantage of the many opportunities to facilitate the sharing of memories and experiences

of people with Alzheimer's disease and related dementias by developing a variety of reminiscence and archival projects. Housden (2007: 30-34) identifies the many benefits of reminiscence including: encouraging sociability, feelings of self-worth and confidence; restoring a sense of identity; passing on family history and cultural heritage; and meeting the needs of the whole person. The thinking behind this holistic approach is that meeting the needs of the whole person is better than just medicating for behavioural changes if they can be shown to occur consistently or with people at a particular stage of their dementia.

The cases that we present here demonstrate the argument that Housden (2007) puts forward: "reminiscence and lifelong learning go hand in hand because memories can be seen as a learning resource". In that sense "reminiscence becomes a useful activity in the development of human potential because it recognises the value of every contribution a learner makes to the group". And as Housden (2007: 12-13) further points out: "The learning that takes place through this process leaves individuals in a stronger place to deal with current difficulties".

The capabilities cultivated in the different reminiscence settings can be related to health capabilities, but only because civic capabilities are cultivated as an empowering of the people with dementias in order for them to "deal with their current difficulties".

The civic capabilities become a precondition for the cultivation of health capabilities. This issue is not only related to the cultivation of the health capabilities because (as explained below) the same goes for the cultivation of digital capabilities in heritage settings. And it could easily be the case with the

cultivation of financial capabilities, but we could not find any examples which illustrate this. The bottom line is that in relation to the cultivation of the citizens' curriculum in heritage settings, it appears as if there is a hierarchy in the cultivation of the four capabilities; the cultivation of civic capabilities becomes a precondition for the cultivation of the other capabilities.

It is important to consider to the previous discussion, because it becomes much clearer that health and civic capabilities fit together due to this general "will to health" that dominates our contemporary juvenile but ageing societies (Higgs *et al.*, 2009). This overlap between the health and civic capability building is also mentioned by Shuller and Watson (2009: 174).

Developing civic capabilities

Shuller and Watson point out that "civic capability for us includes making sense of and shaping one's own and other cultures... Promoting civic capability means inviting people to play a role themselves in cultural activity, whatever form that may take" (Schuller & Watson, 2009: 178-179).

Civic capability is cultivated through freedom and its emphasis is on freedom and potential. It is about enriching civic society through its ability to bring together people from different generations, and to creatively and constructively deal with situations of complexity, uncertainty and risk in order to survive and thrive in the 21st century (Shuller & Watson, 2009: 181). What we suggest here is that "the will to empowerment" is what is being exercised in the cultivation of civic capability.

To develop or cultivate civic capabilities can mean many different things, but concepts such as lifelong learning, empowerment and freedom are key issues. In order to cultivate

civic capabilities, people are encouraged to play an active role in cultural institutions and activities, because this will help them continuously develop their own sense of self as a self-caring process that empowers them by enhancing their control over their lives (i.e. their sense of personal autonomy). From a broader perspective this will potentially help them improve both their own lives and their communities, for example by being able to fight prejudice and discrimination and respect diversities in terms of culture, religion or gender.

Volunteering in a museum can be seen as one way of developing civic capabilities. In Sweden, the majority of heritage volunteers are already older adults who perform many different kinds of tasks, such as the maintenance of venues, administrative tasks, handicraft, events and documentation (Hansen, 2013: 135-138). A study by Anna Hansen (2013: 161) shows that personal development seems to be a motivating factor for people who volunteer at museums and heritage sites. This could involve an increased desire to learn new things and to share new knowledge with others. Making new friends and meeting people that you would not have met otherwise are also identified as important motivating factors by volunteers.

In Norway the majority of volunteers are also older adults. Of the many museums in Norway, Maihaugen in Lillehammer has the longest experience of developing volunteering activities. In Maihaugen the volunteers are organised in specific groups with varied tasks and responsibilities. The first group works with all kinds of events, small and large, that take place in the museum throughout the year. The second group meets every Thursday at the museum and is mainly involved in tasks related to the archive and the library. These tasks

include transcribing old hand-writing, scanning documents, and registering and identifying photos. The third group of volunteers is connected to the Postal Museum at Maihaugen and makes accessible old documents related to the postal services. Employees at the museum function as contact persons who allocate tasks to the volunteers in the different groups. (Hegseth Garberg, 2012: 9).

What volunteers value most about their commitment is to be given tasks and responsibilities that they perceive as meaningful. Other factors which volunteers emphasise, when asked what makes them enjoy working at the museum, include the pleasant atmosphere and the chance to socialise with people over a cup of coffee (Hegseth Garberg, 2012: 16-17).

Volunteering can be seen as quite a traditional way for older adults to develop capabilities through heritage activities even though practices and ideas within this field are constantly developing. A more non-traditional example comes from Finland and concerns older adults' engagement with graffiti and street art. This is not a case from the heritage sector in the strict sense, but the idea has sprung out of a museum setting. The idea behind this case was born in 2009, when Veera Jalava, who was an art educator at the Espoo Museum of Modern Art at the time, started to wonder about ways to make older adults engage with the exhibitions. Jalava (2012) came up with the idea for a senior art project called Graffiti Grannies.

The project consisted of a set of workshops in which ten older adults were first exposed to pieces of street art and contemporary art in the museum. The group then went on to plan and paint large-scale paintings both in the Espoo Museum of Modern Art and on a newly opened, legal graffiti wall. Jalava

(2012) later left the museum and went on to do similar work on a voluntary basis. She contacted a local senior centre, which in time developed into the headquarters of what became known as the K65 Crew, the first independent and non-profit street art group for older adults to be formed in Finland and in a Nordic context. Jalava (2012) describes the members of the group not primarily as artists but as a group of "active citizens interested in contemporary phenomena". To her, being creative is a way of interacting with and understanding the society we live in, something she describes in the following way:

> The senior graffiti project is an attempt to make streets a more meaningful place for everyone. It gives the elderly a possibility to question, investigate and reclaim the changing world around them. My ambition is to open up the messages and symbols contained in the surrounding environment for seniors living in it. My basic principle is lifelong learning as a never-ending process of creating meaning. Following this, I am trying to fight prejudices, develop old people's ability to read the urban environment and to provide them with new opportunities to participate in society. (Javala, 2012)

We have only presented two examples of how museums can play an active part in developing civic capabilities among older adults. There are many other cases that would have been just as suitable in this context. Voluntarism, in a general sense, is something which Schuller and Watson (2009) themselves mention in their study as particularly important for developing civic capabilities. Even though we still know little about

volunteers and volunteering in a Nordic museum context, our cases do reveal that people search for personal development through heritage – as well as for active and meaningful engagement. The Finnish example further illustrates how the key concepts of lifelong learning, empowerment and freedom are operationalised as a method for using graffiti and street art to create meaning and agency, as well as facilitating older adults' interpretation of the changing world around them.

Developing digital capabilities

Digital capability is the fastest-changing of the four capabilities according to Shuller and Watson (2009: 170). Digital capabilities should enable people to make sense of rapid change, to adapt to change, and to shape changes, especially through the access it provides to information and ideas and the links to their fellow citizens that it makes possible. Digital capabilities have the potential to enable older people to stay in touch with friends, family and the outside world in general, which is important to people with limited personal mobility. Shuller and Watson draw the conclusion that "digital capability will be an increasingly central component of family and intergenerational learning" – a conclusion that goes well with the model of an age-integrated society, because the cultivation of digital capabilities involves different domains in later life (see O'Rand, 2005).

Researching family history is a popular activity in the Nordic countries and one that especially engages older adults. In general, family historians only start consulting the archives when they become interested in their own backgrounds. However, developing this interest also means people have to learn things that might seem remote in regard to their initial

historical interest. Today, many of the sources used by family historians are digitised and can be accessed from the archive for free or from home by paying a fee. It is thus inevitable that family researchers will gradually become acquainted with and learn how to use digitised resources.

We are only beginning to get a glimpse of the impact these activities have on individuals' lives, according to Jensen (2014: 69), following a study conducted at the Aalborg City Archive in Denmark. This research suggests that people pursuing an interest in family history, as a side effect, also develop and expand their digital capabilities. She writes: "In general, their interest in family history motivates them to continue developing their competences as they consider it an important task" (Jensen, 2014: 69). Similar conclusions can be drawn from a survey among family researchers in the Regional State Archives in Trondheim, Norway (Press, 2014: 81).

The digitisation of heritage is a major trend in European countries today which will continue for the foreseeable future. But digitisation alone is not sufficient to help people make sense of and use all available resources. Simply making resources accessible does not necessarily make them user friendly or learner friendly, so the challenge facing museums and archives alike is how to turn their digitalised materials into learning resources in self-caring processes.

Developing financial capabilities

Cultivating financial capabilities "means having the ability to locate one's financial needs in a wider context, relating material needs to other factors" (Shuller & Watson, 2009: 176). We need to cultivate a financial understanding of our situation

throughout the life course, as a growing awareness of matching consumption behaviours more accurately to our needs. The last of the four capabilities is not currently represented in the work done by the Nordic museums according to our research in the field. This might well become a new approach for the caring museum to target in the future.

Conclusions

As discussed previously, the bottom line is that in relation to the cultivation of the citizens' curriculum in heritage settings, it seems as if there is a hierarchy in the cultivation of the four capabilities. The cultivation of civic capabilities becomes a precondition for the cultivation of the others. This brings us to our concluding remarks about how to elaborate self-caring processes in later life which take place in the different contexts of Nordic museums. The desire to empower older people in Nordic museums clearly illustrates the current political drive to promote active ageing strategies and agendas. Bennett's (2005: 525) comment on the museum's capacity, "Give me a museum and I will change society", could be taken even further using our analysis: "Give us a museum and we will change the ageing society".

How to change ageing societies in order to produce unburdened and unburdensome older people is also a question about how to govern the ageing population under current neoliberal agendas. According to Foucault (1978/2008) it involves "the conduct of conduct" as a way of shaping "the art of living" in order for the ageing individual to be subject to discourses of active ageing. These act as a technique for taking responsibility for one's own ageing by caring for the ageing but juvenile

self. This self-caring process in later life can be interpreted as quite specific articulations in the broader discourses of active ageing, which emphasise a juvenile and entrepreneurial self.

The process of juvenilisation thus becomes a way of shaping the ageing self as an extension or continuation of the juvenile and entrepreneurial self. This is a "self" that doesn't place an economic burden on society. Indeed, it promotes a self whose actions are designed to avoid the possible outcome of dependency. According to the neoliberal agenda only "dependent" selves burden society – and therefore dependency must be unburdened through empowerment strategies, such as active ageing, in order to produce desired empowered and independent selves.

Our analysis demonstrates that Nordic museums have the capacity to empower people in later life to conduct a pattern of living as active citizens, working on the process of unburdening through heritage participation. What we have explored in these examples from Nordic museums points to an "individualisation" of capability development in later life. In the neoliberal agenda in contemporary societies, each older adult becomes responsible for the development of the four capabilities. The development of health, civic, digital and financial capabilities can be seen as a self-caring process in later life, but when civic capabilities precondition the development of the other capabilities it might also be possible to talk about self-caring as *self-Bildung*.

When the process of self-caring takes place on the individual's own terms, it can be understood as a self-Bildung process in order to become "in order" as an individualised person within an individualised personhood (Hammershøj, 2009: Schmidt,

2005). *Bildung* is an important concept in the German philosophical tradition that refers to the act of self-development, including the ideas of personal and social maturation. Due to advanced individualisation in late modernity; "the will to juvenility" in contemporary ageing societies preconditions self-caring processes as a specific way of taking care of the self in later life. With regard to our investigation into the cultivation of capabilities in the caring museum, we have explored how the development of civic capabilities preconditions the cultivation of the other capabilities. Activities in the museum that facilitate or "care for" the empowerment of people in later life, such as the cultivation of their civic capabilities, can therefore also be understood as a process of self-Bildung.

The central characteristic of self-Bildung is that it departs from "freedom" as a broader philosophical concept in order to cultivate freedom more narrowly as a civic capability in the lives of older adults. This marks a persistent distinction between the museum and its visitors. Museums today need to legitimise their activities as public institutions, and in this process it becomes easy to turn caring practices for older people into organisational goals for the caring museum. In this process the preconditioned freedom inherent in self-Bildung can be overlooked or redirected to serve the internal goals of the museum. The challenge for the caring museum is to try to continuously ensure that all kinds of activities are cultivated on the premise of the individual's free engagement with the museum and their aim of self-realisation across the entire course of their lives. This final point seems to support the explicit role of museums in the self-Bildung process as a key point of reference in providing gerontopedagogical sites and in

designing and implementing activities for people in later life.

Through this chapter, we hope to prompt further discussion on the ways older people might contribute to a new vision for wider impact:

> Museums change people's lives. They enrich the lives of individuals, contribute to strong and resilient communities, and help create a fair and just society. Museums in turn are immensely enriched by the skills and creativity of their public... Individuals and communities are under stress and every museum must play its part in improving lives, creating better places and helping to advance society. (Museums Association, 2013: 3.)

Museums can provide gerontopedagogical sites where people can change their later lives through heritage participation in order to cultivate their civic capabilities in potentially lifelong self-caring practices, elaborated as processes of self-Bildung. With the 21st century's turn towards a gerontopedagogicalisation of ageing yet still juvenile societies, we need to focus on the extent to which we might see older adults' application of the self-Bildung concept through heritage activities as having the potential to change museums into caring institutions. In educating, informing and building older adults' capacities, can the museum itself maintain the same relationship it has tried to have with older adults? Or are we witnessing a change that may radically alter the way we understand museums today and the relationship between museums and their "ageing but still juvenile" audiences?

REFERENCES

Adams, M. and Cotter, N. (2011). *The impact of the development of museum programs for people affected by Alzheimer's disease or dementia*. Audience Focus Inc: Annapolis, MD. https://www.moma.org/momaorg/shared/pdfs/docs/meetme/Resources_AudienceFocus_Evaluation.pdf. Accessed 03.01.2012.

Bennett, T. (2005). Civic laboratories. *Cultural Studies*, 19:5. Pp. 521-547.

Borgström, B-M. (2013). Museums and memories – stimulating the memory and estimating the quality of life. In: A. Hansen, S. Kling and J. S. Gonzalez (eds.) *Creativity, Lifelong Learning and the Ageing Population*. Östersund: Jamtli Förlag, Fornvårdaren no. 34. Pp. 102-113. http://ibc.regione.emilia-romagna.it/en/the-institute/european-projects-1/lem/the-learning-museum. Accessed 07.01.2014.

Cruikshank, B. (1999). *The Will to Empower. Democratic Citizens and Other Subjects*. Cornell University Press, New York.

Epstein, C. and Mittelman, M. (2010). *Research in Meet Me: Making Art Accessible for People with Dementia*, Museum of Modern Art: New York. https://www.moma.org/meetme/resources/index#history.

Finnilä, A. (2014). Museum brings back memories – people with memory disorders as museum guests. In: D. Christidou (ed.) *Implementing Heritage Learning Outcomes*. Östersund: Jamtli Förlag, Fornvårdaren no. 37. Pp. 35-44. http://nckultur.org/wp-content/uploads/2013/06/HLO_Final.pdf. Accessed 07.01.2014.

Foucault, M. (1976/1998). *The Will to Knowledge. The History of Sexuality: 1.* Penguin Books, London.

Foucault, M. (1978/2008). *Sikkerhed, territorium, befolkning. Forelæsninger på Collège de France 1977-1978.* København [Copenhagen]: Hans Reitzels Forlag. [Translated from French: *Sécurité, territoire, population. Cours au Collège de France, 1977-1978.*]

Fristrup, T. (2012a). Gerontopedagogicalization: A critical approach to performAGE in later life. In Jacob Kornbeck and Niels Rosendal Jensen (Eds.) *Social Pedagogy for the Entire Lifespan Volume II, Studies in Comparative Social Pedagogies and International Social Work and Social Policy, Vol. XVIII*, Europäischer Hochschulverlag GmbH & Co. KG, Bremen. Pp. 68-92.

Fristrup, T., Kling, S., Sonne, L. and Zipsane, H. (2012b). *Heritage Learning Outcomes in the Nordic and Baltic Area. Competence Development among Adults at Archives and Museums. Guidelines.* The Nordic Center of Heritage Learning and the Nordplus Adult Project "Heritage Learning Outcomes in the Nordic and Baltic Area, Östersund 2012. http://nckultur.org/wp-content/uploads/2014/03/HLO-publikation.pdf. Accessed 07.11.2013.

Fristrup, T. (2013). Craving Creativity in Later Life. In: A. Hansen, S. Kling and J. S. Gonzalez (eds.) *Creativity, Lifelong Learning and the Ageing Population.* Östersund: Jamtli Förlag, Fornvårdaren no. 34. Pp. 56-77. http://nckultur.org/wp-content/uploads/2013/10/Creativity-lifelong-learning-and-the-ageing-population.pdf. Accessed 07.01.2014.

Fristrup, T. (2014). Performing Implementing Heritage Learning Outcomes. In: D. Christidou (ed.) *Implementing Heritage Learning Outcomes*. Östersund: Jamtli Förlag, Fornvårdaren no. 37. Pp. 83-105. http://nckultur.org/wp-content/uploads/2013/06/HLO_Final.pdf. Accessed 07.01.2015.

Grut, S. (2013). The challenge of ageing populations – assessing the contribution of heritage and creative learning. In: A. Hansen, S. Kling and J. S. Gonzalez (eds.) *Creativity, Lifelong Learning and the Ageing Population*. Östersund: Jamtli Förlag, Fornvårdaren no. 34. Pp. 23-34. http://nckultur.org/wp-content/uploads/2013/10/Creativity-lifelong-learning-and-the-ageing-population.pdf. Accessed 07.01.2014.

Hammershøj, L. G. (2009). Creativity as a question of Bildung. *Journal of Philosophy of Education*, Vol. 4, No. 4. Pp. 545-558.

Hansen, A. (2013). Volunteers and heritage. In: A. Hansen, S. Kling and J. S. Gonzalez (eds.) *Creativity, Lifelong Learning and the Ageing Population*. Östersund: Jamtli Förlag, Fornvårdaren no. 34. Pp. 114-175. http://nckultur.org/wp-content/uploads/2013/10/Creativity-lifelong-learning-and-the-ageing-population.pdf.Accessed 07.01.2014.

Hegseth Garberg, A. S. (2012). *Frivillige i friluftsmuseer*. NCK: Östersund. http://nckultur.org/wp-content/uploads/2013/06/Frivillige-i-friluftsmuseer.pdf. Accessed 12.01.2013.

Higgs, P.; Leontowitsch, M.; Stevenson, F. and Jones, I. R. (2009). Not just old and sick – the 'will to health' in later life. *Ageing & Society* 29, Cambridge University Press. Pp.

687–707.

Holstein, M. B. and Minkler, M. (2003). Self, society, and the "new gerontology". *The Gerontologist*, Dec; 43 (6). Pp. 787-96.

Hostmaelingen, J. (2011). Lager museumstilbud for demensrammede. *Demens & Alderspsykiatri* vol. 15, no. 3. www.aldringoghelse.no/ViewFile.aspx?ItemID=2991. Accessed 07.01.2015.

Housden, S. (2007). *Reminiscence and lifelong learning*. Leicester: National Institute of Adult Continuing Education.

Jalava, V. (2012). Senior graffiti – On an innovative participatory project among the elderly. *Mustekala* #48. www.mustekala.info/node/35780. Accessed 07.01.2015.

Katz, S. (2000). Busy Bodies. Activity, Ageing, and the Management of Everyday Life. *Journal of Ageing Studies Activities and Active Ageing*. www.accessmylibrary.com/article-1G1-63564519/busy-bodies-activity-aging.html Accessed 01.09.2012.

Katz, S. & Laliberte-Rudman, D. (2005). Examplars of Retirement: Identity and Agency Between Lifestyle and Social Movement. In: Stephen Katz. *Cultural Aging. Life Course, Lifestyle, and Senior Worlds*. Broadview Press, Toronto. Pp. 140-160.

Katz, S. (2011). The Embodied Life Course and Biosocial Time: Functions, Boundaries, Reflections. Research paper – work in progress: *Rethinking Life Course Analysis: Social Science and Health Perspectives*. Center for Healthy Aging, University of Copenhagen, August 24, 2011.

Kaufman, S. R. (1986). *The Ageless Self: Sources of Meaning in Later Life*. Madison, Wisconsin: The University of Wisconsin Press.

Kling, S. (2011). Assessing Heritage Learning Outcomes. How do we do it – and why? In: P. Kearns *et al.* (eds.) *Heritage, Regional Development and Social Cohesion*. Östersund: Jamtli Förlag, Fornvårdaren 31. Pp. 40-59.

Lindberg, H. (2013). The house of memory. In: A. Hansen, S. Kling and J. S. Gonzalez (eds.) *Creativity, Lifelong Learning and the Ageing Population*. Östersund: Jamtli Förlag, Fornvårdaren no. 34. Pp. 94-101. http://nckultur.org/wp-content/uploads/2013/10/Creativity-lifelong-learning-and-the-ageing-population.pdf. Accessed 07.01.2014.

Laslett, Peter (1989). *A Fresh Map of Life: The Emergence of the Third Age*. London: Weidenfield and Nicholson.

Museums Association (2013). *Museums change lives. The MA's vision for the impact of museums*. London: Museums Association, July 2013. www.museumassociation.org/museums-change-lives. Accessed 14.01.2015.

Nicholls, A.; Pereira, M. and Sani, M. (eds.) (2013). *Report 2 – Heritage and the Ageing Population*. The Learning Museum Network Project, EU. The report was compiled by Sara Grut at the Nordic Centre of Heritage Learning and Creativity. http://ibc.regione.emilia-romagna.it/en/the-institute/european-projects-1/lem-html-page-redirection. Accessed 07.01.2014.

Nietzsche, F. (1969). *On the Genealogy of Morals*. Random House, New York.

O'Rand, A. (2005). When old age begins: Implications for health, work, and retirement. In: R. B. Hudson (ed.), *The*

New Politics of Old Age Policy. Baltimore: Johns Hopkins University Press. Pp. 109-128.

Popkewitz, T. (2008). The Social, Psychological, and Education Sciences: From Educationalization to Pedagogicalization of the Family and the Child. In: P. Smeyers and M. Depaepe (eds.) *Educational Research: the Educationalization of Social Problems, Vol. 3*, Springer. Pp. 171-190.

Powell, J. L. (2011). *Aging, Theory and Globalization*. New York: NOVA Science Publishers, Inc.

Press, M. (2013). Let the Grey Wave In!: Senior citizens, active ageing & archives. In: D. Christidou (ed.) *Implementing Heritage Learning Outcomes*. Östersund: Jamtli Förlag, Fornvårdaren no. 37. Pp. 72-82. http://nckultur.org/ wp-content/uploads/2013/06/HLO_Final.pdf. Accessed 07.01.2015.

Riley, M. W., and J. W. Riley, Jr. (1994). Structural lag: Past and future. In: M. W. Riley, R. L. Kahn, and A. Foner (eds.), *Age and Structural Lag*. New York: Wiley. Pp. 15-36.

Rippon, I. and Steptoe, A. (2014). Feeling Old vs Being Old. : Associations Between Self-perceived Age and Mortality *JAMA Intern Med*. Research letter published online. December 15, 2014. Pp. E1-E2.

Rozanova, J. (2010). Discourse of successful aging in The Globe & Mail: Insights from critical gerontology. *Journal of Aging Studies*, vol.24. Pp.213-222.

Schmidt, L-H. (1999). *Diagnosis III. Pædagogiske forhold* [Diagnosis III. Educational Relations]. København: Danmarks Pædagogiske Institut [Copenhagen: Danish National Institut for Educational Research].

Schmidt, L-H. (2005). *Om respekten* [On Respect].
Købehavn: Danmarks Pædagogiske Universitets Forlag
[Copenhagen: Danish University of Education Press].
Simon, N. (2010). *The participatory museum*. Santa Cruz, CA.:
Museum 2.0.
Svenskt kulturarv (2014). Möten med minnen [Meeting with
memories]. *KULT. Nyheter från Svenskt kulturarv* [News
from the Swedish Cultural Heritage], no. 3.
Walker, A. and Maltby, T. (2012). Active ageing: A strategic
policy solution to demographic ageing in the European
Union. *International Journal of Social Welfare*, 21. Pp. 1-10.
Watson S. (ed.) (2007). *Museums and their Communities*.
Abigdon/New York: Routledge.
Wearing, S. (2007). Subjects of Rejuvenation. Aging in
Postfeministist Culture. In: Y. Tasker & D. Negra (eds.)
*Interrogating Postfeminism. Gender and the Politics of Popular
Culture*, Duke University Press, Durham and London. Pp.
277-310.
WHO (2002). *Active Ageing: A Policy Framework. A contribution
of the World Health Organization to the Second United
Nations World Assembly on Ageing*, Madrid, Spain, April
2002. http://apps.who.int/iris/bitstream/10665/67215/1/
WHO_NMH_NPH_02.8.pdf. Accessed 07.06.2012.
Zipsane, H. (2011). Heritage Learning in Service for
the Memories and Life Quality of Senior Citizens.
*International Journal of Continuing Education and Lifelong
Learning*, Vol. 3, No. 2. Pp. 91-103.

STRA

TEGY

MUSEUMS AND SOCIAL PRESCRIBING

Helen Chatterjee and Linda Thomson

HEALTH AND SOCIAL CARE organisations are increasingly recognising the necessity to reform the way their services are delivered due to the rising costs of service delivery and a larger number of users. Such reforms will include an increased emphasis on public health and keeping people living independently in the community for longer, focusing on the notion that prevention is better than cure. In part, this will include greater involvement of third sector organisations, including potentially museums. Institutions such as libraries, leisure centres and volunteer agencies are already involved in providing community and social support for medical and psychological interventions. Many arts and other community-based organisations have developed more formalised relationships with health and social care providers, offering schemes described as "social prescribing" which connect primary care patients to local sources of support within the community. As community resources, museums are well-positioned to promote creative, cognitive and physical activity, and in so doing promote individual and societal well-being (Camic & Chatterjee, 2013).

The Marmot Review (Marmot *et al.*, 2010) articulated the principles of a "fair society" linking them to the challenge of addressing health inequalities. The review recognised that there was a social gradient to health where individuals from poorer socio-economic backgrounds experience poorer health, reduced well-being and less resilience to personal and social change. Although Marmot *et al.* did not refer overtly to social prescribing, scaled up nationwide versions of the model could practically address many of the points raised in the review regarding the social determinants of health.

Friedli *et al.* (2009: 2) described social prescribing as a

"non-medical intervention" to improve health and well-being that "supports improved access both to psychological treatments and to interventions addressing the wider determinants of mental health". The concept of social prescribing was established in the mid-1990s with Stockport Metropolitan Borough Council introducing an arts on prescription scheme. Creative activity was shown to: have a positive effect on mental health; was related to self-expression and self-esteem; initiated opportunities for social contact and participation (Huxley 1997); and provides purpose, meaning and improved quality of life (Callard & Friedli, 2005; Tyldesley & Rigby, 2003). The concept of social prescribing became formalised in 2002 through a workshop called Social Prescribing: Making it happen in Bromley, hosted by the London Borough of Bromley Primary Care Trust (that ceased to exist in 2013 due to the Health and Social Care Act). The workshop examined existing social prescribing practices and identified six variants:

1. Information service with advertising on notice boards and directory access but no face-to-face contact.
2. Information and telephone line with advertising and patient self-initiated telephone discussion with a health worker.
3. Primary care referral to a social prescribing service appointment.
4. Primary care referral or self-referral to clinic held in general practice acting as one-stop shop.
5. Primary care referral or self-referral to clinic held in general practice also offering an advice service, referral or signposting onwards.

6. Non-primary care referral from practice-based staff sent to a referral centre such as an community outreach service offering a one-to-one facilitation.

The Bromley workshop kept records of feedback on social prescribing and stressed that although there should be equitable access, services should be prioritised where demand was high or resources were limited, such as for areas of deprivation, vulnerable groups, high resource users of general practice, accident and emergency, secondary care services, and to avert crises.

This chapter discusses the policy impact on individual and community health and well-being and then explores the different models and referral options within social prescribing, with a focus on older adults. A range of examples of social prescribing will be examined to determine their relative degree of success, with a view to advocating models of best practice for the museums sector.

As people age, they are progressively more likely to live with complex co-morbidities, disability and frailty (Kings Fund, 2014: 1). In the United Kingdom, people over 65 account for 51% of gross local authority spending on adult social care (Health and Social Care Information Centre, 2013c) and 70% of health and social care spend is on people with long-term conditions (Department of Health 2013c). Health and social care services have failed to keep up with this demographic shift (Kings Fund, 2014: 1) and furthermore, through consultant specialisation, the NHS primarily treats patients with single organ diseases rather than those with multiple and complex conditions (Beales & Tulloch, 2013). Health reforms across

the world are a necessary response to ageing and increasingly unhealthy populations, resulting in greater numbers of individuals experiencing physical and mental ill health. Noncommunicable chronic diseases, such as heart disease, stroke, cancer, respiratory diseases and diabetes are the leading cause of mortality in the world, representing 60% of deaths (World Health Organisation (2012). In the West, increases in chronic diseases such as heart disease and diabetes are associated with unhealthy life styles and obesity.

Ageing and health

Due to the greater number of older adults there are increases in the incidence of Alzheimer's disease and other forms of dementia, and many older adults suffer mental ill health with a prevalence of anxiety and depression, often seen as precursors of dementia. Statistics show, for example, that at least one in four people will experience a mental health problem at some point in their lives, one in six adults has a mental health problem at any one time (McManus, *et al.* 2009) and that almost half of all adults will experience at least one episode of depression during their life (Andrews, Poulton & Skoog, 2005).

Older adults without a history of depression who experience depression for the first time later in life may be suffering from restricted blood flow or ischemia, where blood vessels harden and prevent blood from flowing normally to organs leading to "vascular depression" (Krishnan *et al.* 2004). As with other age groups more older women than men experience depression (National Institute of Mental Health, 2009). In response to the high incidence of mental illness, the National Institute for Health and Clinical Excellence (NICE, 2004)

established guidelines to reduce levels of inappropriate pre-scribing of antidepressants for mild to moderate depression and set up the Individual Access to Psychological Therapies (IAPT) programme, with more than £400 million committed to it over four years up to year 2014-15. The rationale behind the decision by NICE that a focus on symptoms alone was not sufficient, was due to the wide range of biological, psychologi-cal and social factors that could have a significant impact on response to treatment and yet was not captured by medical diagnostic systems. Anti-depressants were not recommended for the initial treatment of mild depression because the risk–benefit ratio was poor. NICE proposed instead that patients should be offered a guided self-help programme based on cognitive behavioural therapy (CBT). NICE recommended that further trials should be undertaken to test the efficacy of a range of social support interventions for socially isolated and vulnerable people with depression.

Radhakrishnan *et al.* (2013) calculated the costs for single IAPT sessions and found that although they were marginally higher than previously estimated, they were nevertheless a cost-effective intervention. The authors found that the average cost per session was £137.73 with low intensity sessions averag-ing £98.59 and high intensity sessions averaging £176.97. Based on research showing impressive recovery rates with IAPT for mental illness compared with medication alone, such as with cognitive behavioural therapy (CBT) (e.g. De Rubeis, *et al.* 2005), the Department of Health (DH; 2012) stated that their goal was to ensure access to psychological therapies, com-monly known as "talking therapies", by March 2015 for all those who would benefit. IAPT programmes are now available across

many areas in the UK and such programmes offer a potential avenue for cultural organisations, including museums, to link with IAPT providers through social prescribing; for example, there are already several examples of IAPT programmes offering books on prescription as part of their psychological service provision and some therapists argue that a social prescription should be the first treatment of choice given the long waiting lists in some areas for cognitive behavioural therapy.

In relation to dementia there is a significant body of research extending across the biomedical and health sciences. Of particular relevance to museums is work by Spector, Orrell and Hall (2012); this study used a longitudinal Randomised Controlled Trial (RCT) to provide evidence of the value of cognitive stimulation therapy (CST) for people with dementia. Central to CST is the use of multisensory methods associated with increased cognitive processing and establishing new connections in the brain. Spector *et al.* (2012: 244) cited evidence from the neuroscience literature to suggest that "the adult brain retains significant neuronal plasticity and therefore has the capacity for regeneration and compensation". Similarly, social prescribing with activities providing mental and physical engagement is also likely to lead to increased cognitive processing and there are already examples of museums offering CST activities, such as Beamish an open air museum in the north of England. CST offers significant potential and is advocated as a therapeutic intervention in UK guidelines (NICE-SCIE, 2007:1.6.1):

> People with mild-to-moderate dementia of all types should be given the opportunity to participate in a structured group cognitive stimulation programme. This should be

commissioned and provided by a range of health and social care staff with appropriate training and supervision, and offered irrespective of any drug prescribed for the treatment of cognitive symptoms of dementia.

Currently, however, there is very little robust evidence of the impact of cultural-CST interventions using RCTs or other approaches, and this is an area of research which requires further study.

Museums, health and well-being

There is a growing body of evidence which describes the social inclusion role of museums and the role that museums play in improving health and well-being (Chatterjee & Noble 2013; Group for Large Local Authority Museums (GLLAM), 2000; Sandell, 1998). This research has shown that engaging in museum activities (gallery talks and tours, special exhibitions, museum object handling and discussion, reminiscence and creative activities based on museum collections, and outreach activities) has resulted in: positive social experiences, leading to reduced social isolation; opportunities for learning and acquiring news skills; calming experiences, leading to decreased anxiety; increased positive emotions, such as optimism, hope and enjoyment; increased self-esteem and sense of identity; increased inspiration and opportunities for meaning making; positive distraction from clinical environments, including hospitals and care homes; and increased communication between families, carers and health professionals (Chatterjee & Noble, 2013: 115). GLLAM (2000) cited Plymouth City Museum and Art Gallery working with Plymouth City

FIG. 1: UCL Museums outreach activity at a community centre in central London. © UCL.

Council's sheltered housing unit that carried out reminiscence activities with older adults normally isolated from social activities. The approach emphasised the skills and experiences that people in the community could contribute.

Given the wide range of benefits it is not surprising that more and more museums and galleries are adapting their access programmes to consider the wider social, health and well-being benefits that museum encounters can bring about (Figure 1). Research shows that there are many associations between ageing and social isolation, loneliness, physical and mental ill-health (Schoenmakers *et al.*, 2014; Windle *et al.*, 2011). Given the aforementioned benefits of museum engagement it is easy to see how museums could fit into a new era of health commissioning. One of the biggest challenges facing the museums sector is the understanding of how best to meet the social and psychological needs of the local community as an adjunct to medical interventions and forge links between service providers, health and social care services and GP practices. Friedli *et al.* (2009: 2) considered that social prescribing "has the potential to become fully integrated as a patient pathway for primary care practices and to strengthen the links between healthcare providers and community, voluntary and local authority services that influence public mental health". They proposed that local authority services might include culture, education, employment, environment, leisure and welfare, many aspects of which could be provided by museums.

Social prescribing
The mental health report of the UK Government, *The Pursuit of Happiness: A new ambition for our mental health*, (The

CentreForum Mental Health Commission, 2014:6) defined social prescribing as:

> ...a mechanism for linking patients with non-medical sources of support within the community. These might include opportunities for arts and creativity, physical activity, learning new skills, volunteering, mutual aid, befriending and self-help, as well as support with, for example, employment, benefits, housing, debt, legal advice, or parenting problems. Social prescribing is usually delivered via primary care – for example, through "exercise on prescription" or "prescription for learning", although there is a range of different models and referral options.

The CentreForum Mental Health Commission (2014:47) recommended that social prescribing by GPs "should be available in every primary care practice in order to connect patients to local well-being services and other support available in the wider community that can address the psychosocial factors that influence well-being" provided that sufficient community structures were in place.

Friedli *et al.* proposed that within primary care, social prescribing would be helpful for "vulnerable and at risk groups (e.g. low-income single mothers, recently bereaved elderly people, people with chronic physical illness, and newly arrived communities); people with mild to moderate depression and anxiety; people with long-term and enduring mental health problems; and frequent attenders in primary care." They also noted that most models of social prescribing were primary

care-based projects in which vulnerable patients were referred to specific programmes (e.g. arts on prescription or exercise on prescription) although patients also could also be signposted to sources of information or support within the community or voluntary sector.

The Scottish Development Centre for Mental Health (2007: 5) noted that "social prescribing is a valuable complement to other recent and on-going developments within the NHS to promote access to psychological treatments and interventions". The Centre recognised that social prescription or "informal referral" was helpful in addressing the needs of people reluctant to refer themselves to mental health services and offered low cost alternatives to medication or talking therapies, especially where the demand outweighed the supply. It was noted that social prescribing could be particularly useful in addressing psychosocial issues leading to mild anxiety or depression and where direct referral to psychiatric services was not deemed appropriate. The notion of social prescribing was influenced by the quality of life and well-being agenda supported by the Scottish government's policy on arts and culture. The agenda's aims were to increase participation from deprived and marginalised groups, reduce social exclusion and help people take responsibility for actively managing their own health, promoting opportunities for physical activity and a holistic view of health.

The Care Services Improvement Partnership (CSIP) North West (2006) emphasised that social prescribing involved "a range of non-clinical interventions, which recognize that many mental health problems are not purely bio-medical phenomenon, but are influenced by a myriad of social factors.

Social prescribing is an innovative approach to tackling health inequalities, which involves using partnership work to address determinants of mental ill health. It involves signposting and referring to various agencies and initiatives which tackle some of these social causes. It is interesting, therefore, that Grant, Goodenough, Harvey and Hine (2000) found that only 50% of referrals came from general practice with others originating through health and social care visitors and self-referral. Goodhart and Graffy (2000) found that GPs identified additional costs of social referral, particularly in keeping abreast of the various schemes available within the local community and the time taken to identify those of most use to a particular patient. The authors noted, however, that GPs failed to take account of long-term community benefits or the reduction in the burden on social services. Within this framework there is considerable potential for museums and other cultural organisations to contribute to social prescribing, in particular by offering a one-stop shop to GP practices and other prescribers within a model of partnership working.

Models of social prescribing

There are a range of different models of social prescribing and referral options across the UK that have resulted in varying degrees of success. Commonly known models of social prescribing include *arts on prescription, books on prescription, education on prescription* and *exercise on prescription*. Lesser known community referral schemes include *green activity*, a form of exercise in a natural environment and a range of *healthy living initiatives* (HLIs) that use social prescribing models to support health improvement and address health inequalities.

HLIs encourage people to try new activities, develop new skills, make new friends and have the opportunity to experience an enjoyable time. The focus of the HLI is on the future and giving people hope; the schemes reject traditional therapeutic approaches that appear to reinforce negative thoughts (e.g. suicide, self-harm, lack of self-efficacy and self-worth). HLIs include *computerised therapy*, a form self-help reading but online and often with a facilitator; *supported referral*, that could be for any of the schemes supported by a facilitator; and *information prescriptions* signposting people to available services within their communities that support health and well-being. The range of different models of social prescribing within the UK, are outlined and discussed below.

Arts on prescription
Arts on prescription comprise a broad spectrum of creative activities including dance, drama, film, music, painting, photography, poetry and sculpture. Programmes across the UK offer a series of workshops to support participants suffering from anxiety and other mental health issues. Arts on prescription is differentiated from art therapy/art psychotherapy which in the UK is a professional discipline where art therapist/art psychotherapist training is validated by the Health and Care Professions Council though it may have similar aims in enabling a client to change and grow. As with many community based initiatives, however, much arts on prescription evaluation has been based on small-scale surveys with short term outcomes that lack a longitudinal dimension and has also been reliant on anecdotal evidence or has failed to identify arts-specific aspects of the programme (Coulter, 2001). Museums

should consider employing more robust means of evaluation with large-scale studies that consider both quantitative analysis using health and well-being scales (e.g. Hospital Anxiety and Depression Scale; Warwick-Edinburgh Mental Wellbeing Scale) and qualitative analysis of interviews and conversation (e.g. Grounded theory analysis; thematic analysis) for the duration of the intervention with up to two years follow-up assessment taken at regular (e.g. two or three months) intervals. A further consideration is the use of randomised controlled trial (RCT) methodology where participants are randomly assigned to either the intervention group or a comparator group (e.g. waiting list control) and the two groups are compared over time on measures of interest. The use of an RCT is particularly important for interventions with older adults, as a museum activities may show no difference in measures of well-being if the intervention is acting to combat cognitive decline which is often progressive; it is only when the measures are compared with controls experiencing "life as usual" who show a decline in well-being that a comparison can be made.

Books on prescription/bibliotherapy

Bibliotherapy is the use of self-help books and written material to enable patients to understand and manage their psychological problems. Books written by health professionals employ principles of CBT, used by mental health workers for people experiencing common mental health conditions including anxiety, depression, phobia and some eating disorders. Other books give information about a condition (self-help books based on CBT practices) or provide motivation and inspiration (mood-boosting books) to help overcome a range of mild

to moderate mental health conditions (e.g. anxiety, depression, social phobia, obsessive compulsive disorder). Bibliotherapy usually takes the form of a referral by a GP or mental health worker for a particular book to be borrowed "on prescription" from a local library and are also available for people to borrow without a prescription so that people can seek help and support for a mental condition without seeing a GP. Other opportunities for developing bibliotherapy within a social prescribing model include GP referral or self-referral to reading groups or literature with a personal development theme (Reading Agency, 2013).

The Reading Well Books on Prescription scheme is led by the Reading Agency in partnership with the Society of Chief Librarians (SCL) and supported by Arts Council England. The Reading Agency and SCL's aim was to make the best use of resources by creating a shared national model for Books on Prescription, incorporating quality assurance, best practice and creation of a national evidence base. Its core book list of 30 titles was developed by researching existing best practice and consulting with national health stakeholders including the Royal College of GPs, the Royal College of Nursing, the Royal College of Psychiatrists, Mind, the Department of Health's IAPT programme, and the British Association for Behavioural & Cognitive Psychotherapies. Hicks (2006) reported that over half of the library authorities in England operated some form of bibliotherapy and that Books on Prescription operated nationally in Wales but there was little communication between schemes and sharing of good practice.

In 2010, The Reading Agency and the Library and Information Statistics Unit (LISU) at Loughborough University

conducted research for the Museums, Libraries and Archives Council (MLA) that revealed considerable health and well-being library activity but the lack of a coherent strategic framework for delivery. In February 2012, the Public Library Health Offer Group was awarded £19,900 from the Library Development Initiative. Books on Prescription was originally intended to launch as a pilot in January 2013 with 63 authorities but due to the popularity of the scheme, it instead was launched nationally across 84% of English library authorities in May 2013. The Reading Agency worked with the Public Library Health Offer Group and partners to develop central resources and materials and as the scheme rolls out, libraries will operate as the local coordinators working directly with local partners, GPs and community health nurses. Although the scheme was based on self-help reading, it was hoped that participants would be signposted to other aspects of the library health offer such as mood boosting novels and poetry, and reading groups. Although museums are mostly unlikely to be associated with book-lending schemes, they can benefit from lessons learned in partnership practices and use of community spaces.

Education on prescription/Learning on prescription
Education on Prescription consists of referral to a range of formal learning opportunities, including literacy and basic skills. It can involve the use of learning advisers placed within educational establishments, day services, mental health teams or voluntary sector organisations to identify appropriate educational activities for individuals and to support their access. Opportunities for learning can impact positively on health by improving an individual's socio-economic position, access

to health services and information, resilience and problem-solving, and self-esteem and self-efficacy (National Institute for Adult Continuing Education, 2003). A longitudinal American study (Vemuri *et al.*, 2014) examined the relationship between lifetime intellectual enrichment and cognitive decline in older adults. The authors concluded that higher education/occupation scores were associated with higher levels of cognition. Higher levels of mid/late-life cognitive activity were also associated with higher levels of cognition, but the slope of this association slightly increased over time. They concluded that lifetime intellectual enrichment might delay the onset of cognitive impairment and be used as a successful preventive intervention for dementia. Many museums have outreach programmes (e.g. the House of Memories project at the National Museums Liverpool) taking loan boxes of museum objects to care homes and day centres where objects are used to enhance cognitive stimulation for older adults with dementia through creative thought processes and the stimulation of multiple senses.

Exercise on prescription/Exercise referral

Exercise on Prescription involves referring clients to supported exercise programmes such as cycling, guided healthy walks, green activity, gym or leisure centre activity, keep fit and dance classes, swimming and aqua-therapy, and team sports. The benefits of exercise referral include learning new skills and achieving goals, increasing self-esteem, meeting new people, adding structure to the day and improving patterns of sleep, as well as improving physical health. Since being set up in 1990, UK exercise referral schemes have increased to around 600

different programmes (Pavey *et al.*, 2011). Research has shown that regular exercise releases naturally occurring morphine-like neuropeptides (endorphins) produced by the central nervous system and pituitary gland that inhibit the transmission of pain signals and produce a feeling of euphoria similar to that produced by other opioids (Vaughan *et al.*, 2014; Hillman, Erickson & Kramer, 2008). Museums are well-placed within the community to offer their expertise and knowledge for exercise-oriented events such as heritage walks (e.g. historic buildings, botanical gardens, cemeteries) in addition to collections-inspired creative arts exercise (e.g. dancing, playing historic musical instruments, singing). Working in partnership with third sector agencies (e.g. charities such as the Alzheimer's Society, Mind and Sense) can help fill the skills gaps and enable museums to develop programmes which tackle specific physical, cognitive or psychological issues within the community.

The British Heart Foundation (2010) evaluated over 150 schemes and found variation in inclusion-exclusion criteria, programme duration, exit strategies, adherence to Department of Health guidelines, qualifications and scheme evaluation. The Joint Consultative Forum (JCF, 2011) produced professional standards for health professionals and fitness instructors that incorporated performance benchmarks, evaluation, accreditation and appraisal of instructors. The JCF aimed to promote schemes of long-term benefit within the normal management of chronic disease or disability and/or one or more cardiovascular risk factors. NICE (2014:5) updated its 2006 guidelines on exercise referral for adults, stating that, "physical activity can play an important role in preventing and managing health conditions such as coronary heart disease, type two diabetes,

stroke, mental health problems..."

Few schemes specifically target older adults even though many diseases managed through exercise referral become more prevalent with increasing age; there also appears to be mix of reported benefits from such schemes. The Camden Active Health Team in the London Borough of Camden set up an exercise referral scheme with inclusion criteria of chronic disease (e.g. obesity; diabetes; osteoporosis; cardiovascular disease), mental illness (e.g. neuroses; psychoses), and age, 60 years and over. Evaluation by Middlesex University (first 14 months) showed high completion rates and self-reported improvements in mental health and positive mood but problems with public transport were a barrier to attending.

In South Gloucestershire, Flannery *et al.* (2014) used the Warwick-Edinburgh Mental Well-being Scale (WEMWBS, 2006) to evaluate an exercise referral programme involving over 2,500 participants aged 18 to 94 years (average 53 years). Inclusion criteria included a body mass index greater than 30 and depression. They found a significant self-reported pre-post well-being increase with a corresponding decrease in systolic blood pressure and waist measurement but no significant differences for weight, body mass index, hip measurement or diastolic blood pressure.

In Lincolnshire, Henderson and Mullineaux (2013) analysed completion rates for a scheme with over 6,600 participants and showed that older adults aged 70 to 79 were three times more likely to complete the 12-week course than younger adults aged 18 to 29. Milton (2008) evaluated exercise referral in Eastern and Coastal Kent with over 6500 participants (averaging 50 years of age). Although participants reported physical benefits, some

felt demotivated at not achieving physiological aims and drop out factors included injury or ill health, lack of instructor support and not knowing how to use gym equipment correctly. The cost of continuing after the initial subsidised twelve weeks was cited as a barrier by older adults. Overall findings indicate that older adults are generally committed to completing courses provided that they are properly supported in terms of their access, social and psychological needs and that the barriers to programme entry are kept at low level.

Green activity/Ecotherapy/Green gyms

Green activity schemes support patients in becoming both physically and mentally healthier through contact with nature and include gardening, growing food, walking in parks or the countryside, nature conservation work (green gyms) and developing community green spaces. Physical exercise in a natural environment (green exercise) is associated with increases in self-esteem, positive mood and self-efficacy (Pretty *et al.*, 2003). The British Trust for Conservation Volunteers (BTCV) (2002) found a significant improvement in mental health in the first three months of participation as measured by the SF-12 health-related quality of life instrument. Factors motivating continued participation in green activity included the social aspect of working with a group, increased awareness of conservation and countryside issues, and doing something worthwhile. Green activity was viewed by over 260 participants with a common age category of 61–70 years, primarily because of the predominance of older adults in of the walking groups as being beneficial to their mental health and well-being (Pretty *et al.*, 2003). An evaluation of green gyms (BTCV, 2002) demonstrated

a range of physical and mental health benefits, including reductions in symptoms and improvements in quality of life. "Being out in the countryside" emerged as a significant motivating factor, supporting other findings on the potential therapeutic value of the natural environment.

Examples of social prescribing

There are many examples of social prescribing schemes in the UK and elsewhere, and although they are too numerous to discuss in detail here, a selection will be described including, where available, evidence of their value and impact for older adults, with a particular focus on those involving museums.

Claremont Project Social Prescribing

The Claremont Project, a resource centre in the London Borough of Islington, carried out two one-year social prescribing schemes (2012-2013 and 2013-2014) funded by Islington Giving, a charity encouraging local residents to raise money, or give time to the local community. The aim of the Claremont scheme was to facilitate social prescribing to connect isolated older Islington residents to the Claremont Project service providing a range of social, physical and therapeutic activities. The project aimed to reach a sub-set of isolated people aged 55 plus and especially targeted older men aged 70-plus, those who were mobile but not currently engaged in any community services, and those who were from black and ethnic minorities. The referral criteria also included those experiencing mild to moderate mental health issues (e.g. depression) and physical ailments (e.g. balance or co-ordination difficulties). The centre normally offers a range of activities including keep fit, tai chi,

dance, gentle exercise, creative writing and crafts for older adults that participants attend as members with subsidised fees of £1.50 to £2 per class.

It was initially envisaged that referrals would be made through local GP surgeries by GPs and practice nurses who would issue the patient with a Claremont "prescription" though, in fact many prescriptions were made by other health professional including Physiotherapists, Occupational Therapists or Keyworkers (public sector employees offering a key service, e.g. National Health Service staff except doctors and dentists, social workers and therapists), with a minority by self-referral. Participants attended an assessment interview at Claremont where the reason for referral was discussed with the Social Prescription Manager who used the Warwick-Edinburgh Mental Well-being Scale (WEMWBS, 2006) to assess their level of health and well-being, their suitability to function in a group situation and exactly which group would be appropriate. A personalised programme aimed at improving the health and psychological well-being of the patient was devised from the interventions available (except the choir and art therapy due to over subscription) for an initial three weeks and they were given a timetable. Participants were asked to sign a consent form to allow their GP or other referrer to be informed of their progress. After three weeks another interview and WEMWBS assessment was carried out and a further three week timetable determined. Assessment was carried out again at the end of the three weeks.

The total of six weeks of classes was free and if participants wished to continue attending classes at Claremont, they were invited to become "members", paying the subsidised fees.

Participants were signposted to other services of benefit if relevant. Further assessment was conducted at three-month follow-up either through interviews with participants still attending classes or by post. Evaluation by the resident counselling psychologist suggested that both real and perceived barriers to access had been broken down through participation in classes. Participants reported feeling less lonely and isolated, socialised more with others and many would call in, as members, for a hot drink and a chat in the lounge area outside of classes.

Greenwich Healthy Living Service

The London Borough of Greenwich Healthy Living Service provides a number of free activities including weekly one-hour exercise to music sessions for participants aged 50 and over and a series of one-off facilitated health walks exploring Greenwich Park. It offers weekly educational courses for adult carers (6 x 2.5 hours) called Look After Me and adults with a long-term mental health condition (7 x 2.5 hours) called New Beginnings. The courses aim to encourage people to manage their life, time and conditions more successfully using holistic methods that explore skills and techniques (e.g. action planning, difficult feelings, exercise, healthy eating, managing tiredness, problem solving and relaxation).

Aberdeenshire Mearns and Coastal Healthy Living Network

The Mearns and Coastal Healthy Living Network was established in 2002 specifically for older adults living in this part of north-east Scotland. The network operates in partnership with statutory and voluntary organisations, and community groups

to improve the health of older participants. The network aims to increase mental capacity through the Older People's Network, intergenerational activities, training and information, providing services such as shopping, transport and a handyperson, incurring a small charge.

Dulwich Prescription for Art

The Dulwich Picture Gallery in South London in the London Boroughs of Southwark and Lambeth was founded in 1811 and has been involved with outreach programmes for over 20 years. The gallery introduced the Prescription for Art scheme after its success with the Good Times older adults' programme launched in 2005 partnering with 65 organisations to take art workshops into the community. The Prescription for Art programme was developed through GP practices where practice nurses with responsibility for older adults identified those at risk, for example frail, lonely, disabled, caring for relatives or suffering bereavement and who did not attend regular senior or community groups, and offered them a prescription to attend creative art workshops at the gallery. More recently the Kings College Hospital Memory Clinic has referred older adult patients to Dulwich's art workshops for free creative stimulation sessions. Prescription for Art has its own co-ordinator, a team of volunteer helpers and a rota of artists. Sessions attended by up to 20 participants include silk and glass painting, lino printing, sketching and clay work. A review of the Good Times programme by the Oxford Institute of Ageing (Harper & Hamblin, 2010) reported that the gallery "sees no reason why older people, even if they have never been involved in any art before, even if they have physical or mental

disabilities, should not be able to tackle similar sorts of creative challenges as do other adult groups, with a few adjustments to make certain aspects easier".

Oxford Memory Lane Prescription for Reminiscence

The Prescription for Reminiscence project built on existing museum services across the Oxford Aspire Museums Partnership, a consortium of Oxford University museums and Oxfordshire County Council museums Service (and one of sixteen Renaissance Major Partner Museum Services funded by ACE to support excellence and resilience within regional museums). Older adults were referred by local healthcare centres to the scheme and self-referral was accepted. Participants were offered an introduction and access to the Museum of Oxford's Memory Lane Group monthly meetings, also the Memory Lane Movers and Shakers (allied to the Get Moving dance project) offering a second monthly session and other suitable museum services and projects. The scheme was based upon the Memory Lane reminiscence group that started in 2010 as an informal gathering, meeting monthly at the Museum of Oxford, or nearby museum and heritage locations, to reminisce about a chosen theme and enjoy company in a comfortable and stimulating environment. Topics for the sessions were often linked to an exhibition theme, for example in 2013 the Working in East Oxford session contributed content to the community exhibition East Oxford From Above. Each meeting was recorded and a copy of the recording was offered to all participants and also the Oxfordshire History Centre, making a lasting contribution to the Oxfordshire Archives.

A leaflet with relevant information was provided for

referral partners that included information for participants. The Reminiscence Officer made contact with participants and directed them to appropriate museum services and projects across the Oxford Aspire Partnership. The partnership comprises a consortium led by the Museum of Oxford and Oxford Aspire. Delivery Partners include the Oxford University Museums Outreach Service, Ashmolean Museum, Pitt Rivers Museums, Oxford Museum of Natural History, Museum of the History of Science, Oxford Botanic Gardens and Hands on Oxfordshire Heritage (Oxfordshire County Council Museum Service). Referral Partners include the Oxford University Hospitals NHS Trust, Oxford Health NHS Foundation Trust, Guideposts Trust, Young Dementia UK and Oxfordshire County Council Dementia Advisors.

The objectives of the scheme were to increase the number of people benefiting from the existing museum services for older people; target individuals most at risk of isolation and related health problems; increase psychological well-being via a stimulating environment and companionship; maintain and improve physical health through gentle exercise; reduce the number of falls, health problems and hospital admissions; maintain cognitive function by providing a stimulating environment; create a seamless museum offer for older adults in Oxford and the local area; build on the existing service provision for older adults and strengthen partnership work; create opportunities for research into the impact of taking part in museum-related activities on older adults with research partners Oxford Institute for Population and Ageing. The project represents an excellent model for partnership working between museums and health referrers, and benefits from providing

enhanced access to existing museums services which has implications for sustainability.

Museums on prescription: the future

A key feature of many social prescribing schemes is that they are time-limited and often run on a project-by-project basis, as and when funds are available. This has significant implications for sustainability, both for the organisations involved and the long-term health and well-being of their target audiences. Museums also face the challenge of being reliant on time limited funding and as such there is a strong argument for working in partnership in order to pool both resources and expertise. Partnering with health and social care referrers as well as other providers such as third sector charities and community organisations, and other social prescription schemes, including arts on prescription and exercise on prescription, offers an intriguing opportunity for museums. Museums can support both physical and mental stimulation by offering activities involving movement, walking, cognitive and creative tasks. For example, museums with outdoor spaces or even heritage trails around buildings or the museum space itself, provide opportunities for increasing physical exercise. If delivered in tandem with cognitively stimulating and creative activities, there is considerable potential for museums to offer a plethora of interactive and engaging activities, and in so doing contribute to the social prescribing agenda.

Critically, robust evaluation is needed of the impact of social prescribing schemes on participants' health and well-being, but also the value to relevant stakeholders including referrers, other partners, carers and family members. Research

at University College London (UCL), funded by the Arts and Humanities Research Council (AH/L012987/1), is investigating the development and efficacy of a "museums on prescription" scheme in South East England. Despite social prescribing for the arts, books, exercise, education and information being quite well established, the potential museum referral offer is still in its infancy. The research will connect socially isolated, vulnerable and lonely older adults, referred through local NHS, Local Authority Adult Social Care services and local branches of Age UK, to partner museums in Central London (The British Museum, UCL Museums, Islington Museum, Central Saint Martins Museum and Study Collection, The British Postal Museum and Archive) and Kent (The Beaney Museum, Tunbridge Wells Museum and Art Gallery, Maidstone Museum and Art Gallery). A series of other partners in the research, including Arts Council England and the Royal Society for Public Health, will provide policy perspectives on the role of museums in health and consider routes to sustainability. In addition, The New Economics Foundation (NEF Consulting) will produce a cost-benefit analysis to gain an understanding of the economic costs and value of Museums on Prescription.

Within the new era of health commissioning in the United Kingdom, museums have every opportunity of repositioning their services to meet the growing needs of an ageing and increasingly unhealthy society. In 2014 the Cultural Commissioning Programme was launched (CCP, 2014); funded by Arts Council England and led by the National Council for Voluntary Organisations, the programme is working with a range of cultural organisations, including museums, and with commissioners and policy makers to bring these sectors together

and strengthen the environment for cultural commissioning. With a focus on cultural commissioning and grounded in a robust evidence base, museums can make a strong case for being active players in the field of social prescribing, and other areas of health and social care support.

REFERENCES

Andrews, G., Poulton, R. & Skoog, I. (2005). Lifetime risk of depression: Restricted to a minority or waiting for most? *British Journal of Psychiatry 187*, 495–496. DOI: 10.1192/ bjp.187.6.495.

Beales, D, & Tulloch, A. (2013). 'Community care of vulnerable older people: Cause for concern'. *British Journal of General Practice: The Journal of the Royal College of General Practitioners, 63(615)*, 549–50.

Brandling, J. & House, W. (2007). *Investigation into the Feasibility of a Social Prescribing Service in Primary Care: A pilot project.* Bath: University of Bath and Bath and North East Somerset NHS Primary Care Trust.

Brandling, J. & House, W. (2009). Social Prescribing in General Practice: Adding meaning to medicine. *The British Journal of General Practice, 59(563)*, 454–456.

British Heart Foundation (BHF) National Centre for Physical Activity and Health (BHFNC) (2010). A *Toolkit for the Design, Implementation and Evaluation of Exercise Referral Schemes.* Loughborough: Loughborough University; British Heart Foundation. www.bhfactive.org.uk/sites/ Exercise-Referral-Toolkit/downloads.html Accessed 21 January 2015.

British Trust for Conservation Volunteers (BTCV) (2002). *Green Gym Research Summary.* Oxford: Oxford School for Healthcare, Research and Development, Oxford Brookes University.

Callard, F. & Friedli, L. (2005). Imagine East Greenwich: Evaluating the impact of the arts on health and

wellbeing. *Journal of Public Mental Health 4(4)*, 29–41.

Camic, P. M. & Chatterjee, H. J. (2013). Museums and art galleries as partners for public health interventions. *Perspectives in Public Health*, 133, 66–71. http://dx.doi.org/10.1177/1757913912468523.

Care Services Improvement Partnership (2009). *Social Prescribing for Mental Health: A guide to commissioning and delivery.* Manchester: CSIP North West.

Care Services Improvement Partnership North West (2006). *Briefing Document on Social Prescribing.* Manchester: CSIP.

CentreForum Mental Health Commission (2014). *The Pursuit of Happiness: A new ambition for our mental health.* London: CentreForum. http://www.centreforum.org/assets/pubs/the-pursuit-of-happiness.pdf (Accessed 03/10/14).

Chatterjee, H. J. & Noble, G. (2013). *Museums, Health and Wellbeing.* Ashgate Publishing Ltd. Farnham, UK; Burlington USA.

Clark, D.M., Layard, R., Smithies, R., Richards, D.A., Suckling, R. & Wright, B. (2009). Improving access to psychological therapy: Initial evaluation of two UK demonstration sites. *Behaviour Research and Therapy, 47,* 910–920.

Coulter, F. (2001). *Realising the potential of cultural services: The case for the arts.* London: Local Government Association.

Cultural Commissioning Programme (2014). Helping the arts & cultural sector to better engage in public sector commissioning. http://www.ncvo.org.uk/practical-support/public-services/cultural-commissioning-programme Accessed 21 January 2015.

Department of Health (2012). *IAPT Three Year Report: The*

first million patients. London: Department of Health. http://www.iapt.nhs.uk/silo/files/iapt-3-year-report.pdf Accessed 3 October 2014.

Department of Health (2013c). *Improving quality of life for people with long term conditions.* London: Department of Health. www.gov.uk/government/policies/ improving quality-of-life-for-people-with-long-term-conditions. Accessed 19 March 2015.

De Rubeis, R., Hollon, S., Amsterdam, J., *et al.* (2005). Cognitive therapy vs medications in the treatment of moderate to severe depression. *Archives of General Psychiatry 62(4)* 409–416.

Flannery, O., Loughren, E., Baker, C., & Crone, D. (2014). *Exercise on Prescription Evaluation Report for South Gloucestershire.* Cheltenham: University of Gloucestershire.

Friedli, L., Jackson, C., Abernethy, H. & Stansfield, J. (2009). *Social Prescribing for Mental Health - A guide to commissioning and delivery.* Lancashire: Care Services Improvement Partnership. http://www. centreforwelfarereform.org/uploads/attachment/339/ social-prescribing-for-mental-health.pdf Accessed 7 October 2014.

Goodhart, C. & Graffy, J. (2000). Long term benefits need to be taken into account when evaluating family support projects. *British Medical Journal, 320,* 1600–1600.

Grant, C., Goodenough, T., Harvey, I. & Hine, C. (2000). A randomised trial and economic evaluation of a referrals facilitator between primary care and the voluntary sector. *British Medical Journal 320(7232),* 419–432.

Group for Large Local Authority Museums (GLLAM) (2000). *Museums and Social Inclusion: The GLLAM Report*. Leicester: Research Centre for Museums and Galleries (RCMG), Department of Museum Studies, University of Leicester.

Harper, S. & Hamblin, K. (2010). *Oxford Institute of Ageing Report Good Times: Art for Older People at Dulwich Picture Gallery*. Oxford: Oxford Institute of Ageing, University of Oxford.

Health and Social Care Information Centre (2013c). *Personal social services: expenditure and unit costs, England 2012–13, provisional release*. Leeds: Health and Social Care Information Centre. https://catalogue.ic.nhs.uk/publications/social-care/expenditure/pss-expeng-12-13-prov/pss-exp-eng-12-13-prov-rpt.pdf. Accessed 19 March 2015.

Henderson, H. & Mullineaux, D. (2013 Unpublished). *Lincolnshire exercise referral evaluation*. Lincoln: University of Lincoln. http://eprints.lincoln.ac.uk/12661/.

Hicks, D. (2006). *An Audit of Bibliotherapy/Books on Prescription Activity in England*. London: Arts Council England.

Hillman, C.H., Erickson, K.I. & Kramer, A.F. (2008). Science and Society: Be smart, exercise your heart: exercise effects on brain and cognition. *Nature Reviews Neuroscience, 9*, 58-65 doi:10.1038/nrn2298.

Huxley, P. (1997). *Arts on Prescription: An evaluation*. Stockport: Stockport Healthcare NHS Trust.

Joint Consultative Forum (JCF) of Medical Royal Colleges, Chartered Society of Physiotherapy and the Fitness Sector of the United Kingdom (2011). *Professional and Operational Standards for Exercise Referral*. www.ukactive.

com/policy-insight/ukactive-for-health/the-joint-consultative-forum/ Accessed 21 January 2015.

The King's Fund (2014). *Making our Health and Care Systems fit for an Ageing Population*. London: The Kings Fund.

Krishnan, K.R.R., Taylor, W.D., McQuoid, D.R., MacFall, J.R., Payne, M.E., Provenzale, J.M. & Steffens, D.C. (2004). Clinical characteristics of magnetic resonance imaging-defined subcortical ischemic depression. *Biological Psychiatry. 55(4)*, 390-397.

Marmot, M. *et al.* (2010) *Fair Society, Healthy Lives. Marmot Review*. Available at http://www.instituteofhealthequity.org/projects/fair-society-healthy-lives-the-marmot-review. Accessed 20 October 2014.

McManus, S., Meltzer, H., Brugha, T., Bebbington, P., & Jenkins R. (2009) *Adult Psychiatric Morbidity in England, 2007: Results of a Household Survey*. National Health Service Information Centre for Health and Social Care.

Milton, K. (2008) *Final Report of the Evaluation of the Eastern and Coastal Kent Exercise Referral Scheme*. Loughborough: Loughborough University.

National Institute for Adult Continuing Education (2003). *Mental Health and Social Exclusion – Social exclusion consultation document: A commentary and response from the National Institute for Adult Continuing Education*. Nottingham: National Institute for Adult Continuing Education. www.niace.org.uk Accessed 21 January 2015.

National Institute for Health and Care Excellence (2004). Depression: management of depression in primary and secondary care. *NICE Guidelines CG23*. https://www.nice.org.uk/guidance/cg23 Accessed 21 January 2015.

National Institute for Health and Care Excellence (2006). Four commonly used methods to increase physical activity. *NICE Public Health Guidance, 2.* London: National Institute for Health and Care Excellence. www.nice.org. uk/guidance/ph2/chapter/recommendations#exercise-referral-schemes Accessed 21 January 2015.

National Institute for Health and Care Excellence (2014). Exercise referral schemes to promote physical activity. *NICE Public Health Guidance, 54.* London: National Institute for Health and Care Excellence. www.nice.org. uk/guidance/ph54 Accessed 21 January 2015.

National Institute for Health and Clinical Excellence – Social Care Institute for Excellence (2007). Dementia: Supporting people with dementia and their carers in health and social care. *NICE Clinical Guideline 42.* London: https://www.nice.org.uk/guidance/cg42 Accessed 21 January 2015.

National Institute of Mental Health (2009).Women and Depression: Discovering Hope. Besthesda Maryland: National Institute of Mental Health.

Pavey, T.G., Anokye, N., Taylor, A.H., Trueman. P., Moxham, T., Fox, K.R., Hillsdon, M., Green, C., Campbell, J.L., Foster, C., Mutrie, N., Searle, J., & Taylor, R.S. (2011) The clinical effectiveness and cost-effectiveness of exercise referral schemes: A systematic review and economic evaluation. *Health Technology Assessment, 15(44).* Accessed www.journalslibrary.nihr.ac.uk/hta/volume-15/issue-44 Accessed 21 January 2015.

Pretty, J., Griffin, M., Sellens, M. & Pretty, C. (2003). Green Exercise: Complementary roles of nature, exercise, diet

in physical and emotional wellbeing and implications for public health policy. *CES Occasional Paper, 1.* Chelmsford: University of Essex.

Radhakrishnan, M., Hammond, G., Jones, P., Watson, A., McMillan-Shields, F. & Lafortune, L. (2013). Cost of improving access to psychological therapies (IAPT) programme: An analysis of cost of session, treatment and recovery in selected Primary Care Trusts in the East of England region. *Behaviour, Research and Therapy, 51,* 37–45. DOI: 10.1016/j.brat.2012.10.001.

Reading Agency (2013). *Reading well.* http://readingagency. org.uk/adults/quick-guides/reading-well/ Accessed 21 January 2015.

Sandell, R. (1998). Museums as agents of social inclusion. *Museum Management and Curatorship, 17(4),* 401-408.

Schoenmakers, E.C., Van Tilburg, T.G., and Fokkema, T. (2014). Awareness of risk factors for loneliness among third agers. *Ageing and Society, 34,*1035-1051. doi:10.1017/ S0144686X12001419.

Scottish Development Centre for Mental Health (2007). *Developing Social Prescribing and Community Referrals for Mental Health in Scotland.* Glasgow: Healthier Scotland Scottish Government. http://www.scotland.gov.uk/ Resource/Doc/924/0054752.pdf Accessed 10 October 2014.

Spector, A., Orrell, M. & Hall, L. (2012). Systematic Review of Neuropsychological Outcomes in Dementia from Cognitive-Based Interventions. *Dementia and Geriatric Cognitive Disorders, 34,* 244–255.

Tyldesley, R. & Rigby, T. (2003). The Arts on Prescription Postnatal Depression Support Service: An evaluation of

a twelve week pilot. Stockport: Stockport Primary Care Trust.

Vaughan, S., Polit, D., Steel, M., Shum, D. & Morris, N. (2014). The effects of multimodal exercise on cognitive and physical functioning and brain-derived neurotrophic factor in older women: A randomised controlled trial. *Age and Ageing, 43(5)*, 623-629. doi: 10.1093/ageing/afu010.

Vemuri P, Lesnick TG, Przybelski SA, *et al.* (2014) Association of Lifetime Intellectual Enrichment With Cognitive Decline in the Older Population. *JAMA Neurology.* 71(8):1017-1024. doi:10.1001/jamaneurol.2014.963

Warwick Edinburgh Mental Well-being Scale [WEMWBS] (2006) © NHS Health Scotland, University of Warwick and University of Edinburgh. Available at: http://www.healthscotland.com/documents/1467.aspx Accessed on 22 January 2015.

World Health Organisation (2012). *Assessing National Capacity for the Prevention and Control of Noncommunicable Diseases: Report of the 2010 Global Survey. Geneva: World* Health organisation.

Windle, K., Francis, J., Coomber, C. (2011) *Preventing Loneliness and Social Isolation: Interventions and Outcomes.* Social Care Institute for Excellence (SCIE) Research Briefing 39. http://www.scie.org.uk/publications/briefings/briefing39/ Accessed 20 October 2014.

MOMENTUM: DEVELOPING AN AGE-FRIENDLY CITY, CULTURE AND MUSEUMS

Esme Ward and Andrea Winn

THIS CHAPTER EXPLORES the role of museums at the heart of the United Kingdom's leading age-friendly city. Manchester is telling a new story about the ageing experience and culture, with museums as one of its most powerful narrators. Drawing upon evidence and practice across the city, this chapter outlines an integrated approach and reflects on lessons learnt and progress to date.

Manchester: ambition and ageing

Manchester is an ambitious city. As the birthplace of the industrial revolution, a culture of innovation and enterprise was born that continues today. As Manchester embraces the idea of becoming age-friendly, it does so with the ambition of becoming a leading world city. Its aspiration is, put simply, to become one of the greatest places in the world to grow older.

This presents a significant challenge in a city where the profile of disadvantage includes the second lowest male life expectancy in England, comparatively low numbers of over sixties and significant Black and Minority Ethnic (BME) populations and disproportionately high levels of pensioner poverty, ill-health and disability.[1] "There is emerging evidence that urban environments may place older people at a heightened risk of isolation and loneliness." (Scharf and Gierveld, 2008.) Yet in 2003, the Valuing Older People strategy was launched by Manchester City Council to involve older people in decision-making and address the challenge outlined by the World Health Organisation: An age-friendly city is a city that encourages active ageing by optimising opportunities for health, participation and security in order to enhance quality of life as people age (WHO, 2007: 6).

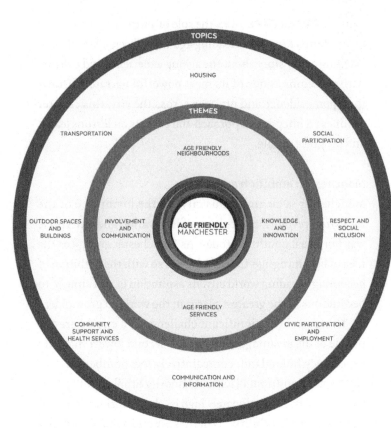

FIG.1: Age Friendly Manchester: Sphere of Influence overview.

In 2009, Manchester became recognised as the United Kingdom's first Age Friendly city. The age-friendly city approach is an internationally recognised concept that enables and facilitates good quality of life for older people. It is also a World Health Organization-led movement of over 100 cities worldwide in which Manchester has played a leading role since 2010.[2] John Beard, Director of the Department of Ageing and Life Course at the World Health Organisation recently commented: "Manchester has established itself at an international level as a leading authority in developing one of the most comprehensive strategic programmes on ageing." (Beard, 2013.) It has done this through adopting a collaborative approach, which sees key partners, organisations and services working together in their collective aim to improve the ageing experience. This cross-sector work brings together housing, transport, public health, social care, research and culture but perhaps most significantly, older people themselves, as an integral part of the process (Figure 1).

Coordinated by Public Health Manchester, the ambition is also to become a centre of excellence for research, policy and practice in the field of ageing. Over the last decade, Manchester has developed a citizen-based approach to ageing. It has shifted the focus away from traditional medical and care models around provision to developing programmes that are led by older people as active citizens. Presented as an alternative to the loss-deficit model of ageing so prevalent in the media, (where the narrative is of bio-medical solutions to ageing bodies), this approach views older people as assets and focuses on active ageing. An increased focus on the individual and personalised resonates across sectors; from the growth in patient and public involvement initiatives within healthcare to

MEDICAL	CARE	CITIZENSHIP
Patient	Customer	Citizen
Focus on individual	Focus on individual, family and informal networks	Focus on neighbourhood and city
Clinical interventions	Care interventions	Promoting social capital and participation
Commission for "frail elderly"	Commission for vulnerable people	Age-proofing universal services
Health (and care system)	Whole system	Changing social structure and attitude

FIG. 2: The citizenship-based approach. Source: Valuing Older People, Manchester City Council, 2012.

the growth in peer-led programming and prioritisation within Arts Council funding to place visitors at the heart of cultural organisations. Figure 2 outlines this distinctive approach in an age-friendly context, with its focus on neighbourhood, participation and social change.

This is the context for cultural organisations working in the city, with culture clearly identified as a strategic priority within the city's Age Friendly Plan. Cultural organisations across the city, including museums, orchestras, theatres and participatory arts organisations, come together to develop the universal age-friendly cultural offer and explore new partnerships and ways of working, particularly how to reach vulnerable older people and those who participate least in cultural activity. An Age Friendly Culture Manager is not aligned to any one cultural organisation, but ranges across the city; coordinating activities, developing funding proposals and partnerships and promoting culture to care settings, charities and older people across Manchester. Museums are at the heart of this work and over the last five years have seen a significant increase in programming, funding and research in this area. An additional £500,000 has been invested in new cultural projects/programmes with older people during the past three years, from a range of sources including Trusts, Foundations and government. Many of these programmes are led by museums, including a volunteering programme targeting socially isolated older people and the development of age-friendly mobile collections.

By older people, for older people

"Age-friendly programmes are created in conjunction with the people of Manchester, for the people of Manchester; bringing

them to the people, for active participation in a way that creates value and experience for all." (Age Friendly Manchester Plan, 2014.) This responds to the asset-based approach to co-production of public services, outlined by Boyle and Harris (2009). Although in museum literature much has been written about co-production, from the perspective of exhibition-making or community relations (Lynch, 2009; Simon, 2010), there has been limited exploration of the co-creative process demanded by an age-friendly ethos. What might co-creation mean for the age-friendly museum? In Manchester, we are exploring this through the development of the Culture Champions programme.

One of the flagship Age Friendly programmes for the city is Culture Champions, a large-scale volunteer ambassador scheme for older people within Manchester's communities. Over 120 Culture Champions advocate, lead and programme activities for their peers. Key to the success of the scheme has been the recruitment of volunteers who are "willing and committed" to the project itself rather than the targeting of specific wards or demographics. This "alliance of the willing" share their insights, experiences and knowledge of cultural programmes with their friends, networks and local communities. Word of mouth is one of the most effective ways to share information about what is on offer. To extend engagement to older people who may be house-bound or socially isolated, we are embarking on an age-friendly community radio scheme, where Culture Champions broadcast content (inspired by and linked to cultural organisations) and reach people in their own homes.

Over the past four years, the scope and reach of Culture

Champions has grown; from advocacy to tour leaders, evaluators and programmers. This shift was most neatly summarised during a meeting to look at a new national Arts and Older People strand of funding. A range of cultural and third sector organisations met with several Culture Champions to explore possible bids. One of the champions, rightly frustrated by the process, commented: "I've sat here for the last god-knows-how-long and heard all about what Manchester's cultural offer can do for me. I'm just wondering when you're going to ask what I can do for it!"

The resultant funding bid was unsuccessful but the process highlighted the untapped creative potential in the city and started a significant shift in practice. In museums and galleries across the city, older people now regularly programme age-friendly events, late night openings, Philosophy Cafes (Manchester Art Gallery), lead tours and group visits and co-develop exhibitions. These are aimed at inspiring and supporting Manchester's diverse older population to fulfil their creative potential. For example, when the Whitworth Art Gallery started a new digital course with Workers Educational Association (WEA), it embedded this "by older people, for older people" approach. Older learners from WEA developed a free, collections-based sensory play iPad app, designed especially for adults and their carers who are living with dementia. The app is intended to start conversations, encourage play and keep the mind active.[3]

Over an eight week course, participants worked closely with curators, app designers, sound engineers and care settings to select specific art works and actions that will help capture the attention and imagination of adults living with dementia. The

FIG. 3: Whitworth ArtSense app.

Art Sense app has been piloted in hospitals, day centres and care homes as part of a wider programme exploring iPad creativity in care settings and is freely available on the app store.[4] Active participation by older people lies at the heart of the age-friendly ethos. An alliance of the willing is a good start and yet we know there remain many barriers to accessing cultural facilities, exhibitions and related offerings. These include transport; finances, physical health and anxiety, particularly for those living in the suburbs. A key shared priority is to reach those who participate least through both the development of outreach work, expanding the cultural mobile offer and developing new ways to welcome and open up the museum to vulnerable and more isolated older people.[5]

Creativity, imagination and cognitive development

Museums and galleries are crammed full of objects and artworks of historical, social and personal significance. In Manchester, we use the collections and sites to open up conversations and focus on in-the-moment creative activity for older people and those who care for them.

The Whitworth and Manchester Museum programme Coffee, Cake and Culture exemplifies this approach. It seeks to stimulate imagination, encourage conversation and develop creative capacity. The programme of fully supported visits to the museum and gallery is facilitated by museum and gallery staff and aimed at groups in which people living with dementia receive support; from a care home, hospital setting or supported housing community. It reaches those least likely to participate by targeting groups through local health and care networks. Participants are introduced to the gallery spaces

FIG. 4: A participant in the Coffee, Cake and Culture programme at the Whitworth.

through a guided tour led by a member of staff who will focus on key objects or artworks allowing for discussion and conversation. The groups engage in sensory-based activities such as handling objects, making their own artworks or listening to music that encourages movement, dance or singing.

The Coffee, Cake and Culture programme developed from a pilot and feasibility study carried out over a six month period in 2012 (Figure 4). During the pilot study, the museum and Whitworth worked on a programme of outreach and in-reach activities with residents with early on-set dementia, from both a residential care setting and a supported housing venue. The focus throughout was on creativity rather than reminiscence, memory or recall, allowing carers and residents to work together without adding the pressure of remembering, which can sometimes create distress. Professor Brenda Roe from the School of Nursing, Midwifery and Social Work, The University of Manchester carried out the feasibility study. She concluded that, "the programme is feasible and facilitates older people from care homes and supported living communities to access public museums and galleries with programmes designed to support their needs. The programme encouraged creative arts, cultural appreciation and social engagement which, in turn promoted well-being, quality of life and social inclusion". (Roe et al., 2014.)

The aim of the pilot study was to identify the potential impact on the health and well-being of the residents and if there were additional benefits for the carers. Seventeen residents, ten care staff and one family member attended the sessions. The visits consisted of several stages, which informed the development of the permanent programme; first, visitors

and carers were met on arrival and welcomed. The second stage consisted of a guided tour of an exhibition or a single gallery space. The third stage was a creative activity followed by refreshments and discussion. The final stage was a farewell and departure. Each stage of the visit was considered important to support care staff. Extra staff were available to support the groups' movement around the building and additional seating or wheelchairs were made available, when required.

Several key findings emerged, including the significance and value of stories and the act of storytelling. Although the focus in not on recall or memory, participants often re-tell familiar stories from their past. Trevor told us of his army days posted in Jamaica, a familiar and often repeated memory for care staff and co-residents. When shown a Jamaican butterfly from the museum's collections, his narrative shifted. He told us, at some length, about the Blue Mountains (the only part of the world this butterfly is found) and how they are so-called because at dusk, they turn an inky colour. He captivated us with his sensory description of this land, how it looked and smelled.

> The grand old process of storytelling puts us in touch with strengths we may have forgotten, with wisdom that has faded or disappeared and with hopes that have fallen into darkness. (N. Mellon, 1992)

Coffee, Cake and Culture actively encourages participants' engagement with collections, but also with each other and their own personal and shared histories. Often, participants create new stories together. *Bert and Charlie's Adventure* was

created after a visit to the museum's natural history collections, as part of a series of Coffee, Cake and Culture visits by residents and carers from Shore Green care setting (Figure 5).

Bertie and Charlie's Adventure

Bertie the tiger is two years old.
Charlie the jaguar is thirty years old.
They are from Africa.
Charlie befriended Bertie because he is so young.
They hatched a plan and escaped Belle Vue
They were fed up of kids coming into the zoo so they escaped for the summer.

They went to Wythenshawe.
People from Wythenshawe are from all over the country.
They took the 101 bus.
They didn't have to pay because they used their teeth to scare the driver.
On the bus they met Bette Lynch and Lenny Henry.
They met a squirrel called Cyril and had a chat.

This is why they shut Belle Vue down.
They had penguins at Belle Vue.

In Wythenshawe, Charlie and Bertie had to go to the park.
They went to the petting zoo. The food there is fresh.
They looked after each other.
Charlie gave food to Bertie.

FIG. 5: A Coffee, Cake and Culture storytelling session at Manchester Museum.

They felt tired then and wanted to go to sleep.
So they decided to go to Shore Green.
They went to the pub on the way.
They needed a drink after their adventure.
They had a few too many sherries so they were tipsy.
They went back to Shore Green, where is safe and secure
and there are no children.
They slept in the gardens.

In this context, within museums where you often encounter
the unexpected, storytelling is both creative act and collabora-
tive learning process. As this project worker from Shore Green
observed of her team of carers:

> It's a talking point to trigger conversations. It gives them
> things to talk about with residents and it helps them
> bond - builds relationships. Not seeing the person in a
> care context but in a social context, the staff saw the res-
> idents differently, in a new light. (Care Centre Manager)

Residents and carers support each other and enjoy their visits
together, often learning something new, whilst collections and
objects can create focus points or catalysts for conversations
that are removed from the daily routine of care-setting life,
allowing each participant freedom to be creative or engaged.
This can often be taken back to the care setting through art-
works and stories created, for example.

We know that people living with dementia need cognitive
stimulation, along with opportunities to interact meaningfully
with their physical and social environments on a regular basis.

They love it, getting out and being in normal society, being in hustle and bustle, seeing other people was good... They enjoyed the learning, all really listened and their attention increased over the weeks, as they knew what to expect. (Supported Housing Manager).

An increase in attention and focus is particularly visible during art and craft sessions. Another resident, Laney, rediscovered her love of drawing, with a high level of attention to detail and absorption in the activity. Now, when stressed or uncertain, staff use drawing as a positive influence on her mood and to help focus her behaviour. But for Laney, drawing does more than calm her mood.

Creativity in later life is nothing new. We can take our lessons on ageing from art history, full of men and women who prove the lie that creativity is the preserve of the young. Examples range from Picasso, Miró, Cézanne and Matisse, all artists who continued working throughout their lives, to Louise Bourgeois, who only became a household name in her late seventies. In *Winter Fires: Art and Agency in Old Age*, François Matarasso shares the compelling stories and experiences of older artists and explores how the practice of art might improve the experience of ageing. He argues that few activities confer agency and autonomy as powerfully as the making of art (Matarasso, 2012: 4-5). This resonates with Laney and others living with dementia, for whom making art provides a unique opportunity to express themselves. In addition, the social context of the visit in the museum or gallery encourages them to share their work and this process with their co-residents and carers.

Across the cultural sector, there are arguably more opportunities than ever to celebrate creativity in older people; from dedicated festivals such as *Bealtaine*, an annual national arts festival in Ireland, to Selfridge's BRIGHT OLD THINGS campaign promoting what it terms the retirement renaissance and inspiring individuals who have found a new artistic vocation in later life. One of the flagship programmes of the reopened Whitworth, Manchester's gallery in the park, is *Handmade*, a weekly sociable craft workshop produced by and for older people, particularly older men.

At the precise moment when fears around ageing are numerous; including economic concerns, campaigns to end loneliness and regular scare stories about dementia and its impact in the media, museums and galleries can bring a different, often more positive perspective focused on well-being and creativity. When you are surrounded by objects hundreds if not thousands of years old or drawings created on the other side of the world, you view things differently. Time slows down. You are no longer a consumer. You draw upon your lived experience to understand the world around you (older people have more of this than most). You make meaning from your encounters.

Collaborative advantage
Coffee, Cake and Culture is an example of a multi-disciplinary programme that has brought together health and social care partners, researchers, museums and older people themselves. It follows the age-friendly model and reflects the desire to create scope and scale through partnership working. In large part, this collaboration is borne of necessity. The Age Friendly Manchester team has no money to give out and instead fosters

collaborative work to sustain and grow the programme. Partnerships can be in the public sector, the private sector, with educational establishments, community and cultural organisations and other third sector agencies.

Cultural organisations across the city have become adept at working together to share practice, training and community programmes. In 2013 Manchester Museum hosted a training day exploring the use of Montessori learning techniques and their impact on people with dementia. The day was aimed at health and culture staff and drew upon the knowledge and experience of Alzheimer's South Australia. The day skilfully interweaved clinical and creative examples and brought staff together to share their expertise. An outcome of this has been the co-development of Montessori resources for people with dementia within the museum and Alzheimer Society Dementia Friends training for staff and volunteers across cultural organisations in the city.

There is also a real drive in building a dialogue between interdisciplinary research, practitioners and older people. The Manchester Institute for Collaborative Research on Ageing (MICRA) at the University of Manchester promotes interdisciplinary research on all aspects of ageing.[6]

The Institute acts as an information hub for research on ageing, linking academics and serving as an entry point for those interested in research. Research spans the breadth of disciplines including architecture, economics, engineering, history, life sciences, medicine and sociology. Through its seminars and events programme, MICRA has a reach of over 1000 people, around half of whom are not academics. Older people actively participate in the seminar programme and the

lunches beforehand provide opportunities for networking and act as a conduit for connecting university academics with older people and practitioners.

As an aspirant Knowledge Capital for Age Friendly Cities, with research and educational partnerships with academic centres of excellence, museums and galleries are able to draw upon a rich vein of expertise, insight and evidence. Manchester Museum and the Whitworth, as cultural institutions owned by the University of Manchester, are perhaps uniquely placed to connect with and learn from the work of MICRA. This includes hosting regular events and seminars and co-developing research and evaluation programmes, such as Coffee, Cake and Culture. In addition to drawing upon evidence to shape programmes and work, they have focused on how to work most effectively to bridge the gap between academic research, policy and practice. Work with university academics has sought to share research and findings with a wider public and highlight the role of the museum and gallery as sites of exchange and ideas.

In 2013, Manchester Museum hosted a cross-sector Age Collective seminar to explore how museums and galleries can better work with and for older people in their communities in partnership with organisations from other sectors. Age Collective (now re-named Age Friendly Museum Network) is a partnership led by the British Museum to encourage museums to work with and for older people (Figure 6).

This seminar was a partnership with the Age Friendly team and MICRA and brought together over 40 academics, clinicians, policy-makers, museum staff, older people and their carers. It used an Open Space technique to enable collaborative

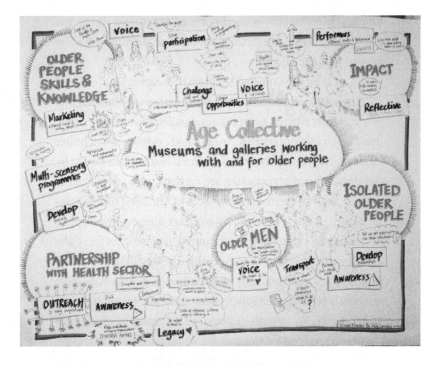

FIG. 6: Visual minutes from Age Collective seminar, Manchester, 2013.

discussion between museums working with older people, and stakeholders beyond the heritage sector.[7] Open Space is an approach which focuses on specific purposes or tasks but begins without a formal agenda, therefore creating time and space for people to engage deeply and creatively around issues that concern them.

The seminar took place at Manchester Museum, surrounded by natural history and geology collections. Many familiar topics were raised as part of this process, including how to measure the impact of this work and how to reach isolated older people. In addition to these, less regularly discussed topics came to the fore, including concern about engaging older men and a focus on end-of-life care. Conversations were wide-ranging and sector-specific terminology was soon replaced with everyday phrases and shared language. What might bravery or risk-taking look like in a clinical as well as cultural context? Did cultural participation include allotments, gyms, pubs and if not, why not? Might exploring other cultures provide new ways to address end of life care for clinicians working in this field? What might we all learn about engaging older people by talking to the person next to us?

If research is a "process of steps used to collect and analyse information to increase our understanding of a topic or issue" (Creswell 2009), this seminar acted as a catalyst for age-friendly museum programmes across the city. We have since held additional seminars: on dementia and intergenerational learning (with MICRA); on creativity and stroke (with the Stroke Association); and on the cultural participation of older men (supported by the Baring Foundation). However, the main purpose of these events is not to create new activities

but to build relationships and understanding between sectors, develop a shared language and embed engagement with quality research from the outset.

Museums are well placed to do this. We are free places for public learning and enjoyment. In a time of significant financial austerity, it is essential to work together in this way to maximise resources, funding, expertise and creativity. It is only by making the most of our collaborative advantage that we will be able to extend our reach to the widest range of older people. For example, by drawing upon evidence from researchers which highlighted low levels of social and cultural participation amongst BME communities in South Manchester, a group of museums, libraries and theatres developed a targeted six-month programme in partnership with the African Caribbean Day Centre.

Momentum

By bringing together thinking, programmes and partnerships, museums are contributing to a city-wide story. Manchester's most recent Lord Mayor was Councillor Sue Coolley. Under her watch, Manchester became the UK's first age-friendly city. Her flagship theme whilst Mayor was Age Friendly Manchester, enabling her to highlight and celebrate the contribution older residents make to the city by working further with communities, organisations and individuals. Cultural organisations and museums are at the heart of this. When the Whitworth Art Gallery recently reopened after £15 million transformation, one of its key events during the opening weekend was an age-friendly afternoon tea, hosted by the Lord Mayor, to encourage older residents, champions and advocates to participate in and

shape the cultural life of the city. The Whitworth's age friendly work was highly praised by judges when they recently awarded the gallery the prestigious Artfund Museum of the Year award. To rewrite the story of old age is a bold aspiration but Manchester is, and always has been a progressive city, not just in thinking, but actions too. As Anne Karpf recently highlighted:

> There's a paradox at the heart of cities and old people, and it's this: all the research on health and well-being – and there's reams of it – suggests that old people are more content and more likely to flourish if they go out, participate in local life and have a decent amount of social interaction.[8]

It's why our work is aligned with city-wide public health priorities and emerging discussions around the role of culture and well-being in the liveable city, particularly within the context of health and social care devolution in Manchester. (Greater Manchester is the first English region to get full control of its health spending, as part of an extension of devolved powers). It's why older people and the health, social care and third sector organisations that work with them are critical partners in our work. The aspiration to be an inclusive city that provides a voice for older people and drives social change means influence is delivered locally but also leads thinking on a global scale for organisations such as the World Health Organisation (WHO).

Alongside academic centres of excellence in ageing research, cultural organisations play an integral role in creating an environment or ecology that supports active urban ageing. Other cities around the world look towards Manchester

as a benchmark, to learn from and engage with. The global and growing interest in the development of age-friendly culture in the city over the last few months has resulted in delegations and study trips (museums, arts organisations and educators) from Singapore, Japan, Denmark, Germany and the United States. Momentum is a useful way of reflecting on work to date; an expression of this growth, a direction of travel, an energy and spirit of continuous improvement. Museums are powerful narrators, adept at storytelling. This story has just begun.

NOTES

1. http://www.manchester.gov.uk/info/200048/health_and_wellbeing/5962/public_ health.

2. See http://www.who.int/ageing/age_friendly_cities_guide/en/.

3. See https://itunes.apple.com/gb/app/art-sense/id710446369?mt=8.

4. http://ipad-engage.blogspot.co.uk/.

5. Museum Comes to You case study: http://www.ageofcreativity.co.uk/items/645.

6. http://www.micra.manchester.ac.uk/events/.

7. http://www.ageofcreativity.co.uk/items/507.

8. http://www.theguardian.com/commentisfree/2015/mar/15/age-friendly-cities-design-future.

REFERENCES

Age Friendly Manchester Plan 2014-2016, Manchester City Council publication. http://www.manchester.gov.uk/downloads/download/5770/age-friendly_manchester_plan.

Beard, J. (2013), *Australian Age Friendly Cities and Communities Conference*. World Health Organisation. https://www.youtube.com/watch?v=P60-qh9sZAc.

Boyle, D. and Harris, M.(2009), *The Challenge of Co-Production: How equal partnerships between professionals and the public are crucial to improving public services*. NESTA.

Creswell, J. W. (2009). *Research Design: Qualitative, Quantitative, and Mixed Methods Approaches*. Thousand Oaks, CA: SAGE Publications.

Lynch, B. (2009). *Whose cake is it anyway? A collaborative investigation into engagement and participation in 12 museums and galleries in the UK*. London: Paul Hamlyn Foundation.

Matarasso, F. (2012), *Winter Fires: Art and Agency in Old Age*. London: The Baring Foundation.

Mellon, N. (1992), *Storytelling and The Art of Imagination*. Yellow Moon Press.

Roe, B., McCormick, S., Lucas, T., Gallagher, W., Winn, A. and Elkin S. (2014). Coffee, Cake & Culture: Evaluation of an art for health programme for older people in the community. *Dementia*, 0(0) 1–2, DOI: 10.1177/1471301214528927.

Scharf, T. & J. de Jong Gierveld (2008). Loneliness in Urban Neighbourhoods: An Anglo-Dutch Comparison.

European Journal of Ageing, 5, 103-115.

Simon, N. (2010), *The Participatory Museum*. Museum 2.0, California.

WHO (2007), *Global Age-friendly Cities: A Guide*. World Health Organisation, Switzerland.

THE CACE FRAMEWORK: A STRATEGY FOR ART MUSEUMS TO THRIVE AND SUSTAIN IN AN AGEING WORLD

Ta-Sitthiporn Thongnopnua

IN THE LIGHT OF the rapidly increasing aging population in most countries around the world and the corollary notion that their well-being would be a global benchmark for civilized living (Kinsella & Phillips), the arts and creativity have been gaining momentum as a model for healthy and purposeful aging (Cohen, 2000, 2001; Hanna; Hanna & Perlstein). The practice of integrating arts and aging has occurred for decades since the focus of successful aging has shifted to emphasize quality of life in addition to quantity of life (American Federation for Aging Research & the Alliance for Aging Research; Bearon; Fries & Crapo; Havighurst). However, there has been a critical gap between creating and sustaining a full cycle of meaningful experiences for the elderly population to engage in art, from passive observation to active participation (Thongnopnua, 2013a; Thongnopnua, 2013b).

To strive for sustainability and social contribution in an aging world, rather than simply riding the wave of demographic change, art museums need to strategically plan and scaffold their own paths to perpetual growth. When we look more closely, apart from turning into inclusive elder-friendly communities, little empirical evidence exists about how to make arts and creativity services successfully play an important dynamic part in building an effective ecosystem of leisure activities for promoting active meaningful lifestyles among senior citizens (Arts Council of Northern Ireland; Cohen, Perlstein *et al.*; Cutler; Hanna & Perlstein; Sherman; Todd & Lawson). In this chapter, I discuss my recently developed CACE Framework, which provides a promising and practical strategy for art museums to thrive and sustain in the global aging societies. The framework not only touches on areas of advocacy

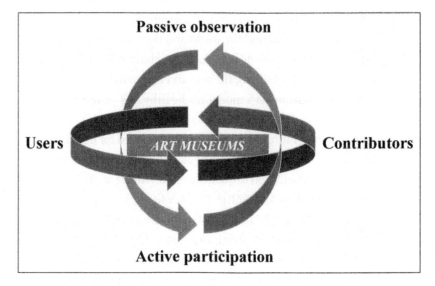

FIG. 1: A full cycle of arts and museum engagement.

and leadership development, but also revolves around aspects of globalized communities by cultivating a healthier sense of universal responsibilities and transforming diversities into creative visions and constructive inventions for everyone.

Contemplate + Associate + Collaborate + Evaluate

I developed the CACE Framework (pronounced the same as *cake*) for art museums to use for the sustainable contribution of values and benefits to society in an aging world. The ultimate purpose of the framework is to create and perpetuate a full cycle of meaningful art experiences and creativity engagement, from passive observation to active participation, for the aging population in and across communities. Since a full cycle of arts engagement animates a process of turning the elderly from users of museum services to contributors to them, the CACE Framework accentuates a series of actions taken in order to not only foster active healthy lifestyles among senior citizens, but to also make a contribution to building an ecosystem of leisure activities for community well-being (see Figure 1).

The framework is a structure for repeatedly generating a cycle that consists of four processes: *Contemplate, Associate, Collaborate,* and *Evaluate.* A review of the literature that supports each of these four courses of action and examples of methods for carrying them out are as follows.

1. Contemplate

In the first stage of developing a full cycle of arts engagement for the aging population, art museums need to *contemplate* every kind of experience that they offer as a means to answer all of the who-what-when-where-why-how questions and to better

understand the big picture. Before examining how museum experiences are constructed, who these older museum visitors are must first be understood (Thongnopnua, 2013b). Furthermore, being aware of factors that form seniors' attitudes and actions helps art museums envisage not only elderly visitors' in-museum behaviors, but also their distinctive motivations for visiting, reflections on their own experiences, and the impacts of their museum visitations on them. Thus, the Contemplate stage incorporates three sub-processes. Fundamentally, art museums need to reflect on and ask themselves these three questions:

- Who are older museum visitors?
- What are older visitors' attitudes and actions?
- When-where-why-how do older visitors' meaningful experiences occur?

Who are older museum visitors?

To gain a deeper understanding of their older museum visitors, art museums need to keep in mind that every cohort "has a different set of shared experiences and external influences during their youth" (Wilkening & Chung, page 7). To make sense of how elderly visitors in their communities have progressed through each of their life stages, the CACE Framework suggests that art museums step back and look at cohorts. Since the term "generation" is reserved to distinguish a unit of structure within a family lineage, this framework uses "cohort" to refer to a group of seniors who all share a common year of birth within a broad age span (Carlson; Hughes & O'Rand). For example, the demographics of older adults living in the United States of America are categorized into three cohorts:

Good Warriors, Lucky Few, and *Baby Boomers.*
Good Warriors: These seniors were born between 1909 and 1928 (Carlson). Taking American life in the twentieth century into consideration, men in this cohort did the fighting for the United States of America in World War II while women played other important roles, both at home and in uniform on the Home Front. So, both men and women in this cohort not only consider themselves, but also are seen by the rest of the country, as "good warriors." Besides the patriotic spirit, native-born homogeneity is the distinctiveness of this cohort. Due to restrictive immigration laws, Good Warriors grew up to be the most native-born cohort in the nation's history. When the stock market crashed in 1929, Good Warrior children witnessed their parents' unemployment and deprivation. Although they experienced The Great Depression, World War I, and World War II, after the hardship they gained unanticipated opportunities in both careers and family lives. Some Good Warriors became parents of the Baby Boomers.

Lucky Few: These seniors were born between 1929 and 1945 (Carlson). As the name implies, Lucky Few is the luckiest cohort of people living in the United States of America so far. Although African American members of this cohort experienced adversities as civil rights pioneers, they also partook in the good fortune of the Lucky Few. For instance, when comparing to earlier Black cohorts, African Americans in the Luck Few "made faster progress in both education and employment" (p. 164), even faster than did the white Lucky Few, relative to earlier White cohorts.

In spite of the fact that the Lucky Few came from The Great Depression era families and were influenced by World

War II, they were perfectly situated to take full advantage of the longest economic boom in American history (Carlson; Wilkening & Chung). Their childhood experiences are rooted in seeing government as a catalyst for this growth. When they grew up, men in this cohort earned veterans' benefits like prior cohorts, but experienced mostly peacetime employment, so they had a chance for being schooled. While the men earned a good living from high salaries and promotions because of their small cohort size and employers' competing for few available young employees, women in this cohort fortunately experienced the change of economic roles for women. Almost two-thirds of the women held paying jobs.

Moreover, the Lucky Few married early and brought up the Baby Boomers (Carlson). The Lucky Few live longer and are healthier than earlier cohorts. With respect to retirement, they were able to not only retire earlier but also draw groundbreaking levels of pensions compared to the preceding cohorts. On top of that, they perceive leisure time and retirement as gratifying rewards (Wilkening & Chung).

Baby Boomers: These older adults were born between 1946 and 1964 (Wilkening & Chung). This cohort is enormous because of a 30% increase in the birthrate from the Lucky Few cohort (Carlson; Wilkening & Chung). In the post-WWII era, Baby Boomers reached adult status and experienced the explosion of mass media, together with a time of soaring idealism in the United States of America that was epitomized by their President John F. Kennedy. In regard to economic opportunity, older Boomers, who were born between 1946 and 1954, have experienced an instance of growing affluence and a high expectation of becoming prosperous. However, younger Boomers, who

were born between 1955 and 1964, did not experience the entire unprecedented economic expansion as older Boomers had.

The Baby Boomers are a pivotal cohort because they "inherited, encountered, and redirected social change" (Hughes & O'Rand, page 224). Furthermore, their life experiences not only differ from earlier cohorts but also vary in their own cohort. Unequal opportunities from the family they lived in, education they received, and jobs they qualified for culminate in a wide range of socioeconomic statuses among the members of Baby Boomers. Based on their heterogeneous lives, along with better health than previous cohorts, Hughes and O'Rand (2005) predicted that the Boomers would extend their mid-life and push the boundaries of their life expectancies. Because of these personal unequal backgrounds, different individual life experiences shaped the diversity in the way the Boomers make sense of their lives. Unlike other previous cohorts, the Boomers appear not to have any certain agreed standards for evaluating success and life satisfaction. As a result, individual Boomers strive to find meanings in their lives by engaging in life-long healthy and active lifestyles.

Mainly, art museums *contemplate* who their older visitors are and which cohorts they come from as a means to gain profound constructive views of their elderly audiences' formative experiences, life stages, and economic environments (Thongnopnua, 2013b; Wilkening & Chung). All these insights prepare art museums for inquiring into how their senior visitors perceive museum visitation experiences and what affects their behaviors in and outside the museum.

What are older museum visitors' attitudes and actions?
After understanding formative experiences and economic

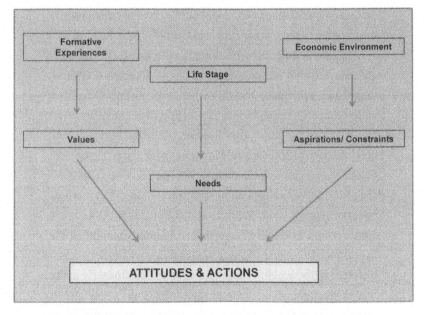

FIG. 2: Wilkening and Chung's concept of factors that shape attitudes and actions.

environments that elderly visitors in their communities have progressed through their life stages, the CACE Framework encourages art museums to apply the following concepts in order to deliberate what their older visitors' attitudes and actions are.

Wilkening and Chung's (2009) concept: According to Wilkening and Chung (2009), museum visitors' formative experiences have formed their values; life stage has affected their needs; and the economic environment has developed their aspirations and constraints. Above all, senior visitors' values, needs, and aspirations/constraints have shaped their individual attitudes and actions (Figure 2).

Given opportunities for constructive engagement within and beyond museum spaces, the CACE Framework suggests that art museums *contemplate* their older visitors' attitudes and actions by figuring out values, needs, and aspirations/ constraints that visitors have shaped from their formative experiences, stage of life, and economic environment. For example, in regard to the life stage of the senior population and economic environment in some communities, art museums may find out that their audiences have both time and spending power (Wilkening & Chung). As stated by Hanna and Perlstein (2008), "older people are currently, and projected to be, more educated and wealthier than previous generations of Americans" (p. 2). Although the retired seek respite and retreat, they also prefer to satisfy their curiosity and learn something new (Thongnopnua, 2013b; Wilkening & Chung). However, aside from developing their own personal growth, some elderly visitors also aim at meeting the needs of their family members including grandchildren. After taking formative experiences

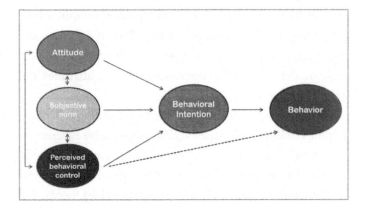

FIG. 3: Ajzen and Driver's Theory of Planned Behavior.

of their visitors into consideration, art museums may learn that most seniors not only seek cultural information but also perceive art museums as strong community institutions where they can feel a sense of belonging.

In addition to Wilkening and Chung's (2009) notion of different attitudes and actions among cohorts, Ajzen and Driver (1992) proposed the Theory of Planned Behavior to support the conception that attitude is associated with intentions to engage in leisure activities. Since attitude is a hypothetical construct, instead of being objectively observable, attitude is inferred from behavior, experience, and psychological indicators (Vaughan & Hogg). The museum visitation is considered to be one type of leisure activity, so the CACE Framework suggests art museums familiarize themselves with the Theory of Planned Behavior and use it to predict individual seniors' intention to engage and their behavioral performance.

Theory of Planned Behavior: According to Ajzen and Driver (1992), the individual's intention to perform the behavior under consideration is assumed to "capture the motivational factors that influence a behavior" (p. 208). In a nutshell, the theory claims that *attitude*, *subjective norm*, and *perceived behavioral control* have an impact on an individual's *intention* to perform a specific *behavior* (Figure 3).

Attitude refers to "the degree to which the person has a favorable or unfavorable evaluation of the behavior in question" (Ajzen & Driver, page 208). *Subjective norm* is defined as individuals' perception of the social pressure relating to whether they should perform a particular behavior or not. Conversely, *perceived behavioral control* calls attention to the level of difficulty of performing the behavior that each individual

perceives. Perceived behavioral control is assumed to reflect not only past experience but also anticipated barriers. Along with the three major predictor variables in the theory, i.e., attitude, subjective norm, and perceived behavioral control, Ajzen and Driver were also mindful of the role of involvement in the particular leisure activity and the role of mood and affect.

When-Where-Why-How do meaningful experiences occur?
The answers to the previous who? and what? questions of the Contemplate stage provide a well-built blueprint for art museums to *contemplate* the contextual relationship between older visitors and when-where-why-how to make their museum experiences meaningful. In order to accomplish the last subprocess of the Contemplate stage, art museums need to make sense of all the complexities of the museum experience.

The museum experience as an inextricable whole: Experience and learning are entwined (Gorman). According to Falk and Dierking (2000), museum visitors "seek a learning-oriented entertainment experience" (p. 73). Museums are not only places where individuals can freely decide whether to visit or not but also where visitors can freely select what to experience and learn. To put it another way, museums offer free choice learning experiences. Thus, engagement within art museums heavily relies on intrinsic motivation; the museum experience is meaningful when it is intrinsically rewarding (Csikszentmihalyi & Hermanson).

With reference to *The Contextual Model of Learning* by Falk and Dierking (1992, 2000, 2013), the experience in museums is the process and product of an interaction between three inseparable contexts: the personal, the socio-cultural, and

the physical. Through the dynamism of the process, museum visitors are constructing their personal experiences while moving through their own socio-cultural and physical worlds. Building layer upon layers, the visitors shape and are shaped by these continuous interactions.

In regard to the interaction of visitor-constructed contexts, Falk and Dierking (2013) explained, "whatever the visitor does focus on is filtered through the personal context, mediated by the socio-cultural context, and embedded within physical context" (p. 30). That is, older visitors from different cohorts tend to possess particular prior knowledge, interests, and beliefs that generate a variation of motivations and expectations that they bring to their museum visitations. While these motivations and expectations distinctively frame individual older visitors' attitudes and intended actions, mediations by and interactions with others, along with surroundings, construct older visitors' personal museum experiences. Different choices that visitors make result in the variance between a potential museum experience and the actual one.

Since the museum experience can be made sense of only when all the components are considered together as an inextricable whole, time plays an essential role in the process of constructing the museum experience through a continuous and dynamic interaction of personal, socio-cultural, and physical contexts (Falk & Dierking, 2000, 2013; Falk & Sheppard). Naturally, the constructed museum experience is not only specific to a particular situation, but also unique to every individual museum visitor. Through the lens of individual visitors, the museum experience should be considered as the totality that connects the dots among "visitor motivation, behavior,

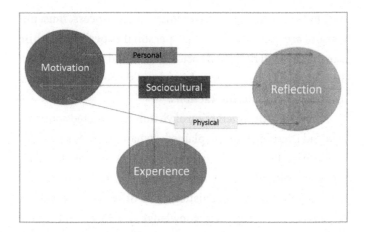

FIG. 4: The museum experience as an inextricable whole.

satisfaction, and impact" (Falk & Sheppard, page 88). In other words, the museum experience begins before a museum visitation and proceeds after an exit from the museum (Falk & Dierking, 2013).

Therefore, to gain insights into the whole inextricable museum experience, which comprises seniors' visit motivations, in-museum behaviors, reflections on their experiences, and the impact of their museum visitations on them (Falk & Dierking, 1992, 2000, 2013), the CACE Framework suggests that museums consider not only physical but also personal and social circumstances that form the relationship between the setting and museum experiences (Figure 4). In essence, this first process of the CACE Framework, the Contemplate stage, helps art museums know themselves best in every aspect. Their holistic conceptualization of themselves serves as a springboard for the second process of the framework – the Associate stage.

2. Associate

To develop a full cycle of meaningful arts engagement for older visitors, after art museums *contemplate* all possible kinds of experiences to offer, they need to figure out the best ways to constructively and distinctively *associate* themselves with an ecosystem of leisure activities that have strong appeal to healthy and active-lifestyle seniors. The impactful conception of seeing the well-being of the senior population as a standard of civilized living and an indicator of the welfare of the nation (Kinsella & Phillips) has caused funding institutions to recognize the significance of making arts and creativity services accessible to senior citizens (Hanna & Perlstein). Apparently, the next critical area of development in museum education is

bound to be the provision for the elderly (Hanna; Heffernan & Schnee; Hooper-Greenhill; Sharpe). However, to succeed and be able to sustain in an aging world, art museums need not only to excel at empowering the aging population to engage in creative experiences but also to be outstanding at promoting community well-being through the meaningful arts participation that museums foster. Accordingly, the second stage of the CACE Framework, the Associate stage, incorporates two sub-processes; art museums need to *associate* themselves with an ecosystem of leisure activities in order to:

- Locate their positions.
- Differentiate their expertise in the global aging societies.

Locating the position of the museum

In this first sub-process of the Associate stage, the framework suggests that art museums immerse themselves in the data they gathered from the preceding Contemplate stage to crystallize their understanding of all the best kinds of experiences art museums are able to offer and develop for their target groups of elderly audiences. Besides acquiring a clear understanding of what they can do the best, it is necessary for art museums to open their eyes to what is going on around them. The better art museums connect themselves with other contributors in the field of purposeful aging, the more accurately art museums locate their positions in relation to these other contributors. Successfully locating the position of the museum in aging societies furthers the understanding of the actual role each art museum plays in building an effective ecosystem of leisure activities for advocating creative and meaningful aging.

For example, contemporary art museums *associate* a clear understanding of factors that affects their Baby Boomers visitors' attitudes towards avant-garde exhibitions and the best they can do to make their target Baby Boomers' arts engagement meaningful, with other kinds of cutting edge experiences that other institutions provide for the Baby Boomers. As a consequence, these contemporary art museums are able to locate any exclusive experiences the Baby Boomers cannot receive from partaking in other kinds of leisure activities other than visiting their contemporary art museums. All in all, being cognizant of their own capabilities and potentials in the context of the prevailing situation paves the way for art museums to differentiate themselves and become extraordinary at what they are doing.

Differentiating the expertise of the museum

As a means to become influential, after art museums are aware of their positions in an aging world, they need to distinguish their expertise from the others. In this second sub-process of the Associate stage, the CACE Framework guides art museums to shift their objectives from creating inclusive elder-friendly places to contributing their expert skills and knowledge in particular art domains to an ecosystem of leisure activities for fostering seniors' high-spirited lifestyles and community well-being. For example, aside from relating the benefits of arts participation and creativity experiences to the mainstream of seniors' health and morale, art museums also need to turn the spotlight on their one-of-a-kind expertise such as constructing social well-being. As a good case in point, by building meaningful connections among individual seniors, their families,

and communities (Hanna), the art museum makes a distinction in creating multigenerational linkages with its audiences in the community.

On this account, art museums should comprehend their transformation, from being creators to becoming contributors, as a process of buildup, followed by breakthrough. The processes and actions art museums need to take in order to differentiate themselves and excel as contributors in the aging field can be seen as analogous to Collins' (2001) concept of turning organizations from good into great. Rather than a single defining moment, this sub-process of the Associate stage takes a fair amount of time and effort to build momentum until the point of breakthrough and beyond will be reached. That is, the key to attainment of this complete process is discipline.

Therefore, the CACE Framework encourages art museums to cultivate a culture of discipline that is comprised of disciplined people, disciplined thought, and disciplined action (Collins, 2001). Both objective and subjective analysis, along with synthesis, are required in this sub-process that art museums *associate* themselves with an aging world in order to differentiate their expertise from others. To inventively provoke disciplined actions, art museums should engage disciplined people in disciplined thought; for instance, to empower museum staff to have an appropriate balance of adherence to a consistent system and freedom to think outside the box.

By combining their cultures of discipline with a deep understanding of their idiosyncratic expertise, art museums will not only differentiate themselves from the others but also complete their mission to develop a sustainable resource initiator to generate a full cycle of meaningful experiences for

the aging population. To all intents and purposes, this second process of the CACE Framework, the Associate stage, helps art museums make preparations for the next step – the Collaborate stage.

3. Collaborate

In order to accomplish the goal of creating the full cycle of meaningful art experience and creativity engagement from passive observation to active participation, art museums need to *collaborate* with aging communities such as senior centers, to better understand seniors' attitudes and behaviors (Thongnopnua, 2013a; Thongnopnua, 2013b). For example, ageism is a huge problem in many aging societies including ones that claim a unique respect for their elderly, such as Japan. China has had to introduce legislation to force children to look after their parents because in spite of the principle of filial piety, rapid changes in lifestyle and the economy have widened the gap between stated values and actual practice in that society. Since an aging world is interconnected, mutualism, which is vital to social well-being, is a key to transforming diversity into creative innovations (Barker). Thus, the collaboration between art museums and local senior centers furthers opportunity to not only make the senior population feel that they belong to and are members of both the aging community and museum community, but also fill a critical gap between the desire to provide and the actual provision of creative aging experiences.

For all the reasons mentioned, the Collaborate stage incorporates three sub-processes. Mainly, the framework provides direction for art museums to work together, side by side, with senior-serving organizations on:

	COOPERATION	COORDINATION	COLLABORATION
AUTHORITY	Own respectively	Own respectively	Decide together
RISK	No	Higher	Increasing
RESOURCE	Own respectively	Shared	Shared
REWARD	Own respectively	Mutually recognize	Own together
COMMON TASK	No	Try to understand and implement	Full commitment and responsibility
FORMING NEW ORGANIZATION STRUCTURE FOR COMPLETING THE COMMON TASK	No	No	Yes
RELATIONSHIP	informal	Formal, clear, and continued	Continued and strong

FIG. 5: Chesebrough's analysis of partnership between institutions.

- finding a mutually-beneficial degree of collaboration;
- exploring senior citizens' art understandings;
- and gaining deeper insights into the relationship between arts and older people.

Eventually, these three sub-processes will lay the foundations for succeeding in constructing and perpetuating a full cycle of meaningful museum experiences for the aging population both within and across communities. For example, after collaborating with a local senior center, an art museum may gain a connection with another senior center in a neighboring county. The art museum then works together with these two senior centers on taking seniors who participate in watercolor workshops at their senior centers on a field trip to come to see art exhibitions that are most relevant to this combined group of seniors' interests.

Finding a mutually-beneficial degree of collaboration

Since museums are perceived as agents of social inclusion (Sandell), promoting networking and partnerships paves the way for building connections with audiences and sustaining them (Bierling *et al.*). To put forward high quality engaging and meaningful art experiences for the aging population, partnerships between art museums and senior-serving organizations, such as senior centers, not only help establish a foundation of resources for the field of arts and aging but also develop best practices in this growing field. Following is a review of the different types of alliances between institutions (Figure 5).

According to Chesebrough (1998), corresponding to the extent of involvement, partnerships between institutions can

be categorized into three types: *cooperation, coordination,* and *collaboration* (as cited in Liu, page 134). Firstly, the relationship in which each institution shares related information in an informal way is called *cooperation.* In contrast to the informal relationship, the relationship that is not only formal but also continuing refers to *coordination.* While each cooperating institution owns its authority, resources and rewards, each coordinating institution has only its own authority. In other words, coordination differs from cooperation because coordinating institutions share not only related information but also the resources and rewards. Lastly, the term *collaboration* is applied to the highest degree of involvement between institutions; this kind of relationship is stronger than formal and continual partnerships between coordinating institutions. Each collaborating institution not only shares its resources and rewards but also willingly embraces a new organizational structure for a common mission with full commitment.

Exploring senior citizens' art understandings

To understand how the elderly engage in art, from passive observation to active participation, art museums and senior centers need to team up and synthesize their expertise related to the arts and seniors. In order to foster meaningful art experiences for older museum visitors, the aging population's art understandings, which are the roots of the variety in their responses to the arts, need to be understood (Thongnopnua, 2013a; Thongnopnua, 2013b). Besides older museum visitors' art understandings, their levels of reflective thinking also play a critical role in how the aging population perceives art. So, the framework recommends that art museums work side by side

with senior centers and use Villeneuve and Erickson's (2008) Taxonomy to learn more about individual seniors' capabilities to understand and appreciate works of art.

Villeneuve and Erickson's Taxonomy

To develop a taxonomy as a means to describe a variety of possible responses to an artwork, Villeneuve and Erickson (2008) integrated Erickson and Clover's (2003) Viewpoints with King and Kitchener's (1994) levels of reflective thinking. Fundamentally, Villeneuve and Erickson (2008) generated fifteen particular reflective art responses by intersecting five viewpoints on the vertical axis with three levels of reflective judgment on the horizontal axis (Figure 6).

Erickson and Clover's Aesthetic Viewpoints

Drawing primarily on Parsons' (1987) Aesthetic Development, Erickson and Clover (2003) developed the viewpoints of art understandings for describing the ways people think about an artwork. The viewpoints are presented as a repertoire instead of stages. According to Villeneuve and Erickson (2008), "Viewpoints do not describe development in which earlier sets of assumptions and abilities are replaced with another set as an individual develops" (p. 93). That is to say, individual seniors can use varying viewpoints, the one they find most appropriate, to approach different works of art. To facilitate positive museum experiences, for instance, art museums can use their older visitors' conversations and responses to works of art to assess their aesthetic viewpoints.

Non-Reflective Viewpoint: People using this viewpoint are attracted to artworks that have subject matter or something

VIEWPOINTS	PRE-REFLECTIVE	QUASI-REFLECTIVE	REFLECTIVE
NON-REFLECTIVE	PR/NR	QR/NR	R/NR
BEAUTY/ REALISM/SKILL	PR/BRS	QR/BRS	R/BRS
EXPRESSION OF FEELINGS/IDEAS	PR/EFI	QR/EFI	R/EFI
ARTWORLD	PR/AW	QR/AW	R/AW
PLURALIST ARTWORLD	PR/PAW	QR/PAW	R/PAW

FIG. 6: Villeneuve and Erickson's Taxonomy.

associated with them (Erickson & Clover; Parsons; Thongnopnua, 2013b). They see an artwork as a collection of elements such as representations and colors that they can make connections with. They do not expect others to share their judgment since their perception of works of art is solely from their personal preference and experiences. With reference to their innocent eyes, their responses and reactions to works of art are less stereotyped but more idiosyncratic than people using other viewpoints.

Beauty, Realism, and Skill Viewpoint: Beauty and degree of realism have a major impact on how individuals using this viewpoint perceive works of art (Erickson & Clover; Parsons; Thongnopnua, 2013b). People using this viewpoint are interested in the subject matter and are attentive to how realistic works of art are represented. To put it another way, they are attracted to artworks that exhibit skill, look real and pretty.

Expression of Feelings and Ideas Viewpoint: People using this viewpoint have empathy, which helps them move beyond judging works of art from beauty and realism and to focus on what artists try to communicate to viewers (Erickson & Clover; Parsons; Thongnopnua, 2013b). While they try to find the meanings of artworks, their emotional responses are from their awareness of subjectivity in both themselves and others. In the most essential respects, they reflect their own experiences and understand that the meanings of artworks is subject to individual interpretations.

Artworld Viewpoint: Individuals using this viewpoint see medium, style, form, and technique as collaborators with artists (Erickson & Clover; Parsons; Thongnopnua, 2013b). They are aware of the social context of works of art. Rather than finding the meaning of an artwork from an artist or an individual

viewer, people using this viewpoint participate in discussions with the community of viewers.

Plural Artworlds Viewpoint: People using this viewpoint understand the nature of art, which assumes that art is a way we articulate our internal world to ourselves and reexamine our self-conscious state; art expresses more than what we envision and is capable of having multiple layers of interpretation; and art can be judged objectively although the judgment is from examining our experience and emotions (Erickson & Clover; Parsons; Thongnopnua, 2013b). Thus, viewers using this viewpoint are constantly sensible of questions and continually reconstruct their interpretations.

King and Kitchener's Developing Reflective Judgment

With respect to King and Kitchener (1994), reflective judgment is related to how people make decisions and justify their choices in uncertain domains such as art (as cited in Villeneuve & Erickson, page 94). Different assumptions about the nature of knowledge, strategies for addressing problems, and justifications of beliefs characterize reflective judgment into three levels: Pre-Reflective, Quasi-Reflective, and Reflective.

Pre-Reflective Thinkers assume that knowledge is absolutely certain, so they believe that there is only one right answer for each problem (King & Kitchener). Their right answers are from their observation, belief, or humble submission to perceived authority figures.

Quasi-Reflective Thinkers start to realize that knowledge can be uncertain and subjective (King & Kitchener). However, they justify their answers to ill-structured problems by either providing their personal reasons or using other contexts to support their claims.

Reflective Thinkers recognize that knowledge is uncertain and changing all the time (King & Kitchener). To respond to particular problems, they take various appropriate sources into consideration and construct answers in context. Inherently, recognizing an array of responses seniors may have to works of art is a key to the provision of meaningful museum experiences for the aging population (Thongnopnua, 2013b). Examining older museum visitors' levels of reflective judgments and viewpoints of art understandings serves as a springboard for customizing exhibitions to them. Not only art museums but also senior centers should be ready to take care of unexpected, emotional reactions, or responses occurring from a gap in the understanding of art. There are many variations in perceiving art and the nature of art, which can be suggested by museums to help older viewers interpret art differently. In short, the aging population's reflective art responses should be taken into consideration not only while museums plan art exhibitions but also when senior centers arrange art museum field trips for their seniors. To make sense of the roles of museums and senior centers in partnerships, art museums and senior centers should discuss and exchange their ideas about the relationship between arts and older adults.

Gaining deeper insights

In this last sub-process of the Collaborate stage, the CACE Framework suggests that art museums work alongside senior centers to amalgamate their understandings of the way the elderly interconnect with the arts. Intrinsically, the elderly play an important role of arts and culture conservators because they transfer the history and values of our communities to the

succeeding generations (Hanna & Perlstein). On the other hand, the arts can be used as a vehicle to help understand and define aging; arts engagement offers life-long learning and the opportunity for self-expression amidst loss, for re-engagement amidst void and uncertainty, and for achievement (Korza, Brown, & Dreeszen; Sherman). By being contributors and resources for the arts, individual seniors can both give and take – share – the wisdom they have gained through their lives.

Thus, by participating in arts activities, the elderly can gain health benefits and play a part in constructing social well-being in the community (Cohen, 2000, 2001, 2006; Cohen, Perlstein, Chapline, Kelly, Firth, & Simmens). In view of their interconnection with mastery and social engagement, the arts create healthy aging (Hanna & Perlstein). However, not only physical, but also communicational and attitudinal barriers need to be eliminated in order to make the arts accessible to every senior citizen (Korza, Brown, & Dreeszen; Salmen). Since meaning and purpose are keys to living longer with healthier lives (Cohen, Perlstein, Chapline, Kelly, Firth, & Simmens), art museums and seniors centers need to take a closer look and become aware of how different entry points that individual seniors start to engage in arts activities have an effect on these seniors' identity-related needs and values. Therefore, the framework puts forward the two following concepts: Hanna's concept of older adults' key entry points to the engagement in art activities and Falk and Dierking's (2013) Identity Lens for Describing Museum Visitors.

Older adults' key entry points to engagement with art activities
According to Hanna, the elderly who are engaged in creative activities can be categorized into three groups: *beginning*,

returning, and *life-long* participants. *The beginning participants* are the ones who become engaged in arts activities for the first time late in life. According to Corbett, this group of older adults has a strong interest in creative expression, which stems from an internal revelation, as a means to accommodate a rebalancing (as cited in Hanna, page 7). *The returning participants* are the ones "who were once involved in creative activities but discontinued these pursuits as job and family commitments took priority" (Hanna). According to Corbett and Cohen (2006), a loss or a change in life status, retirement, the death of a spouse or other family member, or the person's own encounter with illness are examples of the main reasons that this older adult returns to be involved in creative activities in later life. They believe that the arts activities not only bring joy and comfort but also help renew a sense of meaning and purpose. This is an important case in point for art museums that seek to provide value and meaning in their engagement with older people. *The life-long participants* are the ones "who have been substantially involved in creative expression throughout their lives" (Hanna). Most of them are professionals or innovators in social services, policy, or education. According to Hanna:

> These people found creativity early in life and have kept exploring its paths, while obtaining enough substantial support to maintain it as central to their life's work. These individuals have been identified as role models for successful aging because they stay highly engaged in a larger reality where they do not lose their purpose or meaning. Retirement is not an option, in that they would

not choose another way to live and are satisfied with their life choices.

Identity lens for describing older museum visitors

The reasons to visit museums and engage in art experiences reflect not only what the aging population perceives the museum visit provides but also how individual seniors define their "meaningful experiences." According to Falk and Dierking (2013), museum visitors seek leisure experiences that fulfill their own identity-related needs and values. Although the visitor can theoretically possess innumerable motivations, they could be classified into seven categories: *Explorers, Facilitators, Professionals/Hobbyists, Experience Seekers, Rechargers, Respectful Pilgrims,* and *Affinity Seekers*. These seven categories are called "identity-related feedback loops" (p. 47). From a great number of studies in a variety of museum settings, Falk and Dierking (2013) developed the loops by matching up individuals' perceptions of what the museum experience affords; in other words, individuals' personal senses of "what museums are like and how and why they would use them", with the visiting public's identity-related needs and desires. On top of knowing who their older visitors are and who they are not, the CACE Framework suggests that art museums use this following identity lens to better understand and be prepared for meeting diverse needs of their elderly visitors.

Explorers are museum visitors who are curiosity-driven and have a generic interest in the contents of the museum (Falk & Dierking, 2013). Besides searching for something compelling, their expectation is to fuel their curiosity and learning.

Facilitators: Because of their social motivation, *Facilitators'*

museum visitation mainly revolves around facilitating the experience and learning of other people in their accompanying social group (Falk & Dierking, 2013).

Professionals/Hobbyists: Since their reason for visiting museums is to fulfill a specific content-related objective, *Professionals/Hobbyists* are visitors who have a strong bond between their professional or hobbyist passions and the museum contents (Falk & Dierking, 2013).

Experience Seekers: Due to their perception of the museum as "a must-see destination" (Falk & Dierking, 2013: 62), *Experience Seekers* consider having "been there and done that" as their satisfied goal.

Rechargers perceive the museum as a sanctuary from the mundane world (Falk & Dierking, 2013). Being seen as a confirmation of their religious/spiritual beliefs, the museum is the place where Rechargers attempt to obtain a contemplative, spiritual and/or restorative experience.

Respectful Pilgrims perceive their museum visitations as a duty or an obligation because they are morally bound to honor the remembrance of those represented by an institution/memorial (Falk & Dierking, 2013).

Affinity Seekers prefer particular museums or exhibitions that are related to their life stories and/or their cultural heritages (Falk & Dierking, 2013).

Instead of classes of museum visitors, these categories are reasons for visiting a specific museum in a particular day (Falk & Dierking, 2013). Since the same visitor may possess different identity-related motivations for her/his visits on differing times, art museums and senior centers can use Falk and Dierking's (2013) Identity Lens to make sense of the motivation

older visitors possess and their diverse needs in each field trip to the museum.

In essence, all three sub-processes of the Collaborate stage help art museums to work alongside aging communities to completely build a full cycle of meaningful art experiences, from passive observation to active participation, for the aging population not only in but also across communities. However, in addition to creating this full cycle of meaningful creativity engagement, the CACE Framework also puts emphasis on how art museums can keep this cycle going, from generation to another generation. Thus, the last process of the framework, the Evaluate stage, is seen as important as the other three preceding processes.

4. Evaluate

To sustain their success, art museums need to build a culture of evaluation. Everything has life and its function and usefulness are always changing over time. Since the changes are varied, depending on both internal and external factors, museums need to routinely evaluate their people, processes, and outcomes of the Contemplate stage, Associate stage, and Collaborate stage. The CACE Framework suggests that art museums perceive this Evaluate stage as a process of understanding and learning instead of a task of judging. The more the evaluators communicate and engage in an ongoing dialogue with primary stakeholders and intended users along the way, the more feasible the evaluation results will be understood and used (Bell). Since the value of evaluation can be found in both operational and knowledge levels (Fitzpatrick *et al.*), cultivating an evaluation culture in and across communities will not only help museums sustain the provision for a full cycle of

arts engagement but also make persistent contributions to the whole ecosystem of leisure activities in an aging world.

Conclusion

The CACE Framework has been developed for art museums to use in order to thrive and sustain in the global aging societies. The framework analyzes a strategy for what the best museums are, in some cases, already doing and offers a clear developmental pathway for those who need to adapt to this changing, aging world. The CACE Framework is a structure for repeatedly generating a cycle that consists of four processes: *Contemplate, Associate, Collaborate,* and *Evaluate.* In essence, art museums need to not only *contemplate* all kinds of meaningful experiences to offer, and distinctively *associate* themselves with an ecosystem of leisure activities in an aging world, but also *collaborate* with aging communities, and routinely evaluate their processes and outcomes. In addition to turning the elderly from users of museum services to contributors to them, the CACE Framework provides a well-built blueprint for art museums to make arts and creativity services successfully play an important dynamic part in building an effective ecosystem of leisure activities for promoting creative healthy lifestyles and social well-being among senior citizens. Ultimately, the framework strives for creating and perpetuating a full cycle of meaningful art experiences and creativity engagement, from passive observation to active participation, for the aging population not only in but also across communities.

REFERENCES

Ajzen, I., & Driver, B. L. (1992). Application of the theory of planned behavior to leisure choice. *Journal of Leisure Research*, 24(3), 207-224.

American Federation for Aging Research & the Alliance for Aging Research. (1995). *Putting aging on hold: Delaying the diseases of old age.* Washington, DC: AFAR/AAR.

Arts Council of Northern Ireland. (2010). *Arts and older people strategy.* Retrieved from: http://www.artscouncil-ni.org/images/uploads/ publications-documents/aop_strategy.pdf.

Barker, J. (Producer/Director). (2000). *Wealth Innovation & Diversity* [Motion picture]. United States: Star Thrower Distribution Corporation.

Bearon, L. C. (1996). Successful Aging: What does the "good life" look like? *The Forum for Family and Consumer Issues*, 1(3). Retrieved from http://www.ncsu.edu/ffci/publications/1996/ v1-n3-1996-summer/successful-aging.php.

Bell, J. B. (1994). Managing evaluation projects step by step. In J. S. Wholey, H. P. Hatry, & K. E. Newcomer (Eds.), *Handbook of practical program evaluation* (pp. 510-533). San Francisco, CA: Jossey-Bass.

Bierling, A., Brisoux, E., Kuijten, D., Rosa, M. L., & Pereira de Morais Luz, A. L. (2011-2012). *Social Inclusion and Art Museums.* Retrieved from http://alexandria.tue.nl/ vanabbe/public/publicaties/Senseofbelonging.pdf

Carlson, E. (2008). *The lucky few: Between the greatest generation and the baby boom.* Dordrecht: Springer.

Chesebrough, D. E. (1998). Museum partnership: Insights

from the literature and research. *Museum News, 77*(6),
50-53.

Cohen, G. (2000). Creativity and aging. *Grantmakers In the
Arts Reader,* 11(2). Retrieved from http://www.giarts.org/
article/creativity-and-aging.

Cohen, G. (2001). *The creative age: Awakening human potential
in the second half of life.* New York, NY: Quill.

Cohen, G. (2006). *The mature mind: The positive power of the
aging brain.* New York, NY: Basic Books.

Cohen, G. D., Perlstein, S., Chapline, J., Kelly, J., Firth, K.
M., & Simmens, S. (2006). The impact of professionally
conducted cultural programs on the physical health,
mental health, and social functioning of older adults. *The
Gerontologist, 46*(6), 726-734.

Collins, J. (2001). *Good to great: Why some companies make the
leap... and others don't.* New York, NY: Collins.

Corbett L. (2012, June). Successful Aging, *Bringing to Life the
Possibilities and Potentials for Vibrant Aging.* Symposium
conducted at the Library of Congress, Washington, DC.

Csikszentmihalyi, M., & Hermanson, K. (1995). What makes
visitors want to learn? Intrinsic motivation in museums.
Museum News, 74(3), 34-37, 59-61.

Cutler, D. (2009). Aging artfully: Older people and
professional participatory arts in the UK. *The Baring
Foundation.* Retrieved from http://www.baringfoundation.
org.uk/AgeingArtfully.pdf.

Erickson, M., & Clover, K. (2003). Viewpoints for art
understanding. *Translations, 12*(1), n.p. Reston, VA:
National Art Education Association.

Falk, J. H., & Dierking, L. D. (1992). *The museum experience.*

Washington, DC: Whalesback Books.

Falk, J. H., & Dierking, L. D. (2000). *Learning from museums: Visitor experiences and the making of meaning.* Lanham, MD: Rowman and Littlefield.

Falk, J. H., & Dierking, L. D. (2013). *The museum experience revisited.* Walnut Creek, CA: Left Coast Press, Inc.

Falk, J. H., & Sheppard, B. (2006). *Thriving in the knowledge age: New business models for museums and other cultural institutions.* Lanham, MD: Altamira Press.

Fitzpatrick, J. L., Sanders, J. R., & Worthen, B. R. (2011). *Program evaluation: Alternative approaches and practical guidelines* (4th ed.). Upper Saddle River, NJ: Pearson.

Fries, J. F., & Crapo, L. M. (1981). *Vitality and aging.* San Francisco, CA: W. H. Freeman.

Gorman, A. K. (2007). Museum education assessment: Designing a framework. In P. Villeneuve (Ed.), *From periphery to center: Art museum education in the 21st century* (pp. 206-211). Reston, VA: National Art Education Association.

Hanna, G. P. (2013). The central role of creativity in aging. *Journal of Art for Life, 4*(1), 4-13.

Hanna, G. P., & Perlstein, S. (2008). Creativity matters: Arts and aging in America. *Americans for the Arts Monograph.* Retrieved from http://www.giarts.org/sites/default/files/Monograph_Creativity-Matters-Arts-and-Aging-in-America.pdf

Havighurst, R. J. (1961). Successful aging. *The Gerontologist, 1*(1), 8-13.

Hefferman, I. & Schnee, S. (1981). Brooklyn: Building a New Museum Audience. *Museum News, 59*(5), 31-32.

Hooper-Greenhill, E. (1994). *Museums and their Visitors*. London: Routledge.

Hughes, M. E., & O'Rand, A. M. (2005). The lives and times of the baby boomers. In R. Farley & J. Haaga (Eds.), *The American People: Census 2000* (pp. 225-255). New York, NY: Russell Sage Foundation.

King, P. M., & Kitchener, K. S. (1994). *Developing reflective judgment: Understanding and promoting intellectual growth and critical thinking in adolescents and adults*. San Francisco, CA: Jossey-Bass Publishers.

Kinsella, K., & Phillips, D. R. (2005). Global Aging: The Challenge of Success. *A publication of the Population Reference Bureau, 60*(1), 201-244.

Korza, P., Brown, M., & Dreeszen, C. (Eds.). (2007). *Fundamentals of arts management* (5th ed.). Amherst, MA: University of Massachusetts Arts Extension Service.

Liu, W. C. (2007). Working together: Collaboration between art museums and schools. In P. Villeneuve (Ed.), *From Periphery to Center: Art Museum Education in the 21st Century* (pp. 129-137). Reston, VA: National Art Education Association.

Parsons, M. J. (1987). Talk about a painting: A cognitive developmental analysis. *Journal of Aesthetic Education, 21*(1), 37-55.

Salmen, J. P. S. (1998). *Everyone's Welcome: The Americans with Disabilities Act and Museums*. Washington, DC: American Association of Museums.

Sandell, R. (1998). Museums as agents of social inclusion. *Museums management and curatorship 17* (4), 401-418.

Sharpe, E. (1992). Education programs for older adults.

In S. K. Nichols (Ed.), *Patterns in practice: Selections from the Journal of Museum Education* (pp. 262 - 267). Washington, DC: Museum Education Roundtable.

Sherman, A. P. (1996, November). The Arts and Older Americans. *American for the Arts Monographs, 5*(8). Retrieved at http://pubs.artsusa.org/library/ARTSO33/html/1.htmal.

Thongnopnua, S. (2013a). Accessibility for the older population: Seniors and arts participation. *Journal of Art for Life, 4*(1), 33-44.

Thongnopnua, S. (2013b). Visual arts-based research: Art museums as an inclusive elder-friendly place. *The International Journal of the Inclusive Museum, 6*(1), 131-143.

Todd, S. & Lawson, R. (2001). Lifestyle segmentation and museum/gallery visiting behaviour. *International Journal of Nonprofit and Voluntary Sector Marketing, 6*(3), 269-277.

Vaughan, G., & Hogg, M. (2011). *Social Psychology* (6th ed.). Edinburgh Gate: Pearson Education Limited.

Villeneuve, P., & Erickson, M. (2008). The trouble with contemporary art is... *Art Education, 61*(2), 92-97.

Wilkening, S., & Chung, J. (2009). *Life stages of the museum visitor: Building engagement over a lifetime.* Washington, DC: American Association of Museums Press.

THE POLITICAL VALUE OF MUSEUMS IN DEMENTIA CARE

Kerry Wilson

IN 2012, NATIONAL Museums Liverpool (NML) launched a dementia care training programme that has since received critical acclaim across multiple platforms, with more than 5,000 health service, housing and social care workers having participated in the training nationally. House of Memories is primarily a full-day museums-based training intervention that combines dramatic set pieces, forum theatre, interactive facilitation, museum and gallery tours, reminiscence therapy and museum education activities, with the aim of supporting and enabling participating dementia carers to help those directly affected by the condition to "live well" with dementia. The active programme is supplemented by branded training resources, which can be taken away and adapted for use in a range of care settings. Other recent developments include the launch of a dedicated My House of Memories app, which can again be used remotely in a variety of care contexts.

House of Memories has received numerous plaudits and national awards including Winner of the National Institute of Adult Continuing Education (NIACE) regional *Adult Learner's Week* award 2014, in the Learning Life Skills category; Winner of the Museums and Heritage Awards 2014, Educational Initiative; and was Highly Commended at the Alzheimer's Society's Dementia Friendly Awards 2014 in the National Initiative category. Alongside continuation of the full-day professional training programme, other models of delivery are to be developed and made available throughout 2015, including the Buddy day developed specifically for family carers, friends and community volunteers and plans to deliver the programme in acute primary care settings (Figure 1).

This essay critically examines the value and impact of

FIG. 1: Dancing at a House of Memories celebration event, Museum of Liverpool, 2013.

House of Memories, paying particular attention to national policy contexts and the strategic and operational characteristics that have contributed to the initiative's irrefutable success.

Successive evaluation studies (Hanna and Reynolds; Wilson and Grindrod; Wilson and Whelan) have consistently revealed significant outcomes for participating dementia carers, including increased awareness and understanding of dementia and its implications; skills development including listening, communication and professional empathy; improved capacity for [individual and collective] critical, reflective care practice; confidence in trying new, creative approaches to dementia care; and increased cultural engagement with museums. House of Memories therefore brings pertinent attention to the potential of museums to contribute to core skills development in the pastoral dimensions of health care for ageing populations, including most significantly enhanced empathy and compassion, which are integral to the development of person-centred dementia care strategies and practices (Brooker). It is especially encouraging to see this level of contribution from the museums sector in the context of dementia care as a crucial national health priority.

Similarly it reinforces the cultural imperative to consider more closely the collaborative contexts in which many museums operate, highlighting the professional conditions and practices that underpin House of Memories as an example of effective cross-sector working. These include the following factors, which are considered in more detail throughout the chapter:

· Strategic cross-sector collaborations with health and social services.

- Complementary, operational cross-sector partnerships with other arts organisations and academic researchers.
- The effective co-design and co-production of museum activities with relevant stakeholders including people with dementia and their carers.
- Strong ethical, politically-engaged leadership from NML's core team.

Cross-sector strategy, practice and value

I am wholly supportive of the House of Memories. It is an exceptional project. National Museums Liverpool provides an innovative training programme that is making a real difference for social care staff by helping them to connect with the people with dementia whom they support every day... It is fantastic that the cultural sector is involved in work on dementia; it is a great collaboration.
– Norman Lamb MP, Minister of State for Care and Support. (Foreword, Wilson and Grindrod)

The development of House of Memories builds upon a tradition of programming within NML that is tailored towards older museum audiences, including earlier projects that were based on the principles of outreach and reminiscence work. Described as "the use of collections to foster reminiscence for recreational, social support, and health care purposes among groups of older adults and those with dementia" (Silverman, 2010: 117), reminiscence therapy techniques have become increasingly popular within the museum field, with numerous projects that

have been shown to have therapeutic value, promote learning, creativity, improved confidence and skills development (Chatterjee and Noble, 2013: 39). The use of such techniques therefore is not unique to NML. The organisation has however advanced the field by developing a programme specifically for dementia carers, which was achieved in conversation and collaboration with health care sectors after joint acknowledgement of this significant gap. One of the defining characteristics of House of Memories is that it has been funded directly by the UK government's Department of Health, with other examples of funding support from agencies including Health Education North West. Such developmental partnerships with, and core sponsorship from, health departments have helped to consolidate relationships with health care practitioners, and the reputation, authenticity and credibility of House of Memories as a museums-led dementia care training intervention (Figure 2).

In policy contexts, the development of House of Memories has coincided with successive media scandals and subsequent debates in the UK concerning standards of care within and across health services, punctuated for example by the Mid-Staffordshire NHS Foundation Trust public inquiry in 2010; the Cavendish Review of health care assistants in 2013; and the Government's response including a three-year strategy for Compassion in Practice. Evaluation outcomes described above relating to the "culture of care" amongst House of Memories participants adhere closely to objectives outlined by the National Dementia Strategy launched in 2009. House of Memories has subsequently been directly referenced and commended within leading policy response documents including the Prime Minister's Challenge on Dementia (Department of

FIG. 2: Norman Lamb MP, Minister of State for Care and Support, learning about the My House of Memories app, Liverpool 2014.

Health, 2012) and the recent review of care standards for people living with dementia (Care Quality Commission, 2014). The review highlighted that people living with dementia were at high risk of experiencing poor outcomes at some stage in the conventional care pathway.

Undoubtedly the timeliness and pertinence of House of Memories in relation to pervasive political agendas on standards of care have given real gravitas to its cross-sector value and profile. It is important to note however that the programme was not developed *in reaction to* such concerns and public policy objectives. House of Memories rather, creates an opportunity to see *responsive* museum services in action, building upon a legacy of relevant museums practice and the development of purposeful cross-sector collaborative relationships over a period of time. It is this level of responsiveness that creates opportunities for museums to "stay relevant", sustainable and demonstrate their value to communities and "society at large" (Ocello, 2011: 199). The responsiveness of House of Memories in public policy contexts furthermore aligns itself to more preventive health agendas and treatment through sustainable *shared services*. Advocated by all three main political parties in the UK, the preventive agenda is a leading public health priority, with other commentators from specific services making similar campaigns, including recommendations for a "truly integrated and holistic prevention agenda for the NHS" (Beaumont) and a sustainable social care system that makes "prevention and early intervention work for older people" (Age Concern).

Through its collaborative ethos, House of Memories represents the hallmarks of inter-agency working as a strategy for

a sustainable social care system. Such approaches have been powerfully advocated by health care policies in the UK since the 1990s, illustrated by the requirement to work in partnership within new funding and policy initiatives, set within "scathing critiques" of single agency ways of working (Peck and Dickinson). The UK's cultural sector has gradually responded to this, and there is now growing momentum around arts and cultural commissioning within social and public services, illustrated by a propensity of referral schemes such as 'arts on prescription' at local levels, and national initiatives such as the Cultural Commissioning Programme 2013-16 (CCP). Funded by Arts Council England (ACE) and delivered through the National Council for Voluntary Organisations (NCVO), the CCP aims to help arts and cultural sectors to develop skills and capacity to engage in cultural commissioning; develop awareness amongst commissioners of the capacity of arts and cultural sectors to deliver public service outcomes; develop relationships between cultural providers and commissioners; and influence policy makers on the value of arts and culture. House of Memories has been profiled as a best practice case study by the CCP. Arguably it is ahead of its time in being uniquely funded by the Department of Health, and in avoiding dependence on the Department of Culture, Media and Sport (DCMS) as an increasingly vulnerable government office, and rapidly dwindling arts funding resources via ACE and local government.

Museums, arts and academic partnerships
Originally House of Memories was designed and delivered from NML's flagship Museum of Liverpool, and this continues to be the physical base for the main programme. Creative

partnerships, alongside collaborative working with health
and social care sectors, have always been at the core of the
design and delivery of the programme. These include for
example partnerships with the drama-based training agency
Afta Thought, and Collective Encounters, a leading Liverpool-
based professional arts organisation specialising in theatre for
social change. In 2013, NML received additional funding from
the Department of Health to roll-out the programme as part
of a Northern Model, working in collaboration with Salford
Museum and Art Gallery, Bury Art Museum and Sunderland
Museum and Winter Gardens. Inspired by the success of the
Northern Model, the Department of Health went on to fund
a similar House of Memories regional programme across the
Midlands in early 2014, which ran in association with Birming-
ham Museum and Gallery, Nottingham's Wollaton Hall and
Leicester Guildhall (Figure 3).

This intensive, collaborative artistic effort has helped
to distinguish and make explicable the 'uniquely cultural'
attributes of the programme throughout successive itera-
tions of House of Memories, in relation to its impact upon the
dementia care community. Evaluation studies of the regional
programmes for example (Wilson and Grindrod; Wilson and
Whelan) reinforce the empathic qualities of the programme,
and the trust that is generated between the artistic experience,
museum context and participating dementia carers. Muse-
ums are widely recognised for their ability to foster empathy
amongst museum visitors for different cultural groups and
experiences, through their authentic collections, artefacts and
stories of "real people" (Silverman, 2010: 74). Silverman goes
on to describe museums as "untapped and innovative venue[s]

FIG. 3: House of Memories participants engage in arts and crafts activities, Bury Art Museum, February 2013.

for empathy training interventions", particularly within care-giving relationships.

The impact in the room is palpable when participating in House of Memories, due to the immediacy of the cultural connection that is made. It is important to stress however that House of Memories is not a saccharine experience – it is transparent and confronting on the realities of dementia for all who are affected by it. The "cultural connection" that takes place is one of emotional intelligence rather than sentimentality, and participants describe a process of enhanced emotional professionalism, self-awareness and conscientiousness as care-givers. This connection is made through professional storytelling and reminiscence techniques that are creatively engaging, authoritative and trustworthy because of their research-informed qualities. Participants from across the professional care spectrum did not at any point question the medical accuracy or integrity of the programme's content. Such notions of empathy and trust are integral to the programme's value and that of museums in public policy contexts more broadly.

Pilgrim *et al.* discuss the relationship between trust and ontological security – that being the extent to which we *belong* to places and situations – and the relative implications for experiences of health care. The sense of trust and ontological security potentially developed between people with dementia and their carers in museum environments is a key outcome therefore for mutually beneficial professional practice across cultural and health sectors. Here we can begin to see how the intrinsic, "uniquely cultural" practices of one sector create instrumental value for another in terms of improved professional practice and care standards.

In order to validate these emerging ideas of impact and value, the NML team have furthermore demonstrated a commitment to building an evidence base on House of Memories, via the formation of a long-term collaboration with academic research partners at the Institute of Cultural Capital (ICC), a cultural policy research institute jointly hosted by the University of Liverpool and Liverpool John Moores University. The ICC has conducted both regional evaluation studies, adopting immersive approaches including Realistic Evaluation frameworks (Pawson and Tilley) to establish causal contexts, mechanisms and outcomes of the programme; standardised dementia care impact measures; and social return on investment (SROI) methodologies, each helping to establish the "intrinsic to instrumental theory of change" inferred above. NML and ICC are now working together on the development of a substantial, longitudinal research programme, to further test these approaches and ideas.

It is anticipated that this programme of research can make a meaningful contribution to sector-wide contemporary discourse and debate on cultural value, and the political imperative to demonstrate the social and economic impact of publicly subsidised cultural organisations. The concept of instrumental value is particularly contentious, in being contrary to arts and cultural practitioners' own understanding of their practice and its (more intrinsic) value, and that of their public audiences (O'Brien, 2014: 124). The cross-sector collaborative fabric of House of Memories therefore is integral to any assessment of its impact – it is not the intention of any associated research to generate a false mandate on instrumental value, or to endorse its replicability across the arts. What House of Memories does

is demonstrate a collaborative route to instrumental value, where there is an inherent professional propensity and inclination to follow such routes within cultural organisations. The NML team has also consistently demonstrated an interest in sharing their own professional learning through House of Memories, by being active public speakers across multiple knowledge exchange platforms, including academic, cultural and health sector-led events, helping to shape the cultural value debate.

Co-production and dementia care communities

A collective approach filters through all elements of House of Memories practice, most importantly perhaps via the active participation and contribution of people with dementia and their carers. NML's strategic relationships with different health sectors and organisations, ranging from the Department of Health, to the Alzheimer's Society, regional NHS trusts and local voluntary sectors, has facilitated a tailored, co-produced approach to House of Memories design and development from the beginning. The most powerful example of co-production within the programme relates to the development of the My House of Memories app, launched in June 2014. The free digital resource was designed to supplement core House of Memories training activities as an activity that can be undertaken remotely by people with dementia, together with carers, and also to act as a stand-alone offer to extend the reach of House of Memories both nationally and internationally. The app has had in excess of 1000 downloads, and received the international Innovate Dementia Award at the World Health and Design Forum in 2014.

Key features of the app include hundreds of digitised

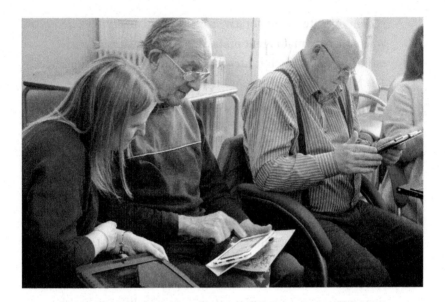

FIG. 4: The co-production process involves regular meetings with people living with dementia and their carers.

images of inspirational museum objects from the 1920s to 1980s to stimulate memory and conversation, which can be saved to memory trees, boxes or timelines; tools for creating personal profiles; carer's toolkits, including tips for reminiscence and memory activities to do together; facts and background information about the objects written by museum curators; accompanying music, sound effects and videos to provide a rich, multi-sensory experience and bring objects to life, produced in collaboration with the Royal Liverpool Philharmonic; easy-to-use design with simple touchscreen controls; and read aloud options for people who prefer to listen than read. Co-production of the app was facilitated by collaborative work with an established group of people with dementia and carers in the city of Liverpool, convened in association with local networks including Mersey Care NHS Trust, Liverpool Dementia Action Alliance (and its Service Users Reference Forum), Everton Football Club, and Liverpool John Moores University care of the international, European Commission-funded Innovate Dementia project (Figure 4).

The effective integration of House of Memories as a respected intervention into such local service infrastructures has enhanced the development of trusting relationships between NML staff and people with dementia, providing a seamless platform for co-produced innovations such as the My House of Memories app. Co-production has become a popular ambition and term of reference in public policy and management of public services, including contemporary arts management and cultural policy narratives in the UK. Hailed as the reformative answer to austerity cuts, the perceived benefits of co-production include the democratic sharing of design

and delivery of services such as health, education and policing between users and professionals, with the ultimate outcome of making public services "more effective, more efficient, and so more sustainable for all". Its defining principles include recognising people as assets; valuing work differently; promoting reciprocity; and building social networks (Boyle and Harris). More cautious observers point to limited existing evidence on enhanced efficiency as a result of co-production in public services, and recommend co-production as a synergy rather than a substitute; avoidance of short-term organisational fixes; and building of a credible commitment between front-line professionals and communities. (Durose *et al.*)

House of Memories, as a package of strategic and operational collaborative activities developed over a period of time, provides an example of the investment required to ensure genuine shared objectives, authentic partnerships and to avoid the superficial adoption of co-production as a tick-box label. In short, this is not a collective practice that is easily replicable. The authenticity of the collaborative, dementia care "community of practice" engendered by House of Memories is also illustrated by the loyalty and commitment shown to the programme and NML via other activities that have grown around House of Memories. These include, for example, its "celebration day" events at the Museum of Liverpool, and spin-off projects including Liverpool's Happy Older People network, which brings together older people, arts and cultural organisations, health and social care providers, housing associations, community groups and volunteers to promote age-friendly arts participation in the city.

Politically-engaged museum leadership

> Working towards social justice is a long-term commit-
> ment; it requires determination and bloody-mindedness.
> It needs to be driven by passion, by a belief that everyone
> deserves equal access to what we do in museums and not
> just because government (or anyone else) tells us that
> this is what we should do, but because it's the right thing
> to do. (Fleming, 2012: 82)

The organisational culture, mission and values espoused
by NML are clearly significant when considering the suc-
cess and impact of House of Memories as such a high pro-
file initiative for the organisation. Explicitly stated mission
and values help to correlate the philosophical principles and
pragmatic functions of cultural organisations; to ensure con-
sistent decision-making; and autonomous, lateral leadership
throughout the organisation (Hewison and Holden, 2011: 58).
This is particularly complex for NML as a group represent-
ing seven internationally reputable museums and galleries,
including Merseyside Maritime Museum and International
Slavery Museum; Sudley House; Lady Lever Art Gallery and
the Walker Art Gallery; World Museum and the Museum of
Liverpool. NML's mission statement is "to be the world's lead-
ing example of an inclusive museum service", which is under-
pinned by values including a belief in the concept of social
justice; belief that museums are fundamentally educational
in purpose; that museums are places for ideas and dialogue
that use collections to inspire people; belief in the power of
museums to help promote good and active citizenship, and

FIG. 5: People with dementia, carers and health professionals celebrate the launch of their co-created My House of Memories app, House of Commons June 2014.

to act as agents of social change.

These values are iterated throughout the development and management of NML's seven venues, programmes and exhibitions and also through strategic initiatives within the wider professional community. The International Slavery Museum, for example, co-ordinates the Federation of International Human Rights Museums (FIHRM) and hosted its inaugural conference in September 2010. NML has also led the development of the Social Justice Alliance for Museums (SJAM), an international network aiming to create a charter for museums as "democratic bodies, open to and valued by the whole of society", in response to a perceived political threat to the social value of museums via reduced public funding and a return to "traditional museum values of exclusivity and elitism". NML's Director, David Fleming, who is a vocal advocate of the democratic museum and associated principles, was recently elected as President of the sector's professional body in the UK (Museums Association). NML therefore leads by example in enacting its own mission and values, and those expected from any socially engaged cultural institution. These actions are symbolic of an inherent professional propensity towards work with clear public policy objectives and collaborative instrumental value, without which, House of Memories would not have had the same degree of prolific success.

The driving force behind House of Memories at NML is the formidable team of Carol Rogers (Executive Director), Claire Benjamin (Deputy Director) and their colleagues within the Education and Visitors team. Their individual and collective leadership skills should not be underestimated. Negotiating common and shared purpose is a fundamental aspect of

FIG. 6: Andy Burnham MP, service user Tommy Dunne and Steve Rotheram MP at the House of Memories reception, House of Commons June 2014.

successful collaborative working, including the articulation of shared vision and values, particularly in the context of multi-agency initiatives (Williams, 2012: 104). Crafting a vision that provides 'a coherent focus for collective action' is regarded as especially difficult and complex within public sector settings – the team at NML has achieved this outcome with aplomb. In this respect, the House of Memories team has helped to position museums as the ultimate "boundary spanners", characterised by the ability to engage with others; deploy relational and interpersonal competencies; and to acknowledge and value difference outside own professional circles (Peck and Dickinson).

One of the most significant leadership achievements of the NML team has been the effective lobbying and engagement of political leaders and members of parliament (MPs), both regionally and nationally. Similar to other elements of collaborative practice throughout the programme's development, this has involved incremental stages of communication and consultation, from inviting local MPs to participate in local sessions and the Minister of State for Care and Support to a specially convened awareness raising event in Liverpool, to galvanising comprehensive support and acknowledgment within the House of Commons (Figures 5 and 6). This represents advocacy at the highest level. Milestone events include a dedicated parliamentary debate led by Steve Rotheram MP on 4 June 2013, which drew attention to the scalable social and economic effectiveness of House of Memories, based on investment from the Department of Health and Liverpool City Council's recognition of House of Memories as a leading driver of its age-friendly city policy. The speech points to House of Memories as an example of how cultural assets can be used to

greater effect in the dementia care campaign, and most notably reflects a passionate care and respect for the work achieved to date by NML. A special House of Commons reception held on 17 June 2014, and again led by Steve Rotheram MP, represents a second significant political intervention for House of Memories. This brought together everyone involved in the programme including people with dementia and carers, with MPs from across the main political parties, to celebrate the achievements of the programme to date and launch the My House of Memories app .

This event acted upon the socially democratic ethos of NML, and was entirely driven by a shared belief in the programme and its impact across the political spectrum. By leading the formation of the ultimate community of practice – including people with dementia; carers, family and friends; museums and arts practitioners; health and social care professionals; Government ministers; academic researchers - throughout its House of Memories journey, the team at NML has created its own pervasive culture of care, with the requisite ontological security and trust within its own networks that are so integral to purposeful and effective collaborative work. It is this shared, impassioned belief and emotional investment in House of Memories, across the "ultimate community of practice", that is the real hallmark of its success.

REFERENCES

Age Concern (2009) Prevention in Practice: Service models, methods and impact. Available from: http://www.ageuk. org.uk/documents/en-gb/for-professionals/health-and-wellbeing/61_0409_prevention_in_practice_service_models_methods_and_impact_2009_pro.pdf?dtrk=true.

Beaumont, G. (2012) Prevention agenda crucial for hard-hit NHS. Health Exchange 6 December 2012. Available from: http://www.healthexchange.org.uk/prevention-agenda-crucial-for-hard-hit-nhs/.

Boyle, D. and Harris, M. (2009) *The Challenge of Co-Production: how equal partnerships between professionals and the public are crucial to improving public services.* Discussion Paper December 2009. London: NESTA.

Brooker, D. (2007) *Person-centred Dementia Care: making services better.* London: Jessica Kingsley Publishers.

Care Quality Commission (2014) *Cracks in the Pathway: People's experiences of dementia care as they move between care homes and hospitals.* October 2014. Available from: http://www.cqc.org.uk/content/cracks-pathway.

Chatterjee, H. and Noble, N. (2013) *Museums, Health and Wellbeing.* Farnham: Ashgate Publishing Limited.

Department of Health (2012) Prime Minister's challenge on dementia: Delivering major improvements in dementia care and research by 2015. Available from: https://www.gov.uk/government/uploads/system/uploads/attachment_data/file/146773/dh_133176.pdf.

Durose, C., Mangan, C., Needham, C., Rees, J. and Hilton, M. (2013) *Transforming Local Public Services through*

Co-production. April 2013. Birmingham: University of
Birmingham.

Fleming, D. (2012) Museums for Social Justice: Managing
organisational change. In: Sandell, R. and Nightingale,
E. (Eds) *Museums, Equality and Social Justice*. Abingdon:
Routledge.

Hanna, J. and Reynolds, C. (2012) *An evaluation of National
Museums Liverpool Dementia Training Programme: health
and social care model*. May 2012. Liverpool: National
Museums Liverpool.

Hewison, R. and Holden, J. (2011) *The Cultural Leadership
Handbook: How to Run a Creative Organization*. Farnham:
Gower Publishing Limited.

O'Brien, D. (2014) *Cultural Policy: Management, value and
modernity in the creative industries*. Abingdon: Routledge.

Ocello, C.B. (2011) Being responsive to be responsible:
Museums and audience development. In: Marstine, J.
(Ed.) *The Routledge Companion to Museum Ethics: Redefining
Ethics for the Twenty-first Century Museum*. Abingdon:
Routledge.

Pawson, R. and Tilley, N. (1997) *Realistic Evaluation*. London:
Sage Publications.

Peck, E. and Dickinson, H. (2008) *Managing and Leading in
Inter-agency settings*. Bristol: The Policy Press.

Pilgrim, D., Tomasini, F. and Vassilev, I. (2011) *Examining
Trust in Healthcare: A Multidisciplinary Perspective*. London:
Palgrave MacMillan.

Silverman, L. (2010) *The Social Work of Museums*. Abingdon:
Routledge.

Williams, P. (2012) *Collaboration in Public Policy and Practice:*

perspectives on boundary spanners. Bristol: The Policy Press.

Wilson, K. and Grindrod, L. (2013) *An evaluation of House of Memories dementia training programme: Northern Model*. Liverpool: National Museums Liverpool.

Wilson, K. and Whelan, G. (2014) *An evaluation of House of Memories dementia training programme: Midlands Model*. Liverpool: National Museums Liverpool.

CONCLUSION

MUSEUMS AND AGEING:
THE CHALLENGE AHEAD

Hamish L Robertson

POPULATION AGEING is not just a discernible demographic phenomenon but a transformative process – it is altering the composition and therefore the characteristics of our societies. Successful aged societies cannot simply replicate younger ones by adding more disability aides or making people work longer. We need to reimagine our societies as aged because this global phenomenon has not yet peaked. To do this, we need to develop new knowledge to cope with the changes ageing is leading us towards. This too is a challenge because that new knowledge has to find a place amongst the prevailing assumptions and orthodoxies we have all grown to live with about age, ageing and older people in general. Many museums are already in the process of responding to that transformation process and we can expect to see this situation progress in coming decades, especially as the experiences of museums in addressing older people as visitors, volunteers, workers and contributors continues to grow and diversify.

Ageing is a change agent in other ways as well. If we are to age successfully as societies, and not just as isolated cohorts of older people, our societies and our ideas about age and ageing must change as well. The scale of population ageing means that museums will become significant contributors to our knowledge about ageing as well as about museums. Both the variety of outreach and in-house activities currently underway and the evaluation of such projects are adding to what we know about ageing, about how to support older people and the potential health effects of opportunities for cultural engagement in later life. Unlike some areas of society, museums and galleries have long known and understood that older age does not automatically negate our capacity for creativity, engagement and

contribution. Now, as population ageing progresses, museums will start to provide evidence for how cultural engagement can improve the health and wellbeing of older people in the community and in institutional care environments.

A major focus for those museums currently addressing population ageing has been the issue of dementia and more specifically Alzheimer's disease. The New York Museum of Modern Art's Meet Me at the MoMA project developed into the MoMA Alzheimer's Project which ran from 2007 to 2014 and this has had a huge influence across the sector in terms of how museums engage with people with dementia and their carers. Recognising and accepting the reality of the dementias has caused museums to begin the process of changing their models of engagement to better fit with the broader phenomenon of an ageing population. The complexity of the dementias requires a sophisticated response because they are highly variable in their effects and the progression of dementia-related conditions can be quite specific to individuals. In addition, when a person has a dementia diagnosis they often have a variety of other health conditions and physical problems as well. Adapting to this important aspect of population ageing and its clinical medical impact makes the museum a much more aware and informed environment because progressive, degenerative conditions like the dementias require an ongoing process of learning and adaptation. To work with the dementias in the context of cultural heritage exhibitions and programmes is to be committed to an enduring process of change management, adaptation and even transformation.

Central to these engagement processes are the concepts of knowledge and memory. Museums have been discussing and

debating their role as institutional places of memory for several decades. The new museology focused on a critical approach to what was remembered and whose memories were emphasised in these traditional institutional settings. Population ageing is adding yet another interesting dimension to this concept of memory work. People with dementia often lose their memories, usually starting with the short-term and then progressing to the longer-term. This is a challenge for their carers but an opportunity for museums whose collections often reflect artefacts with a medium to long-term history. These can correspond very well to the pattern of memory loss experienced by some older people and still fit well with those whose memory is fully intact. Museums possess not only artefacts from the lifespans of older people but they also possess the cultural artefacts that older generations were exposed to in their own youth. This deep memory resource is an established part of what museums do and consequently makes them well-placed to support age-related memory problems.

Reminiscence work and portable history-in-a-box exhibits can provide genuinely beneficial and enjoyable experiences for older people across the health and memory spectrum. Tangible effects such as changes in mood, appetite and social engagement have been observed and documented by a number of contributors in this collection. What will be important looking to the future is to see where this intersectional science goes next. Can memory work have measurable clinical outcomes, to what degree and for how long? Can memory activities be successfully adapted for progressive memory loss while maintaining positive changes in wellbeing and behaviour? Is there a viable "prescription" for cultural engagement that

will provide positive outcomes or delay clinical decline? Can we do this in ways that don't exaggerate the existing focus on ageing as decline and dependency? Also identified in this collection is the need for museums to reach out to a variety of health professionals and researchers to implement these programmes to best effect and to build that developmental knowledge base in a sustainable manner. The museum will increasingly become a locus for these types of intersectional scientific, clinical and research undertakings because the skills and knowledge required to make exhibits and activities engaging for older people will expand as population ageing progresses internationally.

Adding a social dimension to the traditional formal engagement processes of the museum visit, such as those being developed for people with dementia and their carers (including spouses, partners, families, friends, employed carers, social workers and health professionals), will almost certainly change museums for the better. Authors in this collection often identify the spontaneous behaviours of older visitors, including those with dementia, as an entirely new experience for them as professionals. These visitors are frequently thrilled to be invited into the museum and given a level of attention and consideration they can rarely find in other areas of society. As a consequence, their pleasure and surprise are often verbalised, some even break into song – see the case studies for further details. This is also surprising for other visitors in the museum environment because those museums are, by actively engaging with people with dementia, expanding the scope of what is permissible behaviour in these environments. By renegotiating the boundaries of acceptable behaviour in a public

environment, they are changing the scope of what a museum is and what people might expect to experience in museums. Hopefully this will also change how we see and accept older people and their behaviours.

We are also seeing examples of the museum developing as a therapeutic place, perhaps even as a healing place. This is an exciting development because it too breaks with the conventions that tend to dominate ageing practice in our societies. Ideas of how to diagnose and treat illness and disease have become highly regularised over the past two centuries with the doctor, the clinic and the hospital seen as central to health and healing. But current formulations of these institutions were designed for a different time, a different population and its patterns of disease, and certainly not for the processes we see associated with rising population ageing. Many people in healthcare systems complain about the changes population ageing is forcing on them. This makes it sound as if demography can surprise us, when present elderly cohorts were born 70 or more years ago and life expectancies have been rising steadily for more than a century. If museums can contribute to this situation through social prescribing, outreach programmes and related activities, it bodes well for the future of ageing and the aged.

These engagement processes represent strategies for change, even transformation, and ones which will extend not only the concept of inclusion but of representation as well. The contemporary museum is a place for older people in all their variety, and one which benefits from their engagement as well as offering opportunities perhaps absent in the past. It is also important to emphasise again and again that, illness and

disability to one side, many healthy, informed and engaged older people continue to see the museum as a place for them as it currently stands. Where this seems to be changing is in the nature of the volunteer's role within some museums, with both museums and volunteers themselves seeing the need for change. In some cases the skills sets of volunteers are changing significantly with many educated and experienced older people eager for new challenges in the museum environment. Museums too are seeing that to be sustainable and rewarding, the role of the volunteer has to move with the times. Relatively passive activities, in particular, are less rewarding for both volunteers and museums than they were in the past because the visiting experience is itself changing and this affects established practices, routines and habits.

The other significant issue for our ageing societies and museums is how those who have not yet begun to travel down this pathway can do so while minimising losses, mistakes and misunderstandings. In this volume a variety of practitioners give freely of their experience in beginning this journey. It is clear that there is a lot to learn and that museums have the capacity to build meaningful relationships with older people because most of them have being doing so for decades. The real complexity comes in working with people whose health status and disabling conditions make the processes of engagement and relevant forms of participation more challenging for the museum, its board and staff. In this sense, as we can see in these chapters and case studies, this is about building a growing knowledge community around ageing in the museums sector. It is a good thing to undertake projects and programmes that reach out to older people in new and interesting ways, it is an

even better thing to share the knowledge that those processes inevitably produce with others who may benefit.

This collection canvases a variety of issues with which museums and galleries are currently engaged. It exemplifies the thinking and approaches museums see themselves as pioneering in the present circumstances and with an engaged and analytical view to the future. From how to better engage older volunteers through to the concept of social prescribing, museums are innovating in their efforts to engage with age and ageing as conditions affecting individuals, communities and societies as a whole. This is an emerging field in which the engagement between geriatrics, gerontology, the health professions more broadly and museums can only continue to grow.

Domains such as museological theory and cultural heritage education and training will also continue to grow and diversify in response as the issues associated with ageing intersect more pressingly with museum policies and practices and the broader societal politics of ageing. Critical gerontology has been engaging with the health and disability aspects of population ageing for some decades now, while museological theory has been critiquing the position, influence and representativeness of museums for at least as long. The convergence of these streams of thought and practice is likely to produce new understandings and formulations about what ageing means in the context of our cultural heritage institutions and communities.

This collection explores the issues associated with the involvement and contributions of older people to the museum sector. One measure of the interest in these issues was the response to the original call for papers, which was extremely

positive and enthusiastic. Many of the authors and their institutions are developing significant new models of engagement which are clearly changing and adapting their own understandings of both ageing and the role of the museum. The response to the proposal for this book suggests that many museums and museum professionals already care about older people and how they can respond more effectively to population ageing. This collection offers some initial observations at the early stages of what is likely to be an enduring journey for museums.

ABOUT THE EDITOR

 HAMISH L ROBERTSON is a geographer by training. He also has a unique blend of experience in health, ageing and cultural heritage work, having undertaken more than a decade's research into ageing, as well as research into both visitors and diversity in Australia. He currently conducts research, publishes and presents on the importance of ageing, disability and cultural diversity for institutions and societies and is a member of both Museums Australia and Museums Aotearoa.

ABOUT THE AUTHORS

ESZTER BIRO graduated from Glasgow School of Art where she received her degree in Fine Art Photography in 2011, and her Masters of Research in Creative Practices in 2012. Since then she has continued her artistic practice in Hungary, where she received a three year Pécsi József Photography grant. Eszter has worked in teaching, and at the Petofi Museum of Literature. She is an active member of the Studio of Young Photographers Hungary and will shortly be continuing her studies through Glasgow School of Art's PhD programme.

HELEN CHATTERJEE is Professor of Biology at University College London and the head of research and teaching for UCL Public and Cultural Engagement. She was principal investigator for a series of Arts and Humanities Research Council funded projects including Heritage in Hospitals and Museums on Prescription. Her interests include touch and the value of object handling in health and wellbeing, and its pedagogical function in education. In 2008 she edited *Touch in Museums: Policy and Practice in Object Handling* and in 2013 she co-authored *Museums, Health and Well-being*.

LIZA DALE-HALLETT is Senior Curator, Sustainable Futures at Museum Victoria, Australia, where she has worked since 1987. She specialises in the history of rural Victoria, with a particular interest in contemporary issues of sustainability, significant changes impacting rural communities, and the links between city and country. Liza is responsible for developing a range of historical and contemporary collections and research projects, including: the Victorian Bushfires Collection, the Victorian Women on Farms Gathering Collection, the

H. V. McKay Sunshine Collection, and contemporary collections documenting the impact of climate change on the lifestyle, environments and future of communities in Victoria. A core component of her curatorial and research methodology is community engagement and interdisciplinary partnerships with rural communities, government and non-government organisations and universities. Much of her research involves the documentation of intangible cultural heritage, with a particular focus on stories and symbols that help give form to experiences, understandings and knowledge. She has received a number of important industry awards (nationally and internationally) for her work in community engagement and multimedia.

HELEN FOUNTAIN is the Reminiscence Officer at the Museum of Oxford, part of the Oxford University Museums Partnership. Helen began working in the Social Care sector in 1997. A part-time role at the Herbert Art Gallery in Coventry began to inspire the idea of creative partnerships between older people and the heritage sector. Following a Museum Studies MA course at the University of Leicester she took up the post of Reminiscence Officer in 2009. Helen is a volunteer with the Jodi Mattes Trust, an international charity that presents the bi-annual Jodi Awards for excellence in accessible digital culture; and with the Notables Foundation, a West Midlands charity which enables adults and young people with learning disabilities to access and share musical activities.

TINE FRISTRUP is an Associate Professor at the Department of Education, Aarhus University, Denmark, and holds a PhD in

Educational Studies from the Danish University of Education. Tine has research expertise in the fields of disability and age/ageing studies. For the last two years, she has been Researcher in Residence at the Nordic Centre of Heritage Learning and Creativity (NCK) in Östersund, Sweden. Tine is working on conceptualising a framework for heritage learning in later life in order to understand the intersection between heritage, learning and ageing. She has been appointed as an eminent expert in the field of education and learning on behalf of the JPI Assembly to contribute to the development of a strategic research agenda in relation to the European Joint Programming Initiative, More Years, Better Lives: The Potential and Challenges of Demographic Change.

SARA GRUT works as Researcher and Project Manager at the Nordic Centre of Heritage Learning and Creativity (NCK) in Östersund, Sweden. She is interested in conceptualising the different ways of learning through heritage, and in particular in developing a framework for understanding the intersection between heritage and ageing. Between 2010 and 2013, Grut coordinated the activities in the working group on heritage and the ageing population within the Learning Museum Network project (LEM), funded by the Lifelong Learning Programme Grundtvig (Nov. 2010 – Oct. 2013). Sara is now occupied with the launching of a Swedish national platform on active ageing and heritage (KURVA).

DALE HILTON has been Director of Teaching and Learning at the Cleveland Museum of Art's (CMA) Distance Learning (DL) program since its inception in 1998 and has grown the program

to reach some 15,000 participants annually. Dale holds an MA in Art History from the University of Chicago and a BFA from Virginia Commonwealth University. Her DL duties include lesson development, script writing, teacher/client relations, and overseeing the scheduling and development of companion publications. She has produced in conjunction with the Distance Learning staff 47 videoconference topics and frequently represents the CMA at educational technology conferences.

SYBILLE KASTNER is Deputy Director of Art Education in Lehmbruck Museum in Duisburg, Germany. The art education department develops programs for all visitors relating to their needs and curates exhibitions which accentuate particular aspects of the art experience. Sybille develops concepts for museum visitors with special needs, including for people with visual impairments and people with dementia and their caregivers. She also works on a research project, The Development of a Model for Social Participation of People with Dementia in the Museum Space (ISER/MSH Hamburg) and trains art educators in other museums to setting up such programs. In 2012, she curated the exhibition *Hey Alter...!* which in 2014 won second prize in the Robert Bosch Foundation's Senior Citizens' Awards.

FIONA KINSEY is Senior Curator, Images and Image Making Collection, in the Humanities Department at Museum Victoria, Australia, where she has worked across diverse history and technology collections over the last 18 years. Past key projects have included historical research related to photographs of 19th century Australian women cyclists, and the acquisition of Melbourne's Biggest Family Album, a community digitisation and

collecting project. Fiona has a particular interest in industrial history, and for the past ten years her work has been focused on the Kodak Heritage Collection, which was acquired in 2005 after the Kodak Australasia factory in Melbourne closed down.

SHARON LAZERSON has a background and degrees in Education and Movement Therapy. She has been working with people with dementia for the last six years and loves bringing creative artistic experiences to this population. The success of Meet Me at the Clark inspires her to spread joy by developing other community-based programs which those with dementia and their caregivers can share.

KAREN LEVINSKY is Program Coordinator at the Cleveland Museum of Art, having joined in 1998 as a gallery instructor teaching audiences of all ages. She eventually took over management of the museum's continuing education program, and works with community partner institutions to plan and present lifelong learning series comprising staff-led tours in special exhibitions and the permanent collection for adult learners, groups visiting the museum throughout the year. In addition, Karen developed several Art to Go (ATG) topics, curating the suitcases from the museum's Education Art Collection and creating related teacher materials. She now manages all aspects of the ATG program that brings museum art objects to classrooms and other sites for hands-on experiences; and Art Cart, which shares these objects with museum visitors. Karen holds an MAT in Museum Education from George Washington University in Washington DC and a BA in art and art history from Macalester College, St. Paul, Minnesota.

LYDIA LITTLEFIELD is a graduate student of Historic Preservation, a color and lighting consultant for clients with fine and quirky old houses, and a writer hoping to forment hope in the face of predominantly grim news. Lydia and her family have lived in the Berkshires for 25 years, joining ancestors who settled here in the eighteenth century.

ANN ROWSON LOVE is an Assistant Professor of Arts Administration/Museum Education and Exhibitions in the Department of Art Education at Florida State University in Tallahassee, Florida. Museum Education and Exhibitions (MEX) is a new program for MA and PhD students interested in visitor-centered museum practices. Prior to this position, Dr. Rowson Love was the Director of Museum Studies at Western Illinois University-Quad Cities, a graduate program based at the Figge Art Museum in Davenport, Iowa. She has been an art museum educator for over 20 years in the Midwest and Southeast United States. She has taught museum education, exhibition development, social research in museums, and currently teaches visitor-centered exhibitions and visitor studies. Her research interests include visitor studies, art museum interpretation strategies, collaborative curatorial approaches, and museums and social change. She presents and publishes nationally and internationally.

PETER MEHLIN was raised in Williamstown and enjoyed the Clark Art Institute as a child. He received his BA from Middlebury College in Vermont, and his MLS from Columbia University. Peter was a librarian in the Brooklyn Public Library system for 35 years. After retiring, he moved back home to

Williamstown and became an active volunteer.

MARLA MILLER joined the Public History Program at UMass Amherst in 1999 and has directed the program since 2001. She holds a doctorate from the University of North Carolina at Chapel Hill. Her primary research interests explore U.S. women's work and health before industrialization. Her recent book, *Betsy Ross and the Making of America*, was a finalist for the Cundill Prize in History and was named to the *Washington Post's* Best of 2010 list. As Public History program director, Marla also teaches courses in Public History, American Material Culture, and Museum and Historic Site Interpretation. A frequent museum consultant, in 2012, she and three co-authors released *Imperiled Promise: The State of History in the National Park Service*, which won the National Council on Public History prize for Excellence in Consulting.

RONNA TULGAN OSTHEIMER has worked in the education department of the Clark Art Institute for more than ten years, first as the Coordinator of Community and Family Programs and for the past five years as the Director of Adult, School and Community Programs. Her goal as a museum educator is to help people realize that looking at and thinking about art can expand their sense of human possibility and well-being. Before coming to the Clark, Ronna taught at the Massachusetts College of Liberal Arts in the Education Department. She holds an EdD in Psychological Education from the University of Massachusetts and a BA in Sociology and American Studies from Hobart and William Smith Colleges.

SONJA POWER is House and Collections Manager for the UK's National Trust at its South Somerset properties. These include Montacute House, Lytes Cary Manor, Barrington Court and Tintinhull House. She came to the Trust in 1995 from Alloa Museum and Gallery where she began working with volunteers when she set up its first Friends organisation. Her experience of historic houses includes working with the collections at Stourhead, Mount Stewart in Northern Ireland and giving technical collections support to a number of smaller National Trust properties in Wiltshire. She was awarded an MA in Museum Studies from Leicester University in 1994.

TRINA PRUFER has been a docent and co-facilitator of the Alzheimer's program, Art in the Afternoon, at the Cleveland Museum of Art since 2010. She attained a BA from Kent State University in anthropology and sociology in 1971; and, ten years later, an MA from University of Akron in school psychology. The first eight years of her career were in the field of social work, where she worked to unite abused and neglected children with their families. After attaining her MA in school psychology, she spent the next 22 years working in educational, community and private practice settings, specializing in the diagnosis and treatment of learning problems, which included working with older adults with memory loss. As a docent, she is interested in working with older adults and their caregivers and groups with special needs.

JESSICA SACK is the Jan and Frederick Mayer Senior Associate Curator of Public Education at the Yale University Art Gallery. Having worked in museum education for over fifteen

years, Jessica leads the gallery's programs for visitors with special needs as well as school, youth, and family programs. She developed the Wurtele Gallery Teacher Program which trains Yale graduate students as museum educators to teach a variety of audiences in the museum. Previously, Jessica was Senior Museum Educator and Coordinator of Teacher Services at the Brooklyn Museum. She has contributed to publications including *Looking to Learn, Learning to Teach*; *Yale University Art Gallery Bulletin*; and *Picturing a Nation: Teaching with American Art and Material Culture* (Brooklyn Museum). Jessica frequently presents at conferences and other museums. She received her MPhil in Ethnology and Museum Ethnography from Oxford University (UK), and an MA in Performance Studies from New York University.

ELIZABETH SHARPE is a public historian and museum educator who has specialized in connections between history and the aging process. The former Director of Education at the Smithsonian Institution's National Museum of American History, Elizabeth led a successful outreach program in the 1980s to extend museum services to older adults. She holds a doctorate in American history from the University of Delaware and is researching nineteenth-century women American's writing about care-giving and end-of-life. She teaches history online for the University of Massachusetts Amherst and Greenfield Community College, and also consults for museums.

SUSAN SHIFRIN is the founding director of ARTZ Philadelphia. She is a teaching and publishing art historian, museum educator and curator, and arts accessibility advocate. Susan

received her PhD in the History of Art from Bryn Mawr College and has worked on the curatorial and education staffs of a number of large and small museums. Her most recent publications include "Addressing the Whole Person: The Arts as a Conduit to Community for People Living with Alzheimer's" (*Journal of Pastoral Care and Counseling*) and "Building Community to Engage Community: The College Museum as a Site of Civic Engagement," (*Journal of the American Historical Association*).

LEANNE STUVER has been the Director of Lifelong Learning at Menorah Park Center for Senior Living for 17 years. She is a registered nurse with an extensive background in health education and also holds a Master's Degree in Education, concentrating on community program planning. She supervises and manages all the lifelong learning programs on the Menorah Park Campus, which includes the Rose Institute for Life Long Learning, Learning Getaway programs, Distance Learning programs, the Scholar on Campus program and The David P. Miller Computer and Technology Center. The Menorah Park Campus tenants participate in distance learning programming with the Cleveland Museum of Art on a monthly basis.

TA-SITTHIPORN THONGNOPNUA is an artist and currently a doctoral candidate at Florida State University in Art Education, with a concentration in Arts Administration. She earned her MFA in painting from Miami University, USA, and BFA in visual arts from Chulalongkorn University, Thailand. Having grown up in Bangkok and worked for numerous rural development services and environmental campaigns in Thailand, her

perspective on art has evolved from being art-for-art's-sake to art-for-life's-sake. Her personal and professional interest is in how arts and creativity services play a dynamic role in building an ecosystem of leisure activities for community well-being. Her current research focuses on how art museums and local senior centers can collaborate on not only creating but also sustaining a full cycle of meaningful art experience and creativity engagement, from passive observation to active participation, for the aging population in and across communities.

MAUREEN THOMAS-ZAREMBA is Curator of Education at The John and Mable Ringling Museum of Art. She received a BA in Art History from Florida State University and completed graduate work in art history and museum studies while running the university's fine arts museum. She spent several years working for the Arango Design Foundation in Miami, FL where she assisted with the planning and implementation of traveling exhibitions focused on contemporary industrial design. In 1993, she became director of the ArtCenter in Bradenton, Florida, when her family moved to the Gulf Coast. An active community-based visual art center, Maureen was responsible for all aspects of the organization including administration, volunteer management, education programs, exhibitions, and fund-raising. She joined the Ringling Museum in 1998 as Assistant Curator of Education for Adult Programs. Collaborating with curatorial colleagues, she developed adult education programs that addressed all aspects of the museum's collections including the art museum, circus museum, historic home and grounds. She has been Curator of Education since 2009 and oversees the range of education programs at the Ringling

including scholastic, docent, adult, and youth and family programs.

LINDA J THOMSON is a cognitive psychologist and senior research associate for UCL Public and Cultural Engagement at University College London. She has been the lead postdoctoral research associate on the Arts and Humanities Research Council funded Heritage in Hospitals project and subsequent programmes of dissemination and evaluation. She takes a particular interest in creative thought processes and the role that vision and touch play in enhancing health and well-being. Her recent research has been focused on developing a measure for evaluating the benefits of heritage-based activities on the health and well-being of older adults and people with mild to moderate dementia.

ESME WARD is Head of Learning and Engagement at Manchester Museum and the Whitworth, at the University of Manchester, where she leads the development and delivery of a wide range of imaginative participatory programmes and resources for visitors of all ages. She teaches on MA Arts Management/Museology. Esme is also the strategic Culture lead for Age Friendly Manchester, working across the city's cultural organisations to develop work by, with and for older people. She has overseen the growth of learning and public programmes to include adult award-winning arts and health, early years and age friendly programmes. She believes museums and the arts have a significant role to play in older people's care, creativity and well-being.

KERRY WILSON is Head of Research at the Institute of Cultural Capital, a cultural policy research institute hosted by the University of Liverpool and Liverpool John Moores University in the UK. She has been an academic researcher in the fields of cultural policy and leadership since 2003. In this time she has also held research posts at the University of Liverpool Management School, the Department of Information Studies at the University of Sheffield, and Leeds Business School. She has led a number of research and evaluation projects covering varied aspects of cultural work, including contribution to social policy agendas and leadership, for a range of funding bodies including the British Council, the Museums, Libraries and Archives Council, Arts Council England, National Museums Liverpool, the Arts and Humanities Research Council and the Economic and Social Research Council. Her cultural policy research interests include professional identity, instrumental value and collaborative practice.

ANDREA WINN is Curator of Community Exhibitions at Manchester Museum, the University of Manchester and is responsible for managing the museum's outreach programme. A key member of the Learning and Engagement team, she works with community groups to increase awareness of, and access to, the museum and its collections. Andrea works as part of the city's Age Friendly Manchester networks in a diverse range of venues from care settings, supported housing venues through to community centres. The museum's outreach programme provides opportunities to work with partners to shape and develop the museum's public engagement offer.

ALSO FROM MUSEUMSETC

THE MUSEUMSETC BOOK COLLECTION

10 Must Reads: Inclusion – Empowering New Audiences

10 Must Reads: Interpretation

10 Must Reads: Learning, Engaging, Enriching

10 Must Reads: Strategies – Making Change Happen

A Handbook for Academic Museums, Volume 1: Exhibitions and Education

A Handbook for Academic Museums, Volume 2: Beyond Exhibitions and Education

A Handbook for Academic Museums, Volume 3: Advancing Engagement

Advanced Interpretive Planning

Alive To Change: Successful Museum Retailing

Contemporary Collecting: Theory and Practice

Collecting the Contemporary: A Handbook for Social History Museums

Conversations with Visitors: Social Media and Museums

Creating Bonds: Successful Museum Marketing

Creativity and Technology: Social Media, Mobiles and Museums

Engaging the Visitor: Designing Exhibits That Work

Inspiring Action: Museums and Social Change

Interpretive Master Planning

Interpretive Training Handbook

Museum Retailing: A Handbook of Strategies for Success

Museums and the Disposals Debate

Museums and the Material World: Collecting the Arabian Peninsula

Museums At Play: Games, Interaction and Learning

Narratives of Community: Museums and Ethnicity

New Thinking: Rules for the (R)evolution of Museums

On Food and Health: Confronting the Big Issues

On Sexuality - Collecting Everybody's Experience

On Working with Offenders: Opening Minds, Awakening Emotions

Oral History and Art: Painting

Oral History and Art: Photography

Oral History and Art: Sculpture

Reimagining Museums: Practice in the Arabian Peninsula

Restaurants, Catering and Facility Rentals: Maximizing Earned Income

Rethinking Learning: Museums and Young People

Science Exhibitions: Communication and Evaluation

Science Exhibitions: Curation and Design

Social Design in Museums: The Psychology of Visitor Studies (2 volumes)

Sustainable Museums: Strategies for the 21st Century

The Caring Museum: New Models of Engagement with Ageing

The Exemplary Museum: Art and Academia

The Innovative Museum: It's Up To You...

The Interpretive Trails Book

The New Museum Community: Audiences, Challenges, Benefits

The Power of the Object: Museums and World War II

Wonderful Things: Learning with Museum Objects

VERTICALS | writings on photography

A History and Handbook of Photography

Naturalistic Photography

Poetry in Photography

The Photographic Studios of Europe

Photography and the Artist's Book

Street Life in London

Street Life in London: Context and Commentary

The Photograph and the Album

The Photograph and the Collection

The Reflexive Photographer

COLOPHON

Published by MuseumsEtc Ltd.
UK: Hudson House, 8 Albany Street, Edinburgh EH1 3QB
USA: 675 Massachusetts Avenue, Suite 11, Cambridge, MA 02139

www.museumsetc.com
twitter: @museumsetc

Edition © 2015 MuseumsEtc Ltd
Texts © The Authors

MuseumsEtc books may be purchased at special quantity discounts for business, academic, or sales promotional use. For information, please email specialsales@museumsetc.com or write to Special Sales Department, MuseumsEtc Ltd, Hudson House, 8 Albany Street, Edinburgh EH1 3QB.

A CIP catalogue record for this book is available on request from the British Library.
ISBN: 978-1-910144-62-6

The paper used in printing this book comes from responsibly managed forests and meets the requirements of the Forest Stewardship Council™ (FSC®) and the Sustainable Forestry Initiative® (SFI®). It is acid free and lignin free and meets all ANSI standards for archival quality paper.

Dolly Pro, the typeface in which the main text of this book is set, is designed by Underware, a specialist type design studio founded in 1999 and based in The Hague, Helsinki and Amsterdam. The font is "a book typeface with flourishes", designed for the comfortable reading of long texts. The asymmetrically rounded serifs give the type a friendly but contemporary look - and it uses old-style numerals, which we love.

Myriad Pro was designed by Robert Slimbach and Carol Twombly for Adobe Systems and is the sans serif typeface probably best known as Apple's corporate font.

MuseumsEtc

Sharing innovation
in museum practice worldwide.